Publisher's Acknowledgements
Special thanks to **Caroline Eggel**,
Berlin. We would also like to thank
the following for lending
reproductions: **Kunsthaus
Bregenz**; **British Film Institute**,
London; **Dundee Contemporary
Arts**; **neugerriemschneider**,
Berlin; **Tanya Bonakdar Gallery**,
New York; **Masataka Hayakawa
Gallery**, Tokyo; **Sonnabend
Gallery**, New York. Photographers:
**Helmut Claus, Giorgio Colombo,
Nancy Holt, Einar Ingólfsson,
Thibault Jeanson, Anna Kleberg,
Ari Magg, Anders Norrsell,
Richard Payne, Colin Ruscoe,
Markus Tretter, Franz Wamhof.**

Artist's Acknowledgements
Madeleine Grynsztejn, Michael
Speaks, Daniel Birnbaum,
Marianne Krogh Jensen, John
Stack, Gilda Williams, Lars Bent
Petersen, Sanne Kofod Olson, Lise
Bek, Adam Szymczyk, Andrzej
Przywara, Barbara Steiner,
Andreas Spiegel, Hans Ulrich
Obrist, Fjordgaarden, Anna
Viktoria Eliasdottir, Mich Hedin
Hansen, Freyr Einarsson, Lars
Lerup, Sigurjon Sighvatsson,
Mickey Cartin, Andreas Koch, Tim
Frank Andersen, James Rondeau,
Jessica Morgan, Katrina Brown,
Susan May, Sheena Wagstaff,
Sarah Glennie, neugerriem-
schneider, Marianne Krogh
Jensen, Rochelle Steiner, Henrik
Olesen, Marc Foxx, Göran
Christensen, Masataka Hayakawa,
Pat Kalt, Gerard de Geer, Christian
Boros, Robert Hoesl, Thilo Fuchs,
Unit Berlin, Claudia Seelmann,
Einar Thorsteinn-Asgeirson,
Manuela Löschmann, Peter Weibel,
Akiko Miyake, Nobue Nakamura,
Mika Hannula, Tom Eccles, Chad
Smith, Martin Rauch, Katerina
Gregos, Terry Jones, Sanford
Kwinter, Jane Schul, Frank Rishøj,
Alexander Jolles, Björn
Runólfsson, Jürgen Hennicke,
Rüthnick Architekten,
Planungsbüro Martin Müller,
Tomski Binsert, Rudolf
Sagmeister, Yona Friedman,
Switbert Greiner, Markus
Weisbeck, Marvin Solit, Martin
Margulies, Bob Nickas, Katrin
Kaschadt, Jeppe Hein, Silke
Heneka, Mikael Elmgren, Ingar
Dragset, Jeroen Jacobs, Bo Ewald,
Sebastian Behmann, Tanya
Bonakdar, Ethan Sklar, Sean
Hughes, Jay Rice, Frank Haugwitz,
Marco De Michelis, Luc Steels,
Bruno Latour, Christa Steinle,
Yona Freidman, Israel Rosenfield,
Caroline Eggel, Andreas Koch,
Stefan Stefanescu, Salome

Sommer, Christiane Rekade, Tony
Huang, Tim Neuger, Burkhard
Riemschneider, Susanne Küper,
Hans Frederik Neuger, Anja
Gerstmann, Elisabeth Lagerholm,
Staff Zumtobel.

All works are in private collections
unless otherwise stated.

Phaidon Press Limited
Regent's Wharf
All Saints Street
London N1 9PA

Phaidon Press Inc.
180 Varick Street
New York, NY 10014

www.phaidon.com

First published 2002
Reprinted 2004
© 2002 Phaidon Press Limited
All works of Olafur Eliasson
are © Olafur Eliasson

ISBN 0 7148 4036 X

A CIP catalogue record of this
book is available from the British
Library.

Designed by Ben Dale (Onespace)
Printed in Hong Kong

cover, front, **Fivefold eye**
2000
h. 25 cm, ⌀ 150 cm
Stainless steel, mirror

cover, back, **Room for one colour**
1998
Light, control panels
Dimensions variable
Installation, Neue Galerie am
Landesmuseum Joanneum, Graz,
Austria

page 4, **Blitzableiter-
Induktionsspule** (Lightning
conductor induction coil)
2000
Cable
Dimensions variable
Installation, Neue Galerie am
Landesmuseum Joanneum, Graz,
Austria

page 6, **Olafur Eliasson**, 2001

page 34, **The movement meter
pavilion for Lernacken**
2000
h. 288 cm, ⌀ 850 cm
Steel, glass, mirror
Installation, Louisiana Museum for
Modern Art, Humlebaek, Denmark
Collection, City of Malmö, Sweden

page 100, **Green river**
1998–
Green colour, water
Realization, Stockholm, 2000

page 112, **Vortex for Lofoten**
(detail)
1999
Water, Plexiglas, hose, metal,
pump
h. 200 cm, ⌀ 100 cm

page 144, **Olafur Eliasson**
Artist's studio, Berlin

Madeleine Grynsztejn Daniel Birnbaum Michael Speaks

Olafur Eliasson

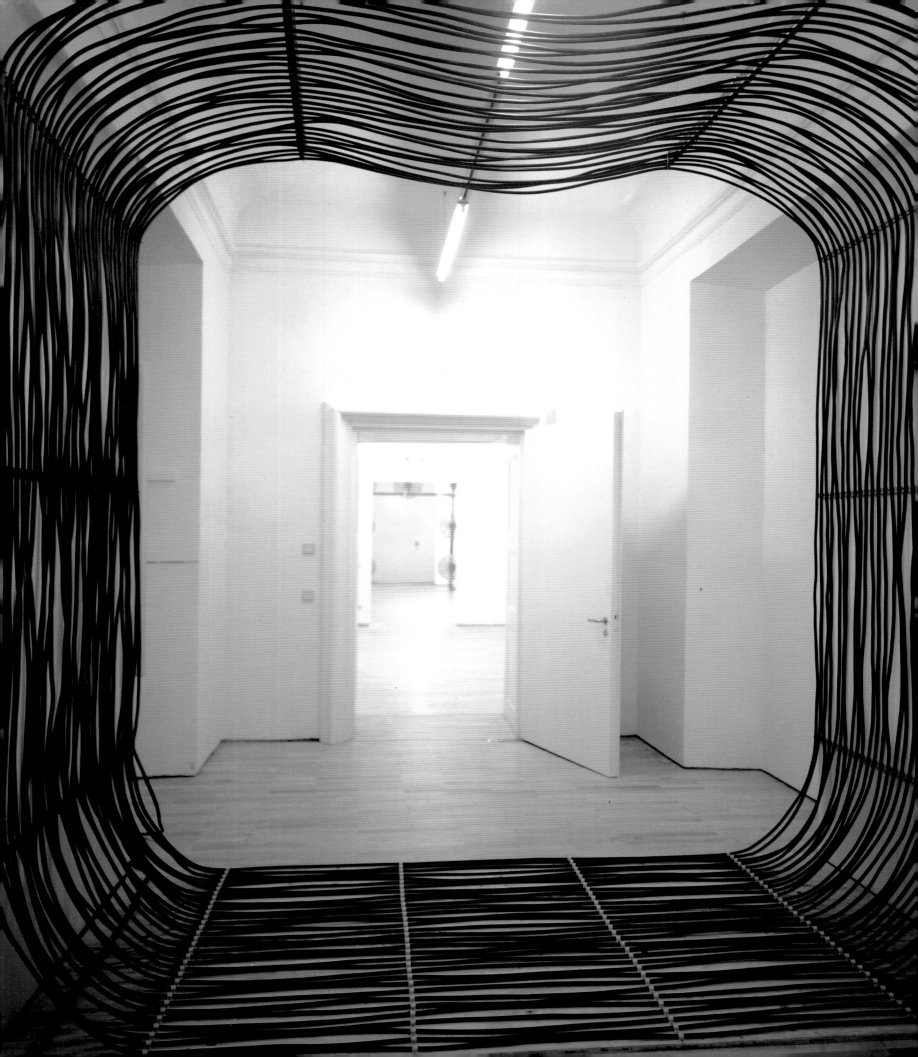

Contents

Contents

Daniel Birnbaum To start, I'd like to ask you about the position of the viewer in your work. Many of your works can be seen from various perspectives. This is often, or maybe always, the case in art, but it seems that you're very conscious of it in your work. And sometimes the changing perspective is the theme of the piece. The work in your exhibition 'Your intuitive surroundings versus your surrounded intuition' at the Art Institute of Chicago (2000), for example, had two parts, which could be seen from different perspectives.

Olafur Eliasson **'Your intuitive surroundings versus your surrounded intuition' was very much about the museum building itself. I had the feeling there that when the viewers finally got to the exhibition area, they would have lost their sense of orientation. When you enter the museum from the street level you walk up and down several flights of stairs, and going through the museum is quite labyrinthine. By the time you've gotten to my work you don't even know what floor you're on – you may even be in the basement. Outside the window there's a kind of train depot, which looks like a bridge. Looking out this window you feel as if you're up quite high, but in fact the 'bridge' is on the street level. I wanted to point out that some buildings have the ability to remove the sense of orientation from the viewer, and that alters the way we see whatever we're looking at in the building. For my show at the Kunsthaus Bregenz ('The mediated motion', 2001), it was extremely clear exactly where you were located in the building as you moved around my work, whereas the Art Institute in Chicago had the exact opposite quality. So I was playing with this sensation of being lost, and when you finally find what you're looking for, you've lost your sense of orientation. This is why I made an artificial garden and artificial sky just outside the window (*Succession*, 2000); something to stand on and something to stand beneath, except that these were outside, so you couldn't actually step out and stand there.**

Birnbaum One way to describe *Succession* would be to say that you lowered the sky, and …

Succession
2000
Grass, soil, scaffolding
Dimensions variable
Installation, Art Institute of
Chicago

Eliasson **Raised the floor, yes.**

Birnbaum And both were equally artificial in a way, although the ground seemed at first glance to be closer to nature – it was outside and it was actually grass. But one could see that it was artificial, that it had some kind of scaffolding.

In a way it seems that this piece is typical of what you've been doing for some time, in the sense that by changing the perspective you can completely change what you see. When you see the grass through the glass, it becomes almost like an image. It's no longer something that's given directly in any way; it's really a representation.

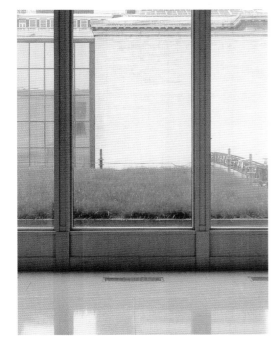

Eliasson **Yes. Looking out of the window might work in the same way as being inside a museum, where everything is presented as if it's isolated from its time, history and context. Looking at a piece of Chinese pottery in a glass vitrine, you tend to see it as if it were in a frame; it becomes a picture, rather than a piece of porcelain that you can actually use or touch or sense in a more tactile way. Being in a museum, you have the feeling entering the space that there will be a garden outside, but the real outside conditions – the wind, the temperature, the birds or the sound of the trains in this case – whatever is outside, won't be there. Is the grass outside real or not? Is it a representation (museum piece) or is it reality (non-museum piece)?**

Birnbaum It seems that your works often make clear that there isn't a sharp line between presentation and representation; that there are many levels – things can be more or less directly presented. You can enter several layers of representation and it becomes more and more unreal.

Eliasson **Or it becomes more and more real. The question with institutions such as museums is, are we seeing reality or are we just seeing pictures; when we look at a piece of armour or a Buddha, or projects such as mine, are they real? The point is that the museum in particular, and the world in general, try to communicate things as if they were real. And I try to show that there's a much higher level of representation than first anticipated in a museum. So what we actually see isn't real at all but artifice or illusion. And going to the next window in the space you can easily see the scaffolding in the train depot raised to a height of two or three floors, and my garden is indeed an artificial lawn, even though it's real grass.**

One can use this as a simple critique of the way in which our surroundings try to convey themselves as reality. For example, in Denmark there's this thing called Legoland, and Legoland is this miniature plastic toy copy of something real. And in Legoland there's something called Lego Skagen. Skagen is the most northern point of Denmark, which is an idyllic fishing village. And the question is, which is more real: the mini-Skagen in Legoland, or the Skagen up in northern Denmark? Of course mini-Skagen in Legoland is more real, because it's not trying to be an illusion. It's not pretending that it's real, like the village up in the north of Denmark where it's all reconstructed in the early twentieth-century language of a remote fishing village where you can visit and have …

Birnbaum An authentic experience?

Eliasson **So-called authentic. So the question is, what is more real? And what is more representational? Of course Legoland is extremely representational, but it's not trying to hide it. And this is what I mean with the museum. It's in fact very representational, but it's also trying to hide it to a certain extent. This is how I saw the grass outside the window, or the lowered sky, in the sense that the windows actually take away our surroundings, or they take them further away than Philip Johnson did with his Crystal Cathedral, or Mies van der Rohe with his Farnsworth House in the north of Chicago, where the surroundings appear to enter the building. I think of it as the isolation of our senses; our surroundings are being taken to a higher level of representation, and therefore taken away.**

Birnbaum In the piece in the 'Carnegie International 1999/2000' in Pittsburgh (*Your natural denudation inverted*, 1999) the same things were negotiated. Here there was also some kind of so-called natural phenomenon that was built on a very obvious construction – the scaffolding again – this water surface and a noisy geyser. Is it a geyser?

Eliasson **I guess you can see it as a geyser, but it was actually the heating system of the building.**

Birnbaum So everything was in fact completely technological – everything was part of some sort of machine. But on one level one could also see it as a joke or at least a comment on natural phenomena. And there again the viewer had the same experience of shifting perspectives: once you entered the museum and you saw *Your natural denudation inverted* through the glass, it became a still-life image as it were, or a photograph.

Eliasson **Exactly, particularly because of the steam. It was a formal garden setting with a big surface covered with water, and in the centre was a steam column sort of rising up through the water. It would be very noisy if you were outside in the courtyard and actually stood face-to-face with the piece; you'd hear the strong sound of the steam, as if it was being pushed through a nozzle. But, when you were inside, it was silent, even though you had the sense that the work was obviously quite loud and aggressive. The wind would blow the steam in various directions, and even though the steam illustrated the wind changing direction you were totally isolated from a physical and sensual engagement with the conditions of the piece. So in this case, also in a museum, it was like looking at a painting through the glass, and you tended to see it as a picture rather than an actual experience.**

But it's a little more ambiguous than this, and I think talking about it like this can limit the piece rather than open it up. The point is, if we know we're looking through a window, it's great, it's OK. If we know we're looking at a TV it's OK. But if we think we're looking at the 'real' thing, it's a problem.

Birnbaum Could this be compared in some way to Brechtian *Verfremdung*, where you always show the tools? One could say that some of your pieces initially lure the spectator into a romantic position of believing in something, or rather of being part of an overwhelming almost natural experience, only to find a few seconds later that it was part of a machine?

opposite and following pages, **Your natural denudation inverted**
1999
Steam, water, basin, scaffolding, trees
15 × 25 m
Installation, 'Carnegie International 1999/2000',
Carnegie Museum of Art, Pittsburgh, Pennsylvania

below, top, **Philip Johnson** (with John Burgee)
Crystal Cathedral
1979
Garden Grove, Los Angeles

below, bottom, **Ludwig Mies van der Rohe**
Farnsworth House
1946–50
Plano, Illinois

Peter Weir
The Truman Show
1998
103 mins., colour, sound

Eliasson **Yes, I think so. Just as people once walked into a church saw a ceiling painting, and were for a moment tricked by the illusion that the ceiling reached infinitely upwards. Or like *The Truman Show* (1998) when Jim Carey's character sails into the end of his world, and finds that it was in fact a stage set. I think there's a subliminal border where suddenly your representational and your real position merge, and you see where you 'really' are, your own position.**

Birnbaum Is it also about reminding the viewer that he or she is actively contributing to the experience? In a way you remind the viewer, when you force someone to change perspective and see things in a completely new way, that *their* experience is unique and that they're not just someone who, in a neutral kind of way, enters into a situation. The meaning of the situation is dependent upon who you are and where you're standing.

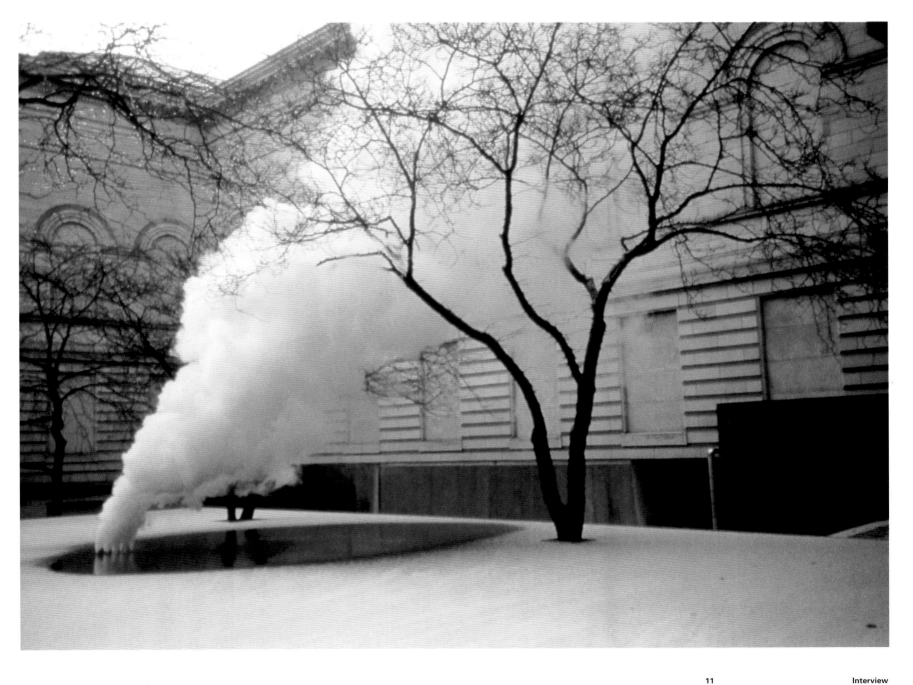

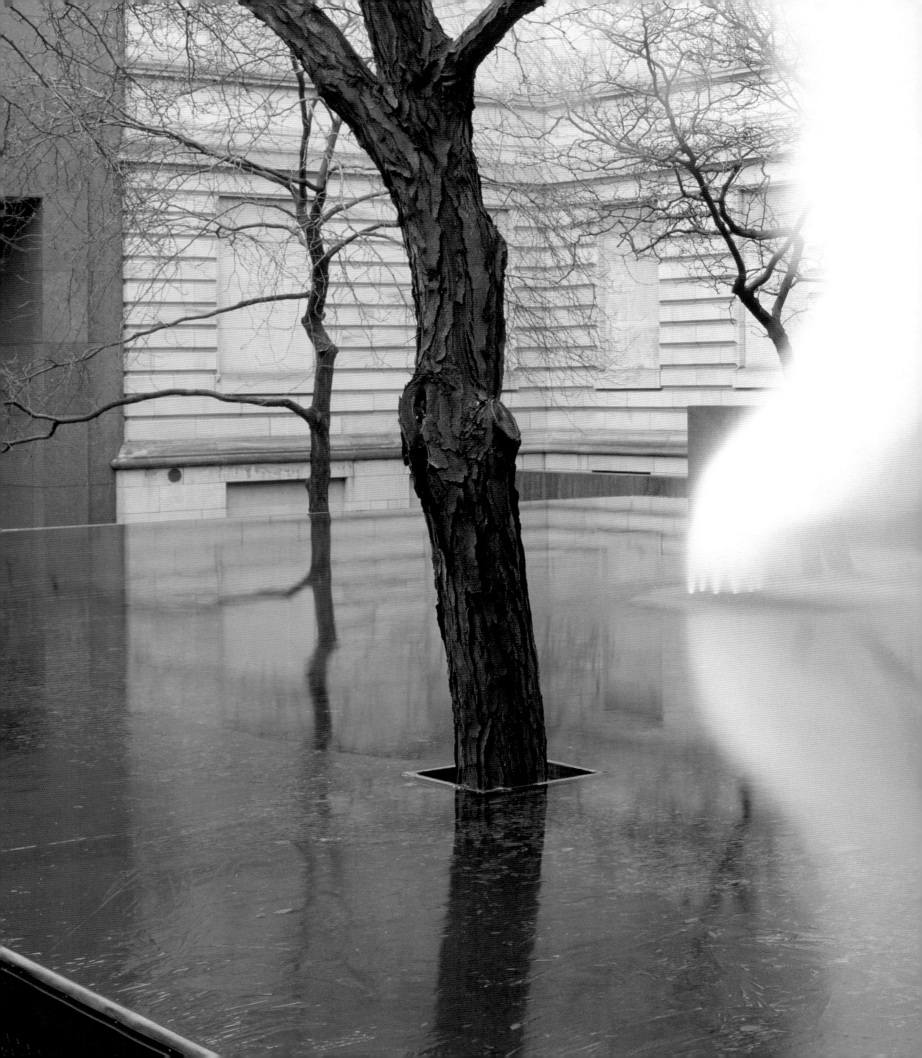

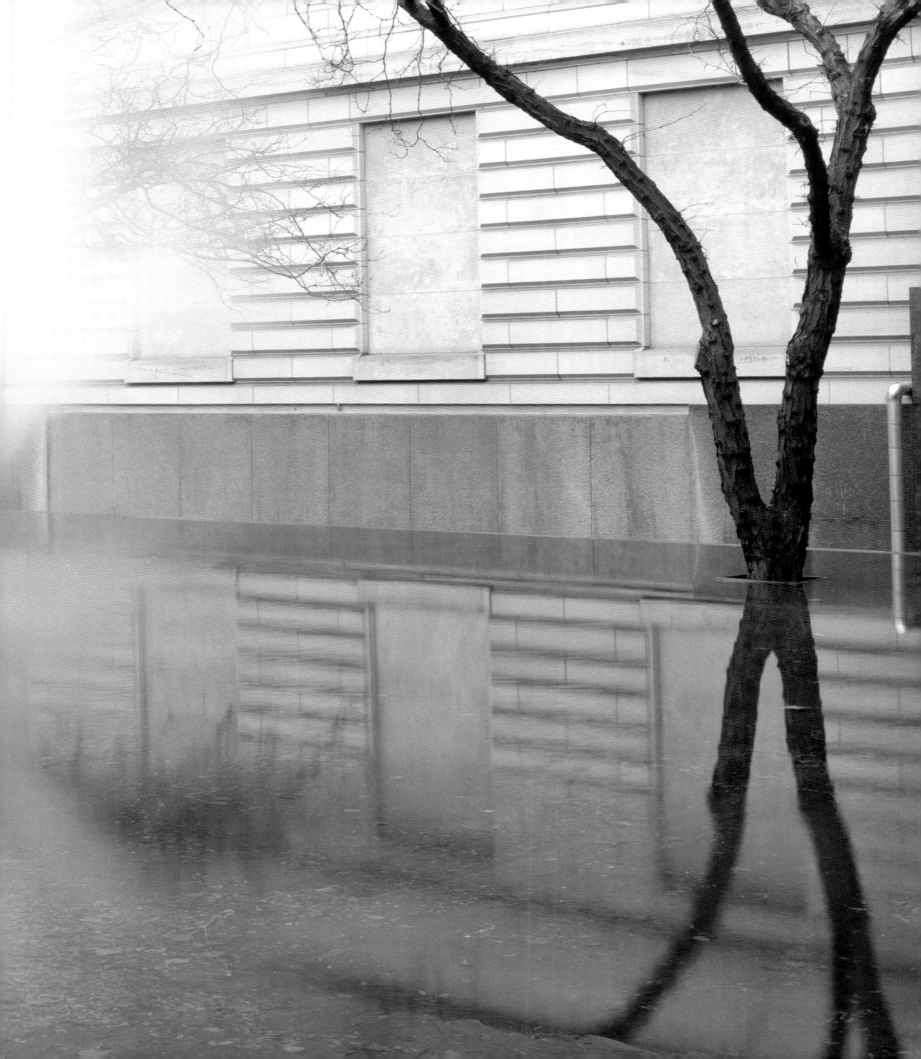

Eliasson **Yes, exactly. I think the situation lies with the viewer. Without the viewer the readings of the the piece could be endless. So with each viewer the readings and the experience are nailed down to one subjective condition; without the viewer there is, in a way, nothing.**

The very large icestep
experienced
1998
Water, plastic, wood
c. 30 × 120 × 800 cm
Installation, Musée d'art moderne
de la ville de Paris and Nanterre,
Paris

Birnbaum Is that why so many of your pieces are called, say, *Your sun machine* (1997) or other titles that start with '*Your*'; who is 'you' here? Is it the viewer? Are you implying that you're somehow handing over responsibility to the viewer?

Eliasson **Yes, it's from me to everybody, or from me to you. I consider the works as sort of 'phenomena-producers', like machines, or stage sets, producing a certain thing in a more or less illusory way. Then the question becomes, when do you reveal the illusion? If you look closely at *Your natural denudation inverted* (1999) in Pittsburgh you can actually see the heating tube going across the wall in the corner of the courtyard. So there's a certain moment where people go 'Aha!'; the moment they say 'Aha!' they see themselves.**

Birnbaum We don't always see the machinery as objective; we see ourselves as part of the machine because it's *our* machine. We see not only the theatre but the machinery behind it. You're reminded of the fact that this is all spectacle. The art critic and curator Charles Esche recently said that he wants to be completely open about how an art project happens; why not keep the space open while you construct the show? And in the development of video art, people were very interested, early on, in the illusionism, but then at some point, Bruce Nauman, say, would show us the projection, the whole construction, how the work had been produced. And someone today like Diana Thater does exactly that: she emphasizes the fact that she's interested not in the illusion itself but rather in the construction of the illusion. One could see your work as related to that of Robert Irwin or James Turrell, who work with light and space; you're interested in those very beautiful and even sensational effects, but you never hide the machinery, and the resulting effects are just as valid.

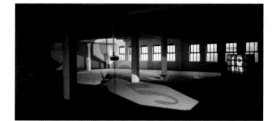

Eliasson **A lot of artists work in this way, I think the reason you want to show the machine is to remind people that they're looking. At certain times you can sit in a cinema and become so engaged with the film that you kind of join the level of representation, but then the next moment you flip back out. And I think the ability to go in and out of the work – showing the machinery – is important today. My work is very much about positioning the subject.**

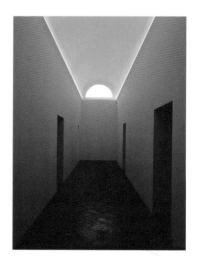

Birnbaum In many of your works there's this idea of the inside and the outside, which could be seen as a comment on the fact that things have a specific meaning when they're inside an institution. This seems connected with the fact that often when you do a project there are several elements to it, and some-times there's a little side-event elsewhere. We could mention *The very large icestep experienced* (Musée d'art moderne de la ville de Paris, 1998), *Corner extension* and *Green river* (IASPIS, Stockholm (2000) and *Spiral pavilion* (Venice Biennale, 1999). All these used the same strategy of presenting a piece that was in many ways a rather classical, beautiful sculpture, but there was also something else going on. Those three are, in my view at least, related in the sense that they all somehow deal with the inside and outside.

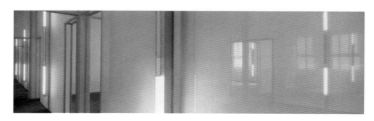

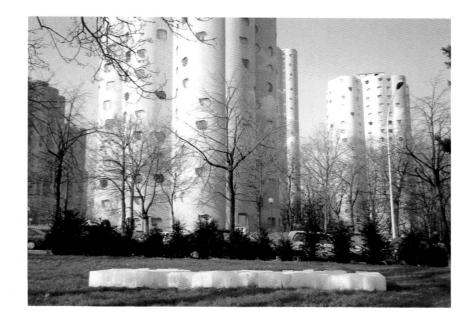

Eliasson **Well, in *The very large icestep* … at the Musée d'art moderne de la ville de Paris I had several melting blocks of ice in a box on the floor, and I had the same amount of ice outside in a suburb of Paris – in Nanterre, close to La Défense. It's not only about the limits of institutions; simply by changing the context I was interested in that shifting level of representation.**

The ice inside the institution was obviously an object, and the viewer was in this case very easily defined as the subject; the dialogue between the two is limited or formalized through history. So even though the ice in the museum was undergoing a process of melting, this process was rather neglected compared to the power of the object itself, as an almost static thing. Anyone who spent five minutes in the museum wouldn't really sense the quality of the melting ice, a very minimal change. Whereas outside, in Nanterre, without the museum surrounding it, the ice was not really considered an object in the same way, since it was no more important than its surroundings. And people there, particularly the people who live their everyday life in this area, would see the process of melting more slowly, I guess over three weeks or some-thing, since it was in the winter. And this creates a different layer or lower level of representation. The changing of the ice gives it an almost subjective quality – the process being something with a history, with a past and a future. And the people passing by and looking at it every day on their way to work were the objects. This is how these pieces work, at least for me: as different investigations of the conditions in which an object is an object and a subject is a subject. It's not merely a critique of the institution as being a limited thing; it's just a different set of qualities in terms of experiencing the work.

Birnbaum Perhaps you could say something about the Venice project (*Spiral pavilion*, 1999) – this pavilion, where the side-event wasn't an event taking place elsewhere, but a little book?

Eliasson **The construction in which my work was shown at the Venice Biennale had a fire-protection system – pumps and water tanks and hoses and so on. I'm sure they'd learnt from the 1996 fire in the famous opera house**

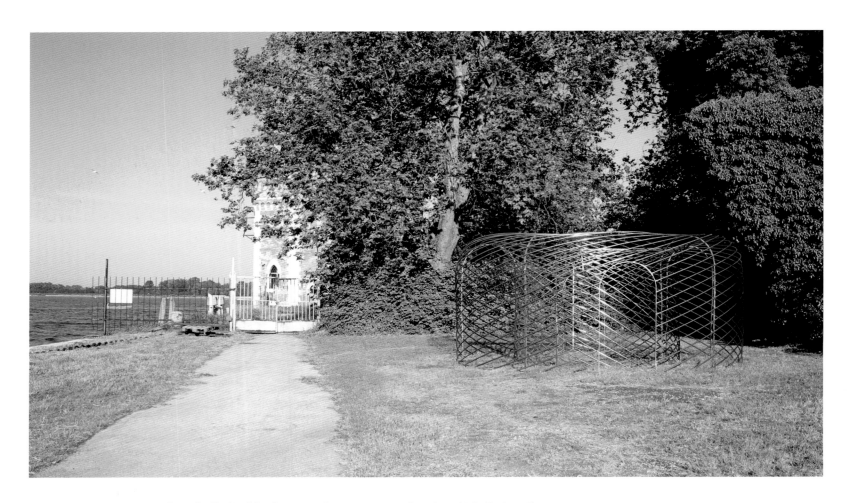

there, La Fenice. My piece was also a structure using pipes. I tried to turn the pipes and the hoses under the huge tanks into a project, without necessarily turning them into art objects. And in a geometrical way they illustrated something like a vortex: water as an energy phenomenon. So my sculpture alluded to a natural phenomenon by using a geometrical set-up. The idea of preventing fire is also a question of the conflict between the cultural and the natural, and since Venice had fairly recently experienced this fire at the opera house I thought it would make sense to make a little intervention in the form of a book about the water system. And this small book was called *Suspensione* – 'Suspension' – since it was about the suspension of water in the tanks. I also included a few found or archival photographs of the burning opera house.

Birnbaum Often when there are two projects that are related in this way, one is more 'inside', so to speak, while the other describes the context and is in that sense more 'outside'. One would think that the inside project would be visually stronger, and the outside would be more delicate or less visually overwhelming. But in Stockholm I would say it was the other way around: you had a delicate light installation, *Corner extension*, in the museum, which of course was visually interesting, but the work outside, *Green river*, was completely overwhelming visually. So the outside predominated, almost like an atomic bomb. How were these two works linked?

Eliasson **They're linked in the way that I talked about before: the inside deals with a much higher level of representation, in the sense that it's always a**

model or it illustrates outside phenomena through a drawing or a photo or installation. I thought about taking it even to the level of a sketch, where it's so representational it's not even really there. But in the end I made a corner light projection, which played with the perspective lines and the way you see a space. It's like an anamorphic principle where you have to be located at a particular point in order to actually see the lines and the space, to find the vanishing point of the perspective, which is an old stage trick. By making lines on the wall you can create the sensation that the space is larger. The other inside piece, *Seeing yourself seeing*, was a mirror which was partly transparent and partly solid, so looking in the mirror you would see the space behind you but your reflection; you'd see yourself seeing through the mirror. The two pieces inside asked, 'How do we see?' and 'How do we see a white cube like this?', which is the Minimalist metaphor for the spatial condition.

The outside piece, which was very physical and organic, was the *Green river* (1998–) project, which I've done in Los Angeles; Bregenz, Germany; and the little town of Moss, in Norway. Every time it turns out differently. In Stockholm we dyed the river green, with an environmentally safe colour, by basically dumping in five or ten kilos of powder, and the turbulence of the water carried the colour rapidly through the central part of Stockholm. When you're in downtown Stockholm, it's so idyllic, it's like being in a museum. It's almost representational, like a postcard. It never changes, and the river – which I consider a dynamic force in the city – was very static. The river in this postcard image was something lively, giving energy to the city. Putting the green colour in the stream for a moment made it hyperreal – it made it totally real. And everybody, without knowing that it was an art project – and this is very important – looked at the river, and for an instant the power and the turbulence and the volume and speed of the water, and all it histories became extremely visible. For a moment, the city – the downtown area – became real. And therefore the normal condition of the downtown area was seen as being almost representational. The point was not even *Green river*; the point was how it looked before and after. The *Green river* is just a catalyst.

Birnbaum Your work triggers off lots of things that activate the whole context and it makes one conscious of what normality is all about, and whether normality is maybe also a construction. And it's of course interesting that it triggered off not only how people saw their own city psychologically, but also the media and the legal system.

Eliasson **Yes, in fact the next day in the newspaper there was a big image of *Green river* – they took a wonderful picture actually – and then they ran a perfect description of what had happened, claiming that it was the government's heating system, which had sprung a leak or something!**

Birnbaum They claimed it was a routine, common occurrence! But the people who have lived there for decades knew that this had never happened before. So there was this really strange cover-up. Which worried people a bit, and triggered off conspiracy theories. If this event was explained away as something normal, then what else has been explained away?

Eliasson **Maybe it's a Swedish thing – they always have an explanation for everything: 'Don't worry; this is safe Sweden, nothing bad happens here!'**

opposite, **Seeing yourself seeing**
2001
Glass, mirror, wooden frame
1 × 1 m

below, **Corner extension**
2000
Light, tripod
Dimensions variable
Installation, IASPIS, Stockholm,
Sweden

Birnbaum Why is it important that the *Green rivers* take place without warning anyone?

Eliasson **Obviously if there was an invitation sent out and a poster hanging on every corner announcing there's an artwork being executed, people wouldn't experience the fear that the river was poisoned. Telling people that it's an artwork makes it more representational – just as the ice blocks in the museum in Paris were more object than the ice blocks outside.**

Birnbaum It's to do with expectations?

Eliasson **Yes, and the pre-knowledge that people bring to the piece.**

Birnbaum There was a *Green river* in Iceland ...

Eliasson **The one in Iceland, I did with my father, my stepmother and my sister. We were totally alone, but after we coloured the whole river, a group of five cars came driving by. I was up on the mountain, away from any danger, but my father was standing by the water and they all ran to him and asked what he'd done! It was very funny. Every time, there was some kind of interaction with people.**

Birnbaum And it also took place in California?

Eliasson **Yes, with only a very few people. In California the concentration wasn't so high, but it was still very green, and nobody cared, nobody stopped, nobody looked. This is weird because Los Angeles is partly in the desert, and water is so important there.**

Birnbaum Maybe they're just used to special effects. Will there be a limited number of *Green rivers*?

Eliasson **Yes; eventually, when repeated many times, the work formalizes itself. The content is lost when it's systematized.**

Birnbaum I'd like to go back to the other works in Stockholm, *Corner extension* (2000) and the first version of what later became *Seeing yourself seeing* (2001), because they seem to deal in a very clear way with the ideas that we've already been talking about. They're absolutely about the position of the viewer. With very subtle means *Corner extension* more or less forces you to think about yourself as you try to find the spot where everything comes into focus. You're reminded of the fact that no experience is just a neutral experience: it always depends upon you. Again, it's about the viewer's position, about the viewer. The other piece – *Seeing yourself seeing* – is perhaps the most subtle piece and so simple. It shows certain paradoxes of what it is to be a subject: you look at this small glass, which is also partly a mirror, and you can either look through it or you see yourself, but you can never do both at once.

Eliasson **Right, right.**

Birnbaum You can pretend, with a small syncope, that you see yourself seeing, but it's very hard to be a subject, or rather very hard to be a self-reflecting

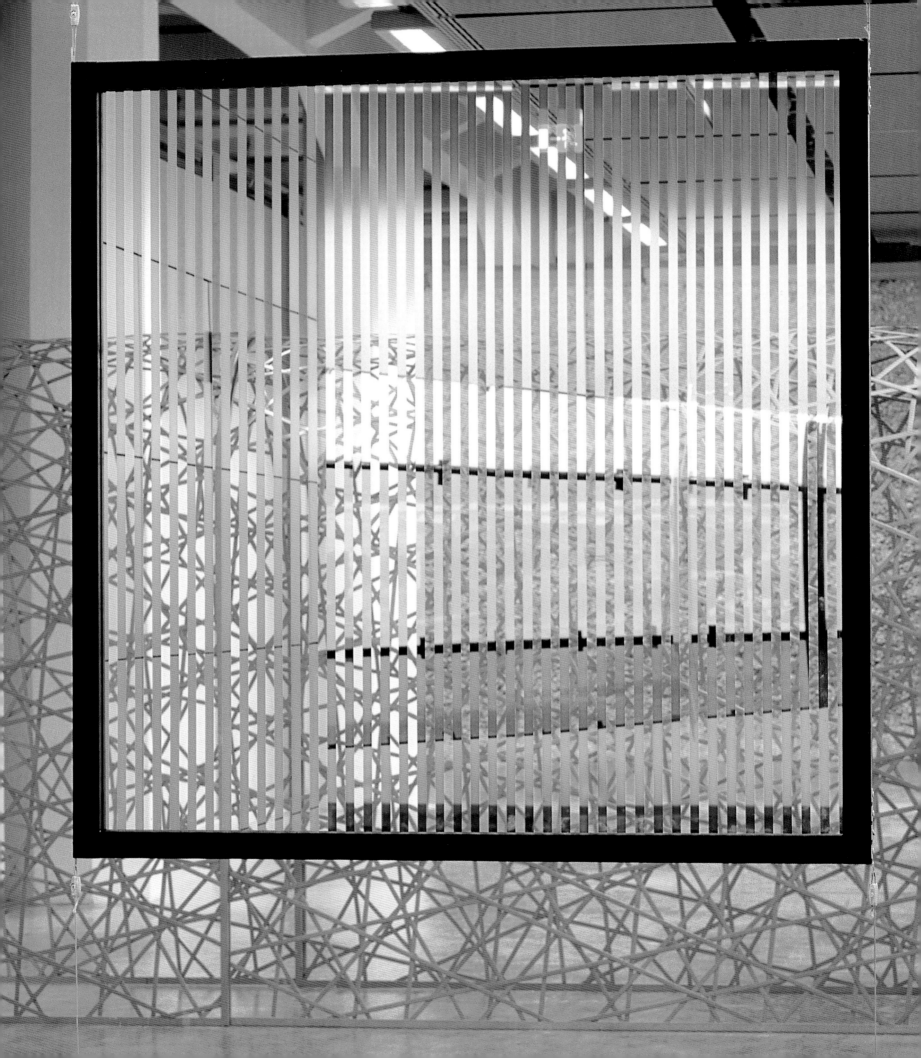

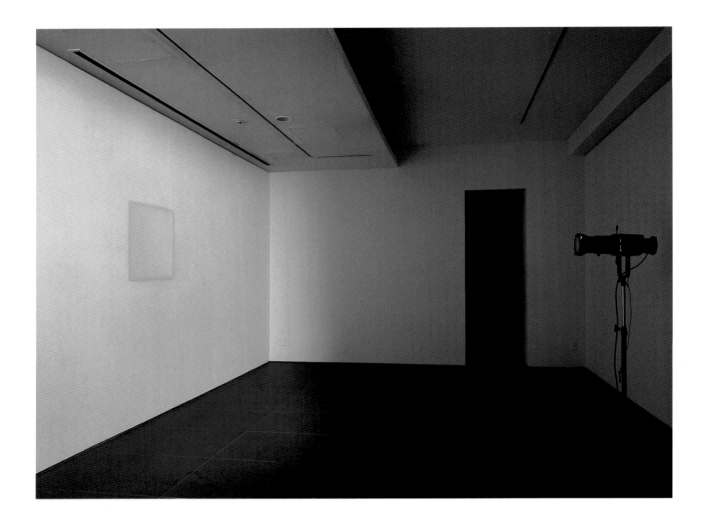

Your orange afterimage exposed
2000
Dimensions variable
Spotlight, dimmer
Installation, Gallery Koyanagi,
Tokyo

subject. Either you look through, and then you're a subject looking for
something else, or you look at yourself, and you turn yourself into an object,
a mirror image.

 Both pieces remind you of the fact that you're an experiencing mind, that
you're a subject – you're subject and object ...

Eliasson **Both at once. In a sense, our spatial history has given us a language
with which we see, and this language dominates our way of seeing. Like you
say, the pieces discuss whether it's possible to be a subject, and whether
you're being forced to see in a certain way.**

Birnbaum At a centre point you can almost get the feeling for a moment that
it's not you looking at the artwork. Sometimes the works are so subtle that they
become an inverted visual experience, and it's the other way round: you're being
seen by the situation. You're not only a productive, phenomenologically active
subject, you're also produced by the piece. You become that subject-object, that
ambiguous space where, as Maurice Merleau-Ponty would say, everything takes
place.

Eliasson **I agree; you could even call it a double perspective. Of course the
wall itself doesn't look at you, but the moment you go 'Aha!' – what I was
saying before – you see yourself from the point of view of the wall. I did two
pieces (*Your blue afterimage exposed* and *Your orange afterimage exposed*,**

both 2000), where I projected light on a wall, and the light gradually got stronger and stronger, until after ten or twelve seconds of looking at it, the light would disappear. The after-image, an imprint of the light on the wall, would be stamped on your retina. What happens then is that you actually project a reversed image with your eye, a complementary image, and for a moment you've been turned into a projector. This is how the piece can look back at us, create something in us. I like the idea of us being the light projector, projecting the piece onto the space.

Birnbaum Suddenly you also recognize the screen upon which something is projected as both passive and active.

Eliasson The reason I think it's important to exercise this double-perspective phenomenon is that our ability to see ourselves seeing – or to see ourselves in the third person, or actually to step out of ourselves and see the whole set-up with the artefact, the subject and the object – that particular quality also gives us the ability to criticize ourselves. I think this is the final aim: giving the subject a critical position, or the ability to criticize one's own position in this perspective.

Birnbaum It's not just a sort of game?

Eliasson No, it's about structures that pretend or make us believe that we're

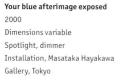

Your blue afterimage exposed
2000
Dimensions variable
Spotlight, dimmer
Installation, Masataka Hayakawa
Gallery, Tokyo

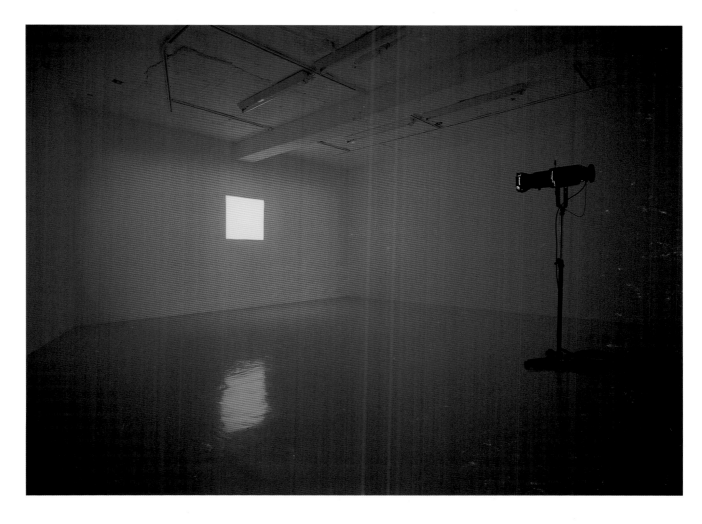

outside, experiencing the piece, but in fact we're inside, behind the glass, not experiencing anything other than an image.

Birnbaum There are two projects that would be interesting to discuss from this perspective. The first is the very early piece *Beauty* (1993), which has been produced in a few different versions; it shows that many of these themes were already present early on in your work. The other is a later piece shown at Marc Foxx Gallery in Los Angeles, called *Your sun machine* (1997). Could you explain *Beauty*?

Eliasson Technically speaking it's a water-curtain of tiny drops and a lamp projecting onto the water at a certain angle. If you're located in the right spot, a spectral phenomenon similar to a rainbow occurs in the water drops. Since the rainbow is obviously dependent on the angle between the water, the light and your eye, if the light doesn't go onto your eyes, there's no rainbow. This piece became important for me because, for the first time, it made it obvious that the spectator is the central issue. The person, the subject looking at the spotlight through the raindrops, is the issue. The water and the light and everything else are just water and light; it's nothing really.

And the same thing, though a little more abstract, is true of *Your sun machine*. I cut a hole in the corrugated metal roof of the Marc Foxx Gallery in Los Angeles, and a round sunspot entered in the morning on the left side of the gallery. During the course of the day this spot would travel diagonally through the space and at the end of the day eventually disappear. People would come into the space and they would turn this sunspot into an object. It's not the same thing as the rainbow, but …

Birnbaum No, but they both link to this central topic of reminding the viewer that he or she is there, and that he or she is positioned in a certain place. *Beauty* does this in a very subtle way: if you step a little bit to the left or the right the piece disappears. The set-up is there, but the phenomenon – that beautiful phenomenon – is gone. That's a very basic way of showing it.

In *Your sun machine* it's about the viewer, but there it's actually very complex and one can trace several stages. First you see the hole, an absence; and then you see something that enters through this absence, and you immediately turn it into an object – it's an image of the sun, or it's the sun itself. And then you might even see it moving, or at least you'll understand that it's moving. And then you're not only displaced on a psychological, geometrical and maybe phenomenological level, you're actually moving cosmologically. At some point, if you start thinking about what that piece is about, your position on a small planet called earth is confirmed.

Eliasson This is why I generally say that the spot of light didn't move, which in fact it didn't; the gallery moves.

Birnbaum Yes. And you're moving with your own vehicle, namely the earth.

Eliasson Exactly.

Birnbaum So that piece brings in literally bigger issues, of space and of our travelling with the earth, and the sun actually not moving at all.

Your sun machine
1997
Cut in ceiling
Cut, ⌀ 120 cm
Installation, Marc Foxx Gallery,
Los Angeles

Beauty
1993
Water, spotlight
Installation, 'Black Box',
Copenhagen, Denmark

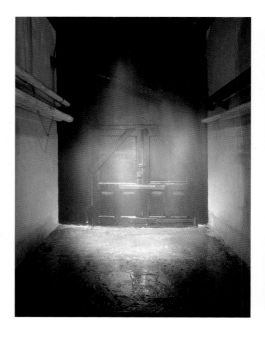

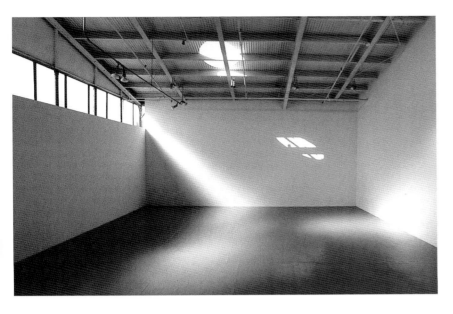
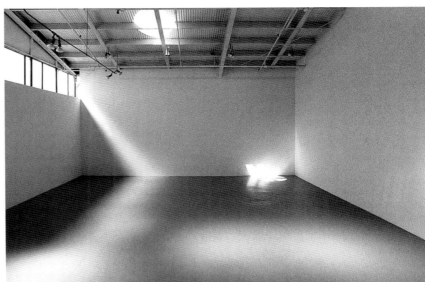
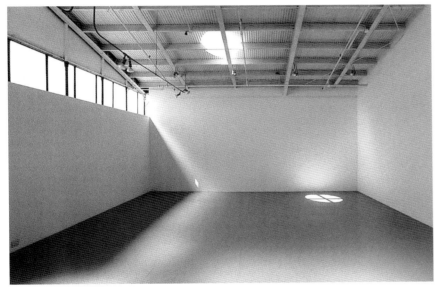
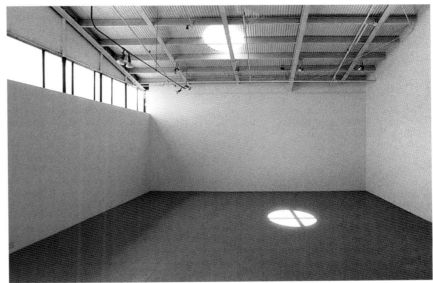
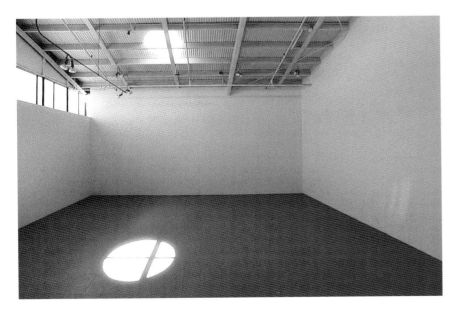
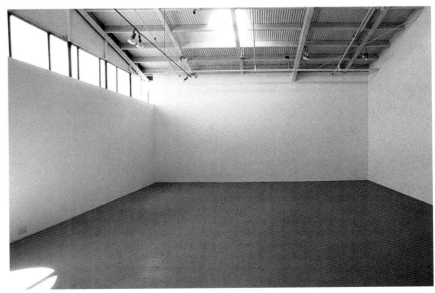

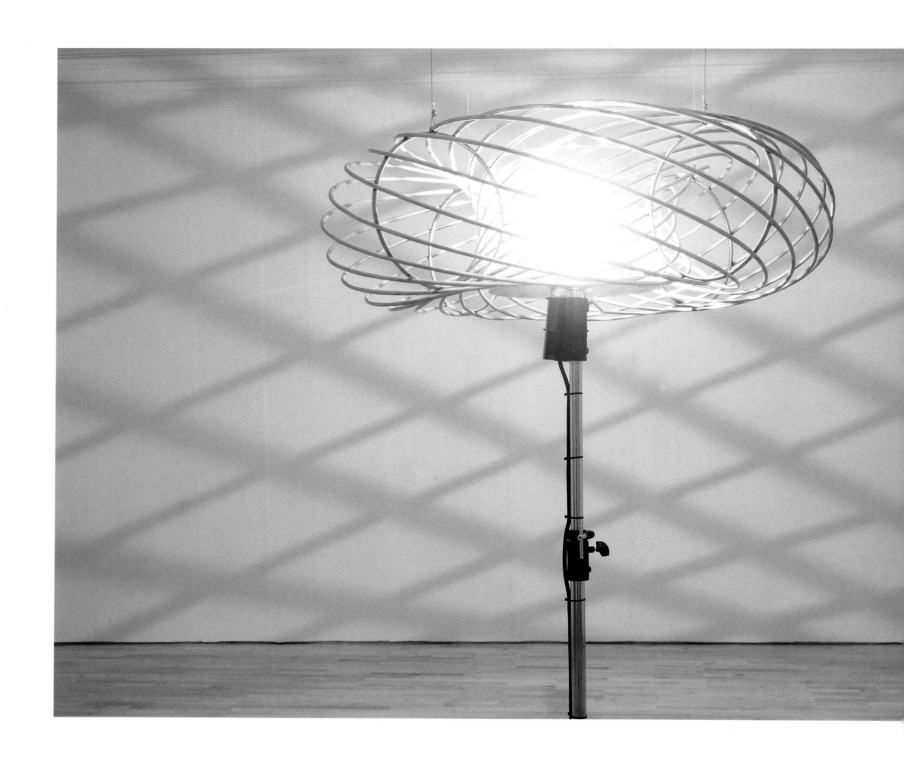

Doughnut projection
2000
Light, steel
Dimensions variable
Installation, Neue Galerie am
Landesmuseum Joanneum, Graz,
Austria

Eliasson **For every experience there's a set of rules or conditions, and these conditions can be set by me or by the spectator, or by other people.**

Birnbaum With the new, bigger projects, you have the original idea but you work with architects, engineers and scientists. How do these networks and collaborations work?

Eliasson **Often people ask if I have a scientific background, but in fact I'm less interested in science than in the result of a particular scientific phenomenon. By 'result' I mean the way people experience it. But I need some media, I need some 'stuff' to create a situation. I need a machine to create a phenomenon in order to have an experience. And since I honestly don't know about science – or mathematics or geometry or architecture for that matter – I engage with people who know better than me. By discussion and testing in my studio I try to set out the formal limits of how this particular relationship can be turned into a project of some kind.**

I work with some people over and over again, and with others I only work once. At the moment I'm collaborating with a wonderful Icelandic architect, Einar Thorsteinn. He has a lot of experience with tensile architecture, and he's also a trained crystallographer; he is extremely knowledgeable in mathematics and geometry. I use him a lot – or should I say we use each other, I hope.

Birnbaum Which of your current projects is Einar Thorsteinn involved with now?

Eliasson **We're working basically with spatial conditions where the lines of the particular space have been altered away from the Euclidian set-up. The Venice pavilion, *Spiral pavilion*, was a result of our collaboration.**

Thorsteinn then did various drawings of doughnut shapes; we worked on them for a long time until we finally arrived at this doughnut shape combined with a Möbius strip (*Doughnut projection*, 2000). It was great when we finally achieved a shape where it all came together, mathematically speaking. I'm totally unable to draw things like this, whereas he's very good at it.

Birnbaum I find these shapes and crystals and geometrical figures everywhere in your studio fascinating. What is it that attracts you to them? Is it their beauty, or their subtleties?

Eliasson **Maybe it's some old-fashioned utopian belief in the worth of looking at alternative structures – ones that aren't common today. It's a questioning of the dimensions we're surrounded by, and looking into the basics of spatial conditions. I'm not quite sure since it's more or less an intuitive practice.**

Birnbaum One might get the feeling when we discuss these things that it's almost like a formalistic game, or some sort of completely planned, strategic set-up where one moves into different positions.

Eliasson **Yes, but it's not. Things become interesting to me without my knowing why. And the things we've been talking about very often occur to me only after I've finished the project. How can you tell exactly what a *Green***

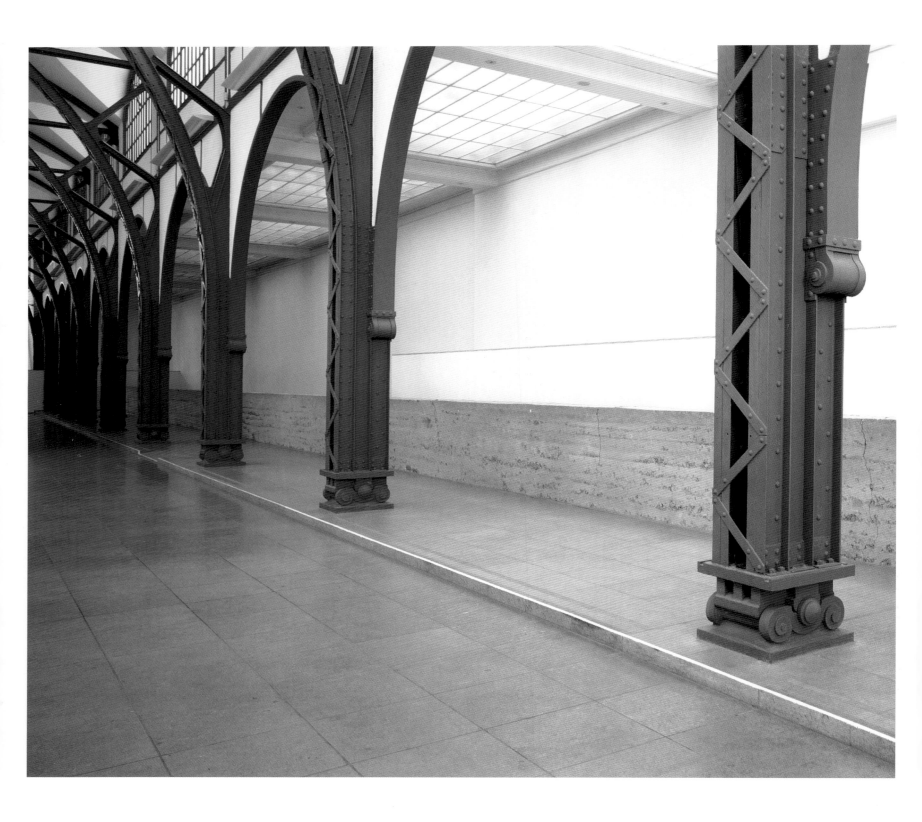

Earthwall
2000
Rammed earth
120 × 8,000 × 40 cm
Installation, Hamburger Bahnhof,
Berlin

river in Stockholm will be like? It has to be unpredictable to a certain extent,
even to a very large extent. And it can turn out to be something different from
your expectation. If the press had reacted differently it would have been a
different piece.

Birnbaum Is the context the work?

Eliasson I made a piece called *Earthwall* (2000) at the Hamburger Bahnhof;
in German I call it *Erdwand*, which means a wall in a house. Obviously a lot
of people saw it as the Berlin wall. And since everyone saw it this way – even
though I made it particularly low and a different shape and so forth – it has
become a work about the Berlin wall. How can I change that? I can't say it's
not, since everybody sees it that way. And maybe that's OK. It wasn't my
intention and maybe the Berlin wall connection makes it a bad or overly
literal or not very interesting work, or maybe it makes it more interesting.

Birnbaum You mention that your interest in mathematical structures has to
do with the fact that one can find alternative ways of seeing the world, more
complex solutions, in a utopian sense. Is there a utopian hope in some of your
projects?

Eliasson In all of them. But I don't think there's an alternative way in the
opportunistic or academic sense. Since the Renaissance there's been a
history of generalizing our spatial conception, how we see, from Panofsky to
Gideon. But throughout the whole practice, questioning what has most
recently been established has always been the issue. And it's not so different
today. In this sense it's a process on a larger scale, and I think it was always
utopian.

Birnbaum So is it a fascination with aesthetics, or is your interest more
intellectual than that?

Eliasson It's both. Like I said, it's often totally intuitive. I take great pleasure
from playing with something I think is beautiful. 'Beauty' is a dangerous
word because it's been standardized into something kitsch. So maybe we
should talk about 'aesthetics' rather than beauty. Often something very ugly
in a particular situation can be unbelievably beautiful in another. So beauty's
not just an isolated phenomenon, it's more a question of something valuable.
For me these geometric forms are about Op Art or optical phenomena –
'optical' in the sense, for example, of how the eye focuses on the strongest
element; how a cube appears invisible in one section, then jumps out in
another; how our eyes have been trained in certain ways. And with
geometric forms you can actually exercise these perceptual-psychological
phenomena.

Victor Vasarely
Vega
1957
Oil on canvas
195 × 130 cm

Birnbaum While on one level one might think that these geometrical
structures and patterns are about abstract representation – the way that
humans have always structured their world – on the other hand they're often
taken directly from natural phenomena: they can be found in plants, or in
crystals or ice. So it's a question of what abstraction is, and about nature. In
very obvious ways your works are about natural phenomena, like the wind for

Your compound view
1998
Mirror, wood, steel
810 × 270 × 320 cm
Installation, Kjarvalstadir, Iceland

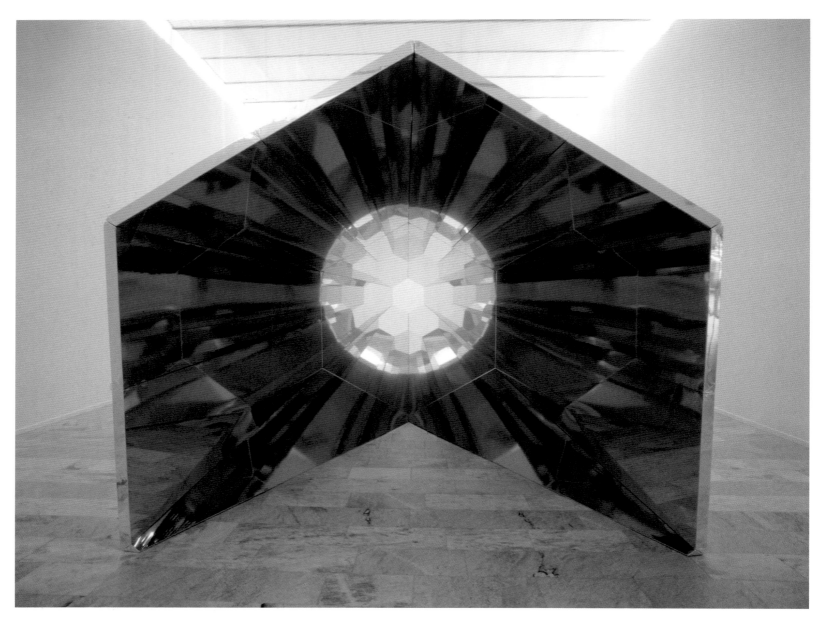

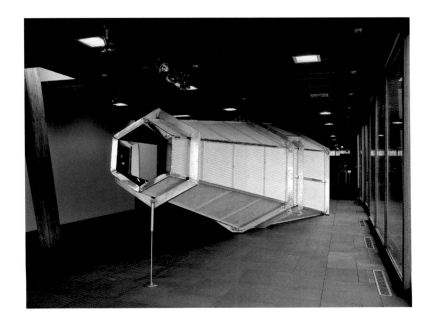

example, but they're also about showing that our way of viewing nature is more complicated; it's never that direct.

Eliasson **Exactly, and this is the point I'm trying to make. The way we look at nature changes nature the moment we look at it. The way we eventually use geometric shapes in houses or structures or as sculpture is about the way in which the spectator interacts with them, actually changes them, either through time, or their position, or by one's mental play with a particular piece. This is part of the history of how we see nature, which is also where mathematics comes from – from trying to encompass and measure natural conditions, or land and the sun and the planets, from Euclidean geometry to Einstein's relativity. Measuring something can actually change its physical condition. And this is where the subject becomes part of the object.**

Birnbaum Of course even if you point to a snowflake and say, 'Look, it's not an artificial pattern, it's a natural phenomenon', it's still about your own projections. You, the viewer, the person investigating, will always remain part of it.

Eliasson **The pointing itself is part of the snowflake. Maybe the snowflake is different when you don't point at it. How can you know? The point is, can we build our world on Euclid, or, as I now think is the question, is seeing the object actually seeing a part of yourself? This is what my projects play with and illustrate a little bit.**

Birnbaum By bringing in experts and people working in other, non-art fields, it would seem that you're trying to branch out in other directions and reach different audiences, away from those expected of an artist. On the one hand it's about bringing things into the art, and on the other it's about bringing yourself and your projects into another reality or another world.

Eliasson **In 2000 I created a smell tunnel for a botanical garden close to Bielefeld, Germany, in a small town called Gütersloh (*Smell tunnel*). I had to**

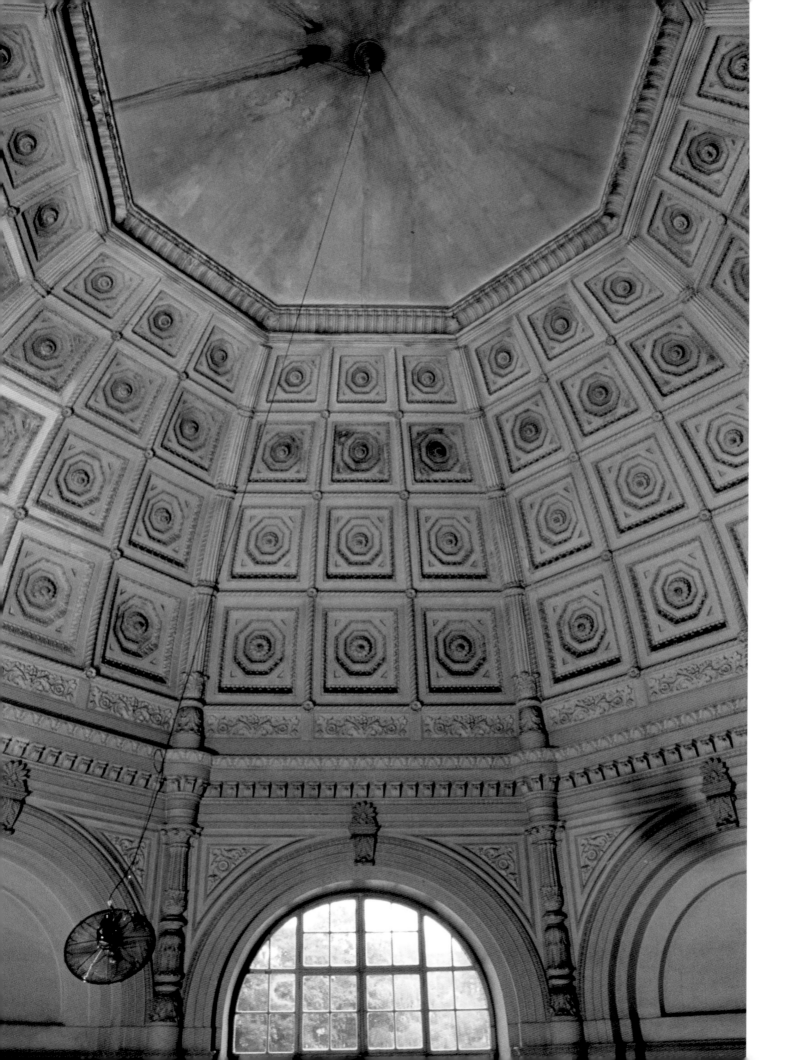

Ventilator
1998
Ventilator, wire
Dimensions variable
Installation, Postfuhramt, Berlin
Biennale

engage a blacksmith, a construction draughtsman, and maybe most important of all, a landscape gardener who specializes in the scent of plants, because I don't really know anything about plants. But I had an idea of what I want people to experience when walking through this tunnel. The people working in this garden don't consider it an art project. And the people who eventually visit it don't care whether it's 'art' or not. The experience doesn't change, I hope.

Birnbaum Is it important whether you're working with art or whether you're working with experiences in general?

Eliasson In general it doesn't matter for the quality of the project whether it's art or not. It's an absurd discussion because saying it's art doesn't add anything; it tends to make it more autonomous, rather than adding something new.

Birnbaum But you're not pretending you're something else; you're not trying, let's say, to be a designer or an architect? You work with all these people to somehow design or shape experiences, but it's still, for want of a better word, 'art', rather than, say, design or architecture?

Eliasson Maybe it has to do with the fact that by adapting a formal set of rules about how to work with others you begin to question them, and gradually, you create a new set of rules. Discussing whether this is art or not will always be one step backwards, since my immediate concern is, 'How can I set up a practice of having people interact with the work in a way that doesn't formalize the process into telling them how to experience it? How can the piece constantly change with every new visitor? How can the piece be one thing one day and the next day something else?' In order to leave that openness it's very important not to lock it up in a certain frame that determines how people see it.

Birnbaum What does it mean to you to work in places such as the Fysik Centrum (Department of Physics) at Stockholm University, where you are currently developing a project?

Eliasson It's not different. This project is still a work-in-progress, so I don't know what ultimately it will be – it might not even be art. But whatever it becomes, it'll be on a different level of representation: not on a pedestal behind glass. I do know that it will interact with the architecture, which is considered a 'functional' building. It's very satisfying to work in a 'functional' frame like this, out of the artistic context. Something more artistic can make the work representational, and it would lose its ability to question.

Birnbaum You're involved in so many projects all over the world – Asia, South America, the US and Europe. It seems that the issues you're interested in are general enough to be relevant in all of these places. But is it very different when you do something in say, Asia, and when you do it in a European art centre?

Eliasson Yes. I've been showing a lot in countries that have had a similar understanding of the object in relation to the subject, so that's why the basic

mechanics have been similar. The city structures in various parts of our Western world are very similar. It's only when getting into the fine tuning that you realize that there are differences between America and Europe, and even between Denmark and Sweden. In this way the projects are slightly different in one place or the other, but they always adapt to their surroundings. So the same work in two different countries might be two different projects, like *Green river*, which takes place in different sites and ends up changing. A project in a formal garden in Italy will look like one thing, and the same project in an entrance to a private American home looks totally different. I haven't shown in developing countries, where my work might seem totally absurd. I'm sure it would be very different. So yes, I think the location matters.

Birnbaum When you first started to show internationally – in the mid 1990s, in Germany, where you've been based for some years – people tried to interpret your work as typically Scandinavian. This overly simplistic kind of identity politics can sometimes be a bit annoying. Things are made to make sense in this way, but at the same time the work and the artist's identity is a bit reduced. It's so easy to say: 'Olafur Eliasson is one of those Scandinavian artists who's obsessed with processes of nature and the tradition of melancholy and romantic landscape painting.' Is this still something that happens all the time? Is your work instantly related to some Scandinavian tradition?

Eliasson **It's definitely a problem, and it still happens, yes. It tends to be art historians, who mostly seek a solution with a single reading. Having been educated in a traditional, analytic track where almost everything has a general objective explanation. The relationship between the work and the spectator has only in recent years gained relevance. Too often the art historians of my and previous generations have this whole romantic tradition of seeking answers in where an artist comes from. I do think it matters where I come from, Iceland, but maybe it's more important that I grew up in Denmark, a sort of pseudo-Protestant Scandinavian country. That probably had a larger impact on my work than so called nature. Of course art historians always think there are autobiographical elements in my works, especially in my photos, but to use this as the reading of the work is, for me at least, a big misunderstanding.**

Birnbaum Or at least a big limitation, if not a tomb. The final result is that you bring it back to what you knew from the starting point.

Eliasson **Exactly. And it makes the work extremely representational.**

Birnbaum Even if one were to try to say that some Scandinavian artists are more interested in nature than artists in other parts of the world, it seems to me that the outcome now would not be some sort of romantic idea about nature, but an interest in the interplay between technology and nature, and the fact that everything takes place within a machine context. On one side there's this old idea that Scandinavia has some sort of romantic obsession with nature and all that. On the other hand everybody knows that Scandinavia is a high-tech part of the world, with Nokia and Ericsson and a lot of Internet companies – a society brimming with digital information. And those different elements are

not so easy to reconcile, although Scandinavian society is comfortable with them. This is not to make your art more understandable, but at least one could say that the issues that you deal with relate to those things?

Eliasson **Yes. I think this is an interesting issue, because I think it's good to demystify some of these background issues. I do think Scandinavians have a special relationship to nature. And while I don't think this is why I do my work like this, of course there's something unique about every single Scandinavian country. But there's something unique about Germany too, so it's not as if that uniqueness doesn't exist elsewhere. Our history of defining the subject in terms of an idea of freedom is quite unique. We have a history of the self – existential or psychological or whatever – while in Japan, and maybe in Asia in general, there's no self whatsoever. We have a history of the self in order to have a community; we have a wonderful humanistic tradition. The Japanese don't have this tradition at all, whereas the Americans have only the self without the community. My work is interested in the subject in relation to its surroundings, which perhaps has to do with the importance in Scandinavia of questioning freedom.**

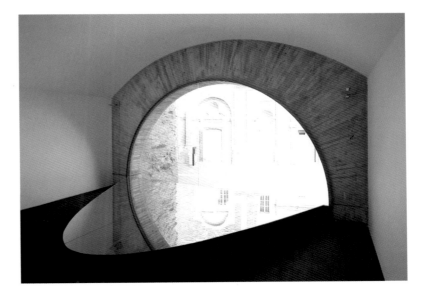

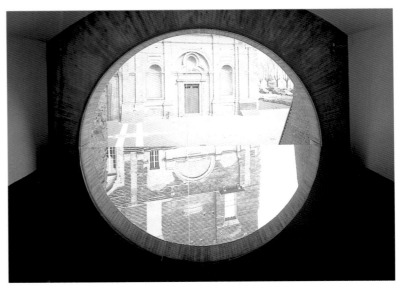

Your circumspection disclosed
1999
Window, mirror
Dimensions variable
Installation, Castello di Rivoli,
Turin

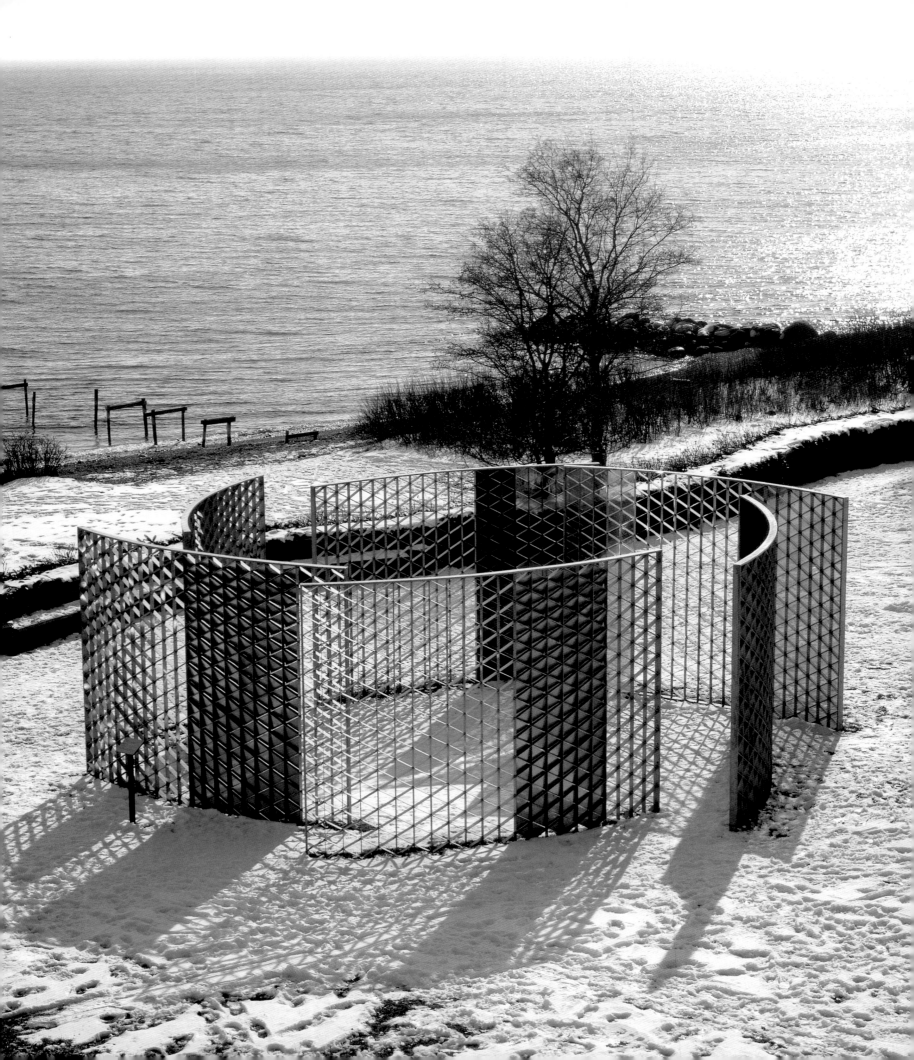

Contents

Camera obscura
1999
Lens, black foil
Dimensions variable
Installation, ZKM Karlsruhe,
Germany

At the very threshold of the exhibition begins a narrow, enveloping corridor, lined on one side with plywood, which in its exposed material and rough construction conveys the sense of an object's raw back.[1] We will later realize that we have been situated behind rather than in front of the painted Sheetrock walls that often partition exhibition spaces – behind the scenes, as it were, where the artificial support that carries the exhibition's appearances remains evident. We are thereby attuned to a certain reflexiveness, a resistance to all-out illusion, conveyed through both a literalism of materials and an uncovering and displaying of the means of support. At the same time, this slender passage, with its compression of space, exerts a kind of gentle kinesthetic demand on the body to advance, quietly drawing the static observer into the role of a stroller or *flâneur*. Clearly our often passive visual absorption of works of art will be challenged at every turn here; our experience will be grounded in a mobile, sentient body, with our temporal passage through space becoming the very basis on which vision will be made possible.

In both of these dimensions the exhibition confounds the primacy of visual perception. Then, too, before our eyes ever settle on a discrete object we not only move but *hear*, for the corridor is filled with a roaring sound whose source – a waterfall machine of the artist's invention – will not reveal itself until the last moment of the show, at the end of our perambulations. This aural overload disrupts the traditionally dominant position of vision in the task of interpreting the world, allowing sound to take on a volumetric, almost sculptural quality, even as it remains immaterial and its source invisible.

By no coincidence, the first object that we encounter on purely visual terms during this walkabout is *Camera obscura* (1999), in which a pinhole in the plywood wall casts a beam of light onto a sheet of translucent plastic hanging freely from the corridor's ceiling at eye level. The plastic is finely ribbed; light passes through but diffuses as well, so that the inverted image cast by the beam on the plastic's surface cannot be clearly distinguished.[2] The camera obscura has historically served as an apparatus for the observation of a universe imagined as given, definable, truthful and constructed along primarily visual lines.[3] In fact this classical instrument of vision presupposes and reflects a belief in an external world of objective truth, and also in an equally autonomous and secure observing subject. The relationship between viewer and viewed is here defined along stationary and strictly optical terms: the universe is conceived of as a fixed, unified visual continuum exterior to human perception, independent of the observer's retinal apparatus and whatever physiological distortions it may bring, and the observer as a detached and disembodied 'eye', free from that bundle of contingent sensations that is the human body. Learned and independent, the individual looks out from a privileged vantage point onto a world imagined as fully exterior to him- or herself.

This idea projected by the camera obscura model, in which a detached observer and an

Waterfall
1998
Steel, pump, water, scaffolding
9 × 9 × 6 m
Installation, Neue Galerie am
Landesmuseum Joanneum, Graz,
Austria

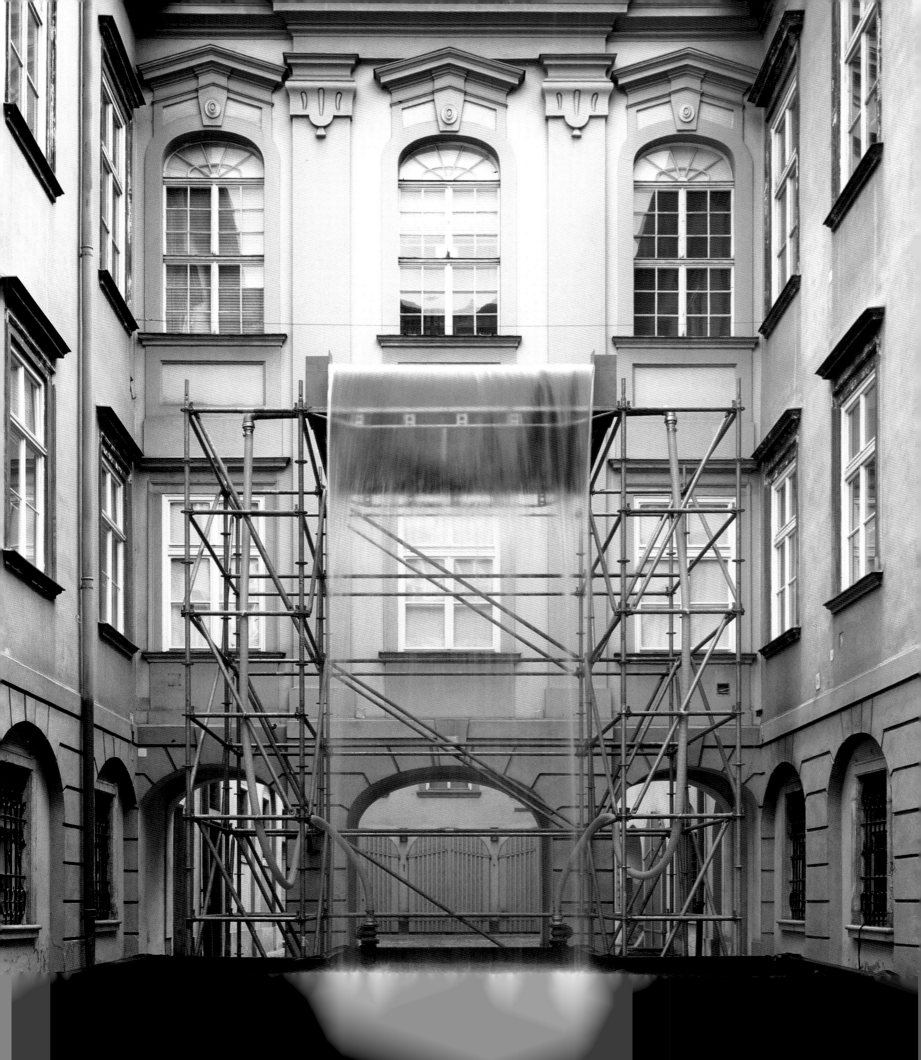

Surroundings surrounded
2001
Strobelights, mirror
Dimensions variable
Installation, ZKM Karlsruhe,
Germany

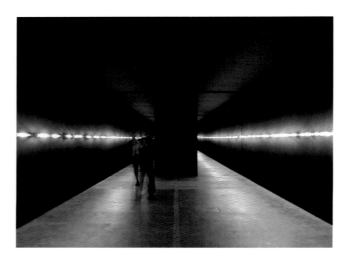

Pier Paolo Calzolari
Untitled (Malina)
1968–95
Blocks of ice, albino dog
Dimensions variable
Installation, Studio Bentivoglio,
Bologna, 1975

Jannis Kounellis
Untitled
1971
Steel pipes, wire, propane gas,
torches
Dimensions variable
Installation, Herbert Collection,
Ghent

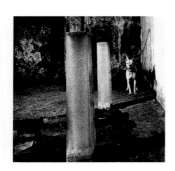

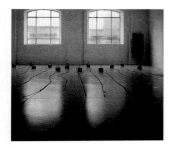

independent world relate on an exclusively scenic level, is radically contravened upon entry into the next room, which contains the installation *Surroundings surrounded* (2001). Coming from one of two directions into a pitch-black gallery, the visitor is caught in a rush of sudden flashes of pulsating white light that seem to race at eye level around the room's perimeter. The walls to either side of the opposite-facing entrances are mirrored in such a way that the lights, placed in a long line on the perpendicular walls, are multiplied infinitely in the reflections on the facing planes. Light trips across the surface of the room, off on off on, at such a rapid rate that the eye in its physiological limitation sees everything as a staccato series of starkly lit, discontinuous images temporarily frozen in time, emerging and disintegrating far too quickly for the viewer successfully to retain and suture them into a continuous field. This cognitive tripping-up is

deliberate: it disables the perception of the world as an uninterrupted continuum, like a screen or a picture. Instead what one actually 'sees', what this artwork seeks physically to instantiate, is the here-and-now, snapping into sharp and immediate focus over and over, precisely captured in the light of an indivisible instant, as if our world were constructed from 'an infinite number of suspended, static moments'[4] or 'now-apprehensions'.[5]

Within this ceaselessly self-renewing experience of immediacy, not only presentness but corporeal being are both asserted and established in a state of heightened consciousness. In the context of this installation, the perceiver is no longer a disembodied optical surveyor located at the outer point of a perspectival projection – as in the camera obscura model – but is instead a haptic producer of optical sensation, actively contributing specific retinal effects to an environmental experience. At the same time, she is also an object of external technical effects, caught by and within a 'dazzling, pulsatile'[6] crossfire of onrushing lights, even as these effects are intimately dependent on her physiological involvement. A powerful intertwining of body and space thus ensues. From the grip of this insistent non-hierarchical 'relay between subject and site'[7] flows an apperception of space and body as simultaneously in formation, as involved in a constantly renewed, mutual interaction. Meanwhile the work of art itself becomes the interface between site and subject, framing the one in relation to the other and transforming both at once.[8]

Herein lies the crux of Olafur Eliasson's practice: for all of their formal diversity, his works cohere clearly and powerfully along a line of serious argument for an embedded and exhilarating being-in-the-world that would return to the individual a heightened sense of him- or herself in the act of perceiving. And by extension, they make a case for a proactive ownership of processes of cognition that tend to be standardized, automated and otherwise impoverished by the mediating modernizing world. Eliasson describes his works as 'devices for the experience of reality',[9] an experience so physically intense, so indivisibly present, as to hold out the promise of an unqualified actuality of existence – an actuality located not fully inside the body, not fully outside it in the world, but at the living edge between a haptic self and a heterogeneous and constantly changing universe, in an encounter somewhere between a concrete event and its luminous apperception, before consciousness subjects experience to assessment, analysis and static judgement. This process of encounter and negotiation, rather than its settled endpoint, is what the works compel, and their deeper meaning – their ethical charge, even – is revealed in the collaboration with the spectator. For in staving off the moment of closure, in opening up and extending the pathway from phenomenon to interpretation to (deferred if inevitable) definition, these pieces create for the subject a 'space of trans-action from which one can begin again ... the collaborative work of aesthetic invention, play and transformation'.[10] This

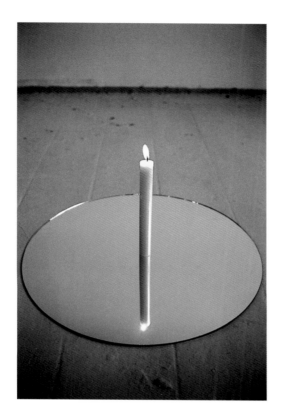

'in-between' space is the crucial space of process, creativity and agency that Eliasson wishes both his work and its viewers to inhabit.

The dynamics of Eliasson's art were honed during his student days at the Royal Academy of Fine Arts in Copenhagen, Denmark, where he studied from 1989 until 1995, with extended visits to New York in 1990–91 and to Cologne in 1993. The art that prevailed in Denmark at the time was a neo-expressionist style of painting aligned with a widespread trend (which began in the mid-1980s) towards an object-oriented, market-conscious production. Reacting against this, Eliasson was part of an international generational shift away from more traditional object-making and towards experimentation with visual phenomena and experientially based work using intangible and ephemeral materials – in Eliasson's case light, mirrors and candle flames. His approach may to some extent have been inspired by Arte

above, left, **Untitled**
1991
Candle, mirror
h. 25 cm, ⌀ 50 cm

above, right, **Sun window**
1997
Sunlight, glass, colour filter
Installation, Kunsthalle Vienna

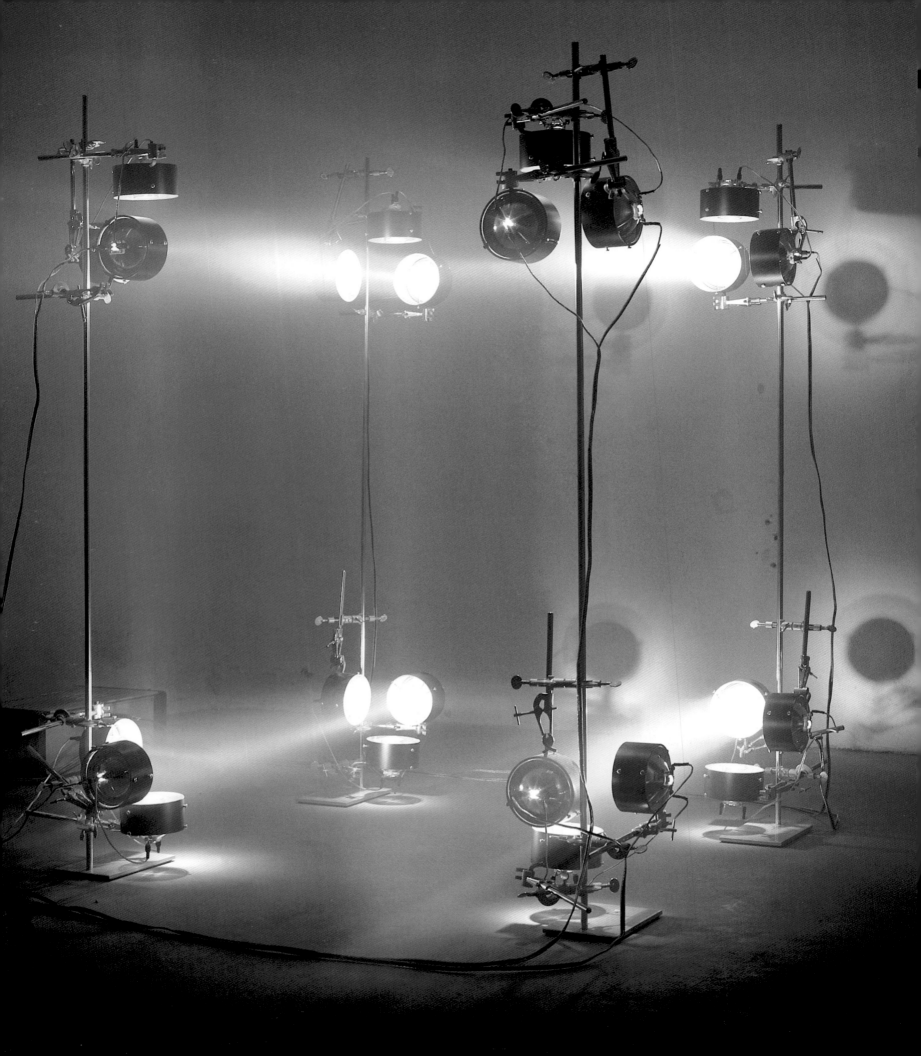

1m³ light
1999
Light, fixture, smoke
100 × 100 × 100 cm

Povera, which, he has said, he 'followed with interest for its formal language of low tech and its dematerialization of high-art objecthood'.[11] At the same time, he was drawn to the philosophy of phenomenology, whose focus on the workings of consciousness grew in large part out of the early twentieth-century writings of Edmund Husserl.

Phenomenology provided Eliasson with a theoretical basis for his own convictions and informed his development of artworks producing what Husserl calls a 'now effect'[12] – an instance of absolute presentness that goes hand-in-hand with a sense of indivisible self-presence,[13] which, for Husserl and for Eliasson in turn, marks the site both of consciousness itself and of the reality from which all experience devolves. Eliasson's works carry echoes of Husserl's argument in favour of a primordial or 'precognitive' perception that would be able to see the world outside of perceptual and intellectual habits, without need for mediation or analysis to reinvest experience with meaning: 'Nothing comes "before" to shape the aperture that perception opens onto the field of experience; nothing structures that opening in advance.'[14] Rather, the individual faces experience directly – that is, faces a world prior to the cognitive operations that would isolate and define our surroundings, would standardize and even dictate our behaviour. That space between phenomena and their interpretation is for Eliasson where private introspection and intellectual freedom can still take place, before reality is constituted and fixed.

Husserl's position informs Eliasson's practice generally, but his idea of the 'blink of the instant'[15] – a contracting of experience to a single irreducible point in time – materializes most strongly in *Your strange certainty still kept* (1996). In the middle of a room sheathed in black, and spanning its entire length, a thin curtain of water falls continuously from a perforated gutter on the gallery's ceiling. The violent noise of the downpour as it falls into a long shallow pan on the floor is one indicator of its torrential volume. This wall of water is lit from above by a series of strobe lights, which cause the observer's eye to freeze the falling droplets into a mesmerizing screen of static crystalline forms that gleam like precious stones. The strobes' pulsation works a saccadic operation on the retina to shatter any sense of fluid time or motion, emphasizing instead a relentlessly reiterated and dazzling instant of seeing of the most vivid visual intensity. Just as the object of perception is brought to an absolute standstill and an unbelievable clarity, so, too, our sense of ourselves seeing is clarified; and as this happens we act out that 'originary, direct interface with the phenomenally given'[16] that Husserl proposed, realizing ourselves in a world that both exists and is 'lived by us in the same instant'.[17]

Through works like this one the sympathetic observer of Eliasson's work is invited to share in an attitude of heightened perception and reception that is subsequently available for transposition into the world at large.[18] Husserl himself compared this notion of a heightened attention to the '*image of a projected ray of light, a searchlight ... illuminating not objects and*

following pages,
Your strange certainty still kept
1996
Water, pump, strobelight, foil, wood
Dimensions variable

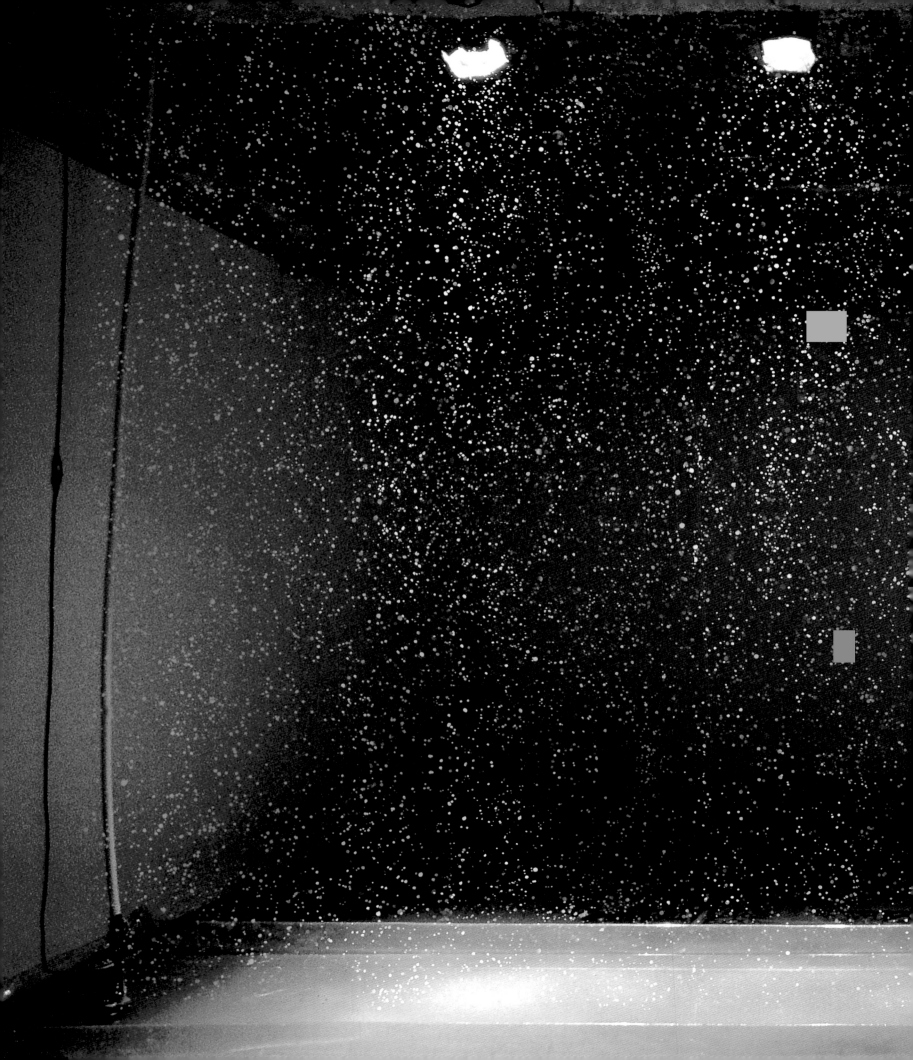

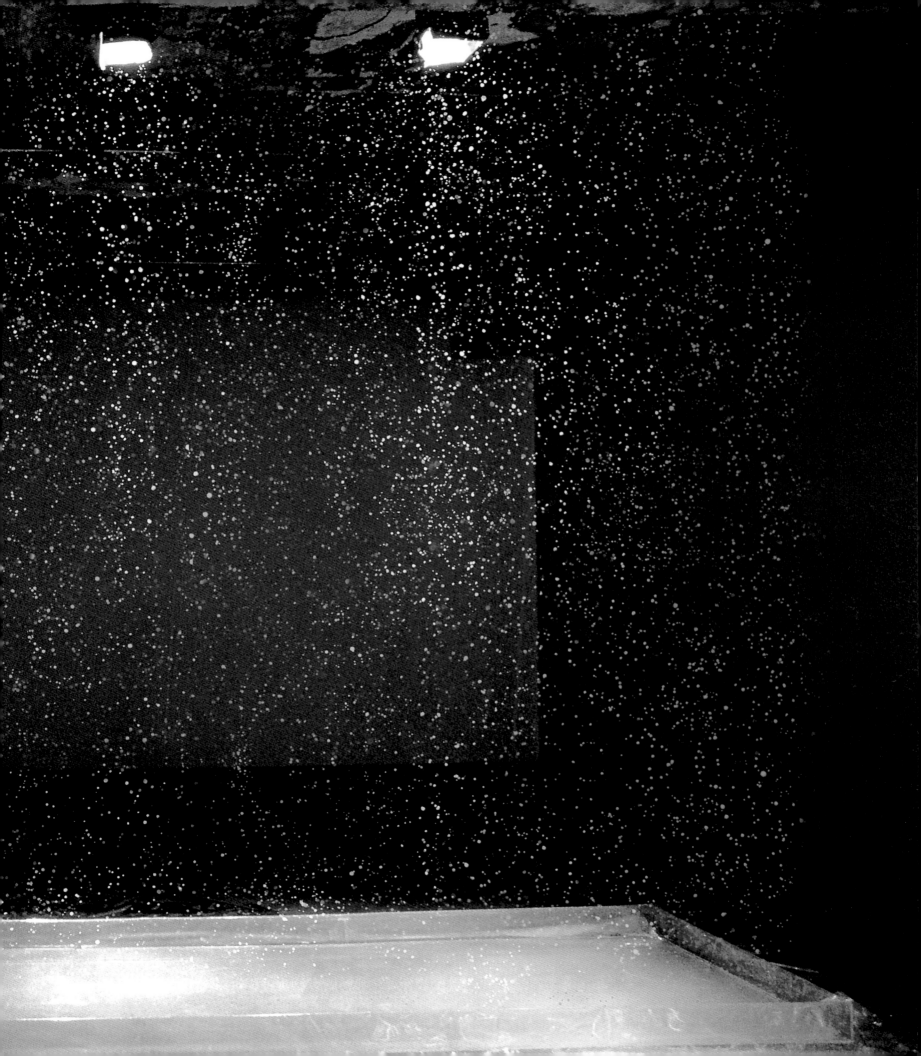

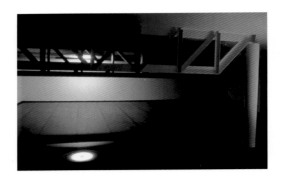
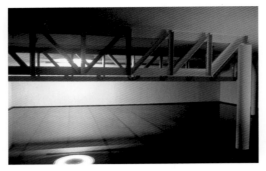
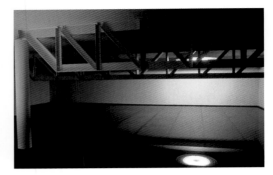

Your only real thing is time
2001
Neon circles, water, scaffolding,
basin
Dimensions variable
Installation, Institute for
Contemporary Art, Boston

empirical relations but essences and noema. *Attention, as a searchlight beam, becomes a quasi-machinic figure for an unwavering mode of looking at the act of looking, and thus for a suspension of the "natural attitude".'*[19] Fittingly, a recent work by Eliasson entitled *Highlighter* (1999) literally performs this notion of an 'attentional beam':[20] a spotlight, located in the ceiling and controlled by a computer program, is made to glide its circular ray at random over the exhibition space, focusing moment by moment on a particular detail of floor, wall or ceiling, which in their turn directly affect the work, distorting the round spot of light into varied ovoids depending on the distance and angle between the source and the receiving surface.

Eliasson's oeuvre is further infused by an early and continual regard for the phenomenological writings of Maurice Merleau-Ponty, with whom he shares a conviction that human experience, including perception, is embedded in a corporeal self, that the world is accordingly understood from within a physiological being, and that reality is conditioned by a perceiver who is herself always responsive to unfolding circumstance. The individual and reality, then, are powerfully imbricated, and the physical body is the very ground on which experience, including our encounters with objects in the world, takes place: *'There is, therefore, another subject beneath me, for whom a world exists before I am here, and who marks out my place in it. This captive or natural spirit is my body ... The body [is] no longer conceived of as an object of the world, but as our means of communication with it, to the world no*

longer conceived as a collection of determinate objects, but as the horizon latent in all our experience.'[21]

Eliasson's readings in the phenomenology of perception led him to the work of the American Minimalists of the 1960s, for whom Merleau-Ponty's writings had particular relevance.[22] The work of these artists provided the art-historical ground on which his own has flourished: even while Minimalism remained too object-bound for his taste, he responded to its self-evident structure, the literal quality of its materials, and its insistent anti-illusionistic and anti-symbolic stance. Further, he also recognized that Minimalism had brought to a head the shift in avant-garde practice from a focus on the object – on its autonomous, internal and formal compositional makeup – to a concern with the subject, or with a primary engagement of the spectator.[23] In Minimalism, Robert Morris wrote in 1966, the artwork was not an independent and fixed entity, it was *'but one of the terms in the newer aesthetic ... The better new work takes relationships out of the work and makes them a function of space, light, and the viewer's field of vision.'*[24] Minimalist objects sought to blur the relationship between viewer and viewed, making both more permeable to the space at large; thus the work came to fruition in a reciprocal and mutual interaction between object and spectator. Eliasson was particularly drawn to the work and writings of Morris, whose explicitly phenomenological stance championed a 'directness of experience ... embedded in the very

Suney
1995
Mylar
Dimensions variable
Installation, Künstlerhaus
Stuttgart

Robert Morris
Steam (second version)
1967/1974
Vapour vents, stones, wood
Dimensions variable
Installation, Western Washington
University, Bellingham, 1974

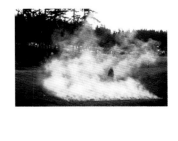

nature of spatial perception' that would at the same time render vision itself 'more conscious and articulate'.[25] Informed by such writings, Eliasson early on formulated an understanding in his own work that 'the gaze of the spectator constituted the piece'.[26] Equally galvanizing for the young artist was Morris's use of intangible materials – steam, thread waste, earth – that successfully 'dematerialized' the object and engaged the forces of the natural world in the making of the piece.

Of additional and crucial influence in Eliasson's formation were Robert Irwin and James Turrell, pioneers of the Southern California Light and Space movement of the 1960s. Employing visual phenomena as their material, these artists seemed willing to dematerialize the object much farther than their East Coast Minimalist counterparts. A comparison of Eliasson's early pieces to the work of Irwin and Turrell – which Eliasson had seen during his early New York sojourn – is instructive for the way the young artist both absorbed and departed from the example of his predecessors. The first work he exhibited upon graduating from the Academy, *Suney* (1995) consisted of a large, floor-to-ceiling section of transparent yellow Mylar dividing a rectangular gallery into two uneven parts, each available to entry. Depending on one's position in the room, one was either 'in' or 'in front of' a space empty of objects but filled with a chromatic volume that seemed almost solid in its optical density. If one stood on one side of the large translucent yellow plane, the geometry of the space opposite was clearly diagrammed and, given the

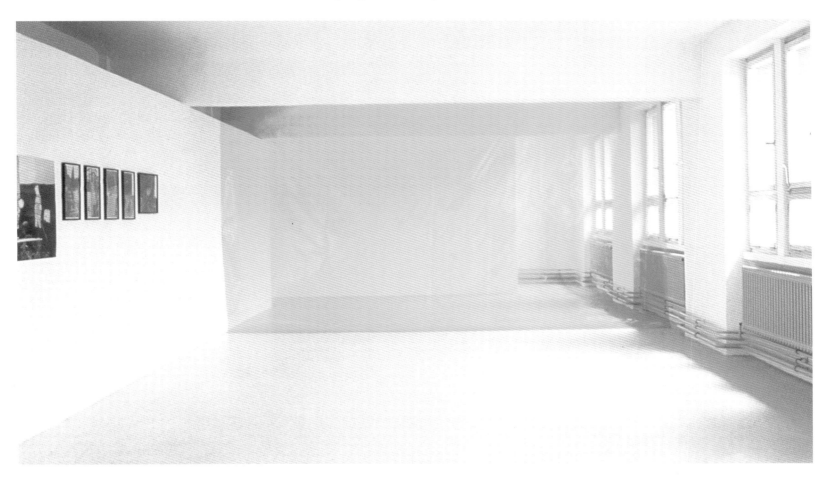

foreshortening that naturally occurs in perception, was turned into a 'classic pictorial situation'[27] – the box-like model of Renaissance space. In much the same way that Irwin's now-classic nylon scrim installations are both delimited by and make clear the contours of the rooms in which they exist, *Suney* intensified the parameters of the architectural enclosure that it created. 'Inside' the yellow field, colour was experienced as optically fluid, severed from any stable point of reference and from any source of origin, and architecture was enlisted as a walk-in, live-in space that drew the visitor inside its 'frame'. Either way, the perception of space was heightened and the awareness of perception increased, 'allowing people', in Turrell's words, 'to perceive their perceptions – making them aware of their perceptions'.[28]

Installed in a separate room in the same exhibition was *Konvex/Koncav* (1995/2000), a wall-mounted reflective disk, suspended away from the wall, that subtly changed its surface from concave to convex and back again by way of a pneumatic pumping system located inside a clear Plexiglas box on the floor below. Pump and pistons

were clearly visible and breathed noisily in an effortful rhythm, moving air in and out behind the disk's mirrored Mylar surface, so that the image reflected in it inflated, deflated and contorted as the disk swelled towards and shrank away from the viewer. Irwin too had made wall-mounted discs, in the 1960s – slightly convex forms protruding from the wall, lit to create a clover-leafed shadow play. But where those works aimed towards a dissolution of the picture plane to the point where the object itself might be seen to dissolve, *Konvex/Koncav* counteracts any dematerialization through its conspicuous exposure of the machinations that drive its effects.

Two years later Eliasson was invited to create a work for a gallery in Santa Monica, in the originary and geographic heart of the Light and Space movement to which he had been so receptive. Highly attuned to the art-historical and environmental context within which he was working – and particularly to the importance of sunshine to the region's cultural identity – Eliasson cut a circular hole in the gallery's metal roof and let in a shaft of light. In the resulting work, *Your sun machine* (1997), a beam of light drifted slowly and steadfastly across the gallery's walls and floor through the course of the day, charting the inexorable passage of time and directly reflecting the movement of the earth and its distant sun. Eliasson's piece honed in on the moment-by-moment variation of ambient light conditions, harnessing the soft morning light as it turned to full-day radiance and then to waning dusk. This 'hair-trigger'[29] focus on the specificity

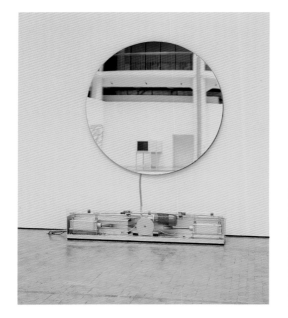
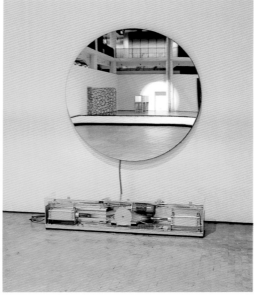

Konvex/Koncav
1995/2000
Mirror, pump
⌀ 150 cm
Installation, ZKM, Karlsruhe,
Germany

of light was further pressed home by a scope-like effect produced by two narrow roof beams that crossed immediately below the roof opening, casting cross-hair shadows in the circle's centre when it hit the floor. The formal structure of the work deliberately recalled Turrell's 'skyscapes' – rectangular openings in architecture that frame unmediated outdoor light as solid coloured material, producing an intense illusion of dense substance that materializes a condition of ineffability and invites a prolonged state of focus or meditation that is essentially timeless in nature. But where Turrell encourages an effect of indefinite mystery, *Your sun machine* made a bold, finite incursion into an extant building of which it made the visitor quite specifically aware. In this respect, in the subtractive activity of cutting out that its production entailed, and in its blurring of art and architecture, it was more closely aligned with the work of Gordon Matta-Clark, particularly *Day's End* (1975), in which the artist cut into an enormous abandoned New York City pier, allowing the sun to materialize within the building as a gigantic, radiant, moving almond shape for people to experience.

With *Beauty* (1993) Eliasson's project came fully into its own. First installed in a Copenhagen warehouse, the work consists of a perforated hose-pipe, placed high against a darkened interior wall, that releases tiny drops of water to produce a curtain of mist on which is trained a prismatic spotlight. The economical means of creating this work – water tap, hose, electrical socket, spotlight – are all clearly exposed. The visitor, her bodily

sensations piqued by the sound of barely condensed matter hitting the floor, and by the touch of humidity on skin, visually receives the refractive effects of light passing through water, and this extreme interface between eye and phenomenon produces a vision of an astonishingly beautiful rainbow. The work is experienced in a special relationship to the body, for the rainbow disappears from sight, or certain colours within it are emphasized, depending on one's position in space. That this celestial phenomenon had (in its Copenhagen installation) found its way to an unlikely industrial indoors; that the mechanisms by which it is brought into being are overt; and that the image itself could not be more familiar or clichéd, none of this detracts from a deep emotional enjoyment and even exhilaration in the face of the piece, an overwhelmingly affective experience that is 'immediate, not mediated'.[30] Surmounting distances between our being and the world, this pleasure of presence aided by nature and artifice is the gift that Eliasson's work consistently makes to us.

The title of *Beauty*, not to mention the work's ethereal and evocative properties, is telling for its unabashed embrace of an aesthetic quality that until recently had long been denigrated in the annals of art practice.[31] The title is equally a clear invitation to consider Eliasson's relationship to the eighteenth-century concepts of the sublime and the beautiful, concepts that, while they no longer pertain in their original form, nevertheless continue to exert an imaginative hold. The Romantics understood the sublime as an affective

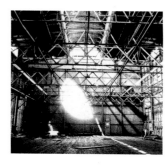

Robert Irwin
Untitled
1965–67
Acrylic automobile lacquers on prepared, shaped aluminium wit hmetal tube, four 150-watt floodlights

Gordon Matta-Clark
Day's End
1975
Intervention, Pier 52, Gansevoort and West Streets, New York

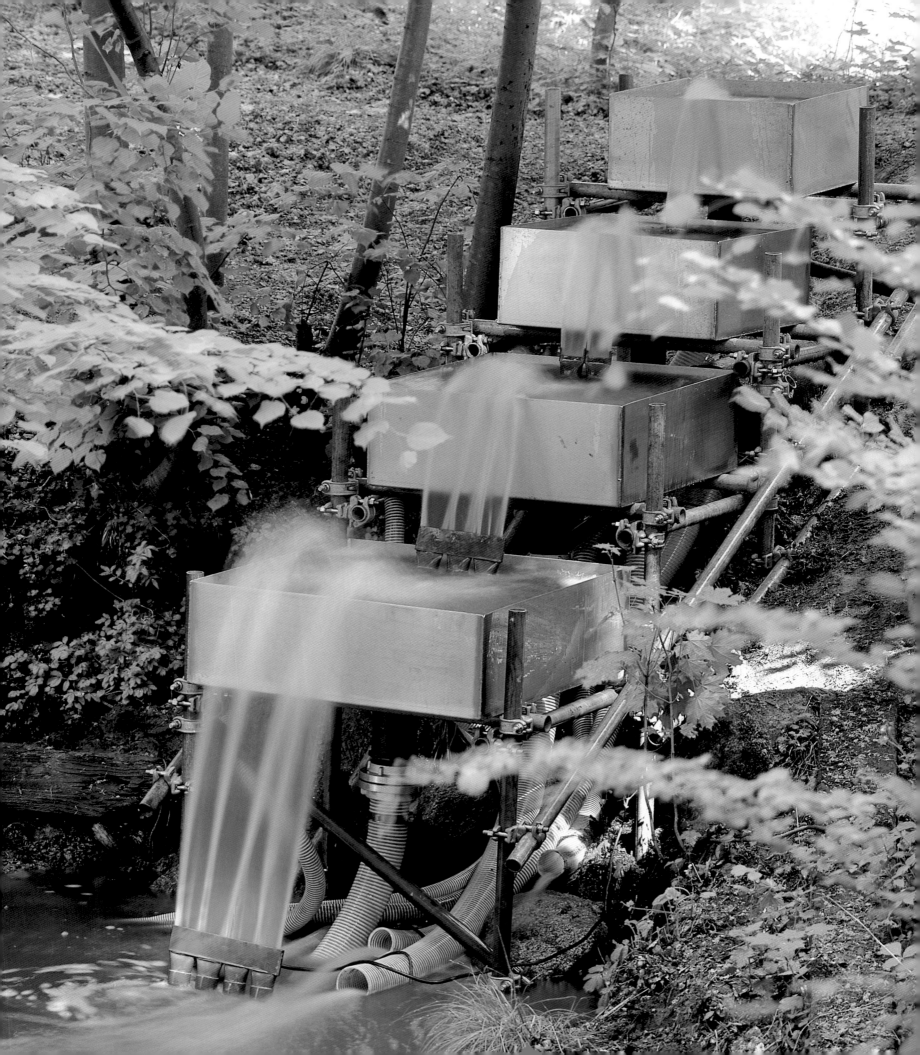

condition aroused in the face of overwhelming circumstances such as those generated by the excessive and threatening powers of nature. Unable to grasp the supersensible forces of an overwhelming surround, the Romantic is overwhelmed, giving rise to a state of intensified emotion synonymous with spiritual passion. Thus he is psychically and emotionally galvanized into an immersion in an expanse beyond and outside of his body, into an exalted 'fusion with the All'.[32] In classical pictorial tradition, the grounds for an experience of the sublime might be pictured as a potent nature: landscapes of towering mountain peaks, inexorable looming icebergs and boundless seas obscured by mist or enraged by thunderstorms.

In intentionally adopting such Romantic tropes as the rainbow, the waterfall (*Reversed waterfall*, 1998) and the sunset (*Double sunset*, 1998), Eliasson evokes precisely this possibility of the sublime only to hinder its functioning. What the critic and curator Lynne Cooke has written of the photographs of Andreas Gursky applies equally to Eliasson's work: what is crucial about it is 'the way that [it] can never be read as transparent, as

unproblematically illusionistic representations of a world beyond'.[33] The 'natural' phenomena are always marked as fabricated, and the operations of the sublime are thereby demystified and revealed, as if in a scientific demonstration. Thus Eliasson deliberately interrupts any sense of an unmediated relationship to or transcendental contemplation of 'nature' that would ally his work with the Northern Romantic tradition. At the same time, at the level of affect, his works audaciously and paradoxically carry for us an emotional charge both transcendent and actual: '*A horizon of transcendence then is fully embedded in a world of immanence, a world of finitude and from which the absolute implied … is evacuated. For the neo-romantic Eliasson, transcendence is driven back into the actual world and made to serve an immanent function in terms of the creation of effects, desires, epiphanies and temporalities which are embodied in a social and human world.*'[34]

Both the work's clear material basis and the emotional investment by which we engage with its conditions – the literal and the metaphoric, scepticism and belief – are kept in productive tension. Each time perception goes beyond a ground-level apprehension of what it is given to look at, moving towards what would constitute meaning, it is immediately led back to the work's structural components, the materials and devices that exist prior to its effects. This generates a special attention that is at once and paradoxically phenomenological *and* transcendent. Neither object nor subject is permitted to return to some hypothetical pure or 'original' root condition; on the contrary, nature, culture and self are

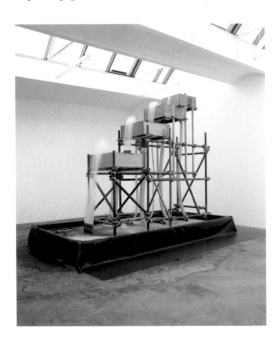

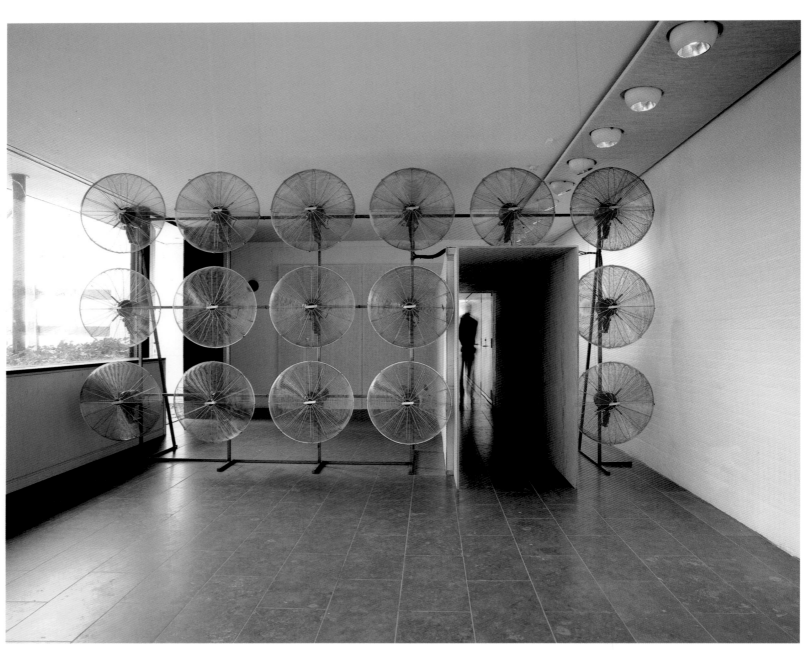

Your windless arrangement
1997
Dimensions variable
Ventilators, motors, metal frame
Installation, Louisiana Museum of
Modern Art, Humlebaek , Denmark

No nights in summer, no days in winter
1994
Fire, ring, gas, metal, hose
⌀ 60 cm
Installation, Forum Galleri
Malmö, Sweden

presented in all their material impurity, contingency and intense presentness.

Eliasson's work is positioned within an urban realm, yet it evokes natural phenomena; it is assisted by the most minimal and clear of constructions, leaving little formal imprint, yet it brims with rich, unpredictable detail and tactility; it knowingly and explicitly collapses the natural and the artificial, the evanescent and the concrete, the literal and the metaphoric; and it constitutes itself finally in the eye, which is imbricated in the body. In *Double sunset*, a giant yellow corrugated-metal disk, measuring over 124 ft (38 m) in diameter, was set above a tower block so that, viewed from a busy highway on the outskirts of Utrecht, it was adjacent to the setting sun, creating a double image of a real nature and a fake one. In the thunderous *Waterfall*, the mundane metal scaffold, hoses and pumps that drive the work are sited in town squares or exhibition galleries far from any indigenous landscape. In *Your windless arrangement* (1997), a long bank of large industrial fans stacked around the entrance to an exhibition blows a forceful wind directly at the incoming visitor – concrete elements put in the service of a dematerialized atmospheric effect. *No nights in summer, no days in winter* (1994) comprises a wall-mounted ring of countless little gas flames that shimmer blue in a darkened room filled with their heat and noise, so that the piece resembles an eclipsed sun. In *Your intuitive surroundings versus your surrounded intuition* (2000), a clearly visible rack of 150 white fluorescent light tubes hangs above a panel of translucent white scrim that in turn hangs over an

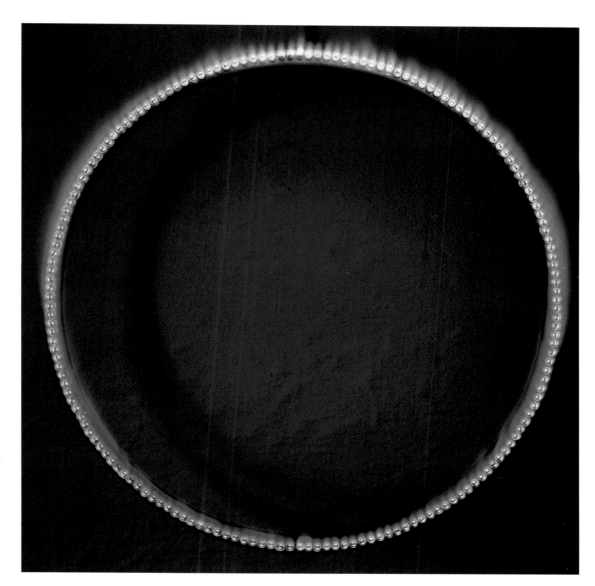

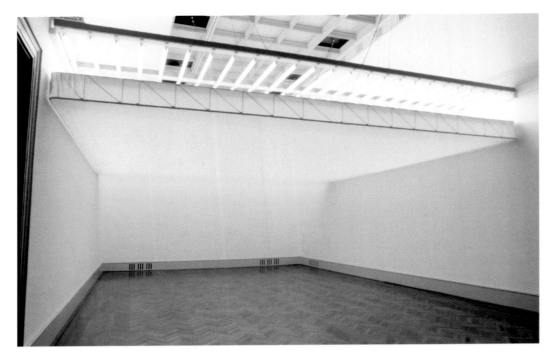

**Your intuitive surroundings
versus your surrounded intuition**
2000
Light, screen, dimmer
Dimensions variable
Installation, The Art Institute of
Chicago

otherwise empty gallery, enveloping the space in a diffused, computer-controlled light that echoes (in accelerated fashion) the effect of a cloudy day of intermittent light and shadow, much like the weather outside. *Neon ripple* (2001), whose scaffold underpinnings you see well before the work's central image, consists of a large, shallow body of water reflecting the concentric circles of fluorescent rings installed in the ceiling above, their alternating bright and faint gleaming simulating the chance shimmerings of a liquid ripple. Each of these works is squarely located between nature and culture, and each projects a geography of reciprocal connections. Rather than nostalgically conjuring up a primitive or Edenic nature, the work acknowledges the strange and significant beauties of a landscape that commingles the natural and the artificial, on a scale unique to each viewer.

Eliasson's route to this approach may be partly explained by his biography. Born in Denmark, he was mostly raised in Iceland, where he still summers, so that he grew up in the vicinity of a spectacular primordial landscape, one easily associated with the sublime. Yet Eliasson's intimate knowledge of this strikingly elemental

region may perhaps have inoculated his art against any adulation or domination of nature, engaging it instead in a practice of co-operation with nature's specific effects. While nature certainly exerts a powerful influence on Scandinavian culture, the argument has been made that its constant presence has also produced in the region's artists a sense of the 'Nordic everyday',[35] a more intimate, less sensational, but ultimately no less awed approach to nature's attributes.

The permission to reflect on the specific and the regional evident in Eliasson's work is also related to a movement in the art of the 1990s stemming from multicultural practices that welcomed into art the texture of previously ignored biographies, places and geographic locales. By extension, Eliasson's artistic vocabulary is grounded in elemental but highly particular forces, materials and effects: gravity, erosion, turbulence; earth, arctic moss, blackthorn, duckweed; light, colour, wind, heat; and, especially, water, in all of its various stages from liquid to solid – steam, fog, mist, moisture, ice. *Moss wall* (1994), for example, employs an arctic moss indigenous to Iceland and incorporates into its formal composition the natural predilections of the material, with which Eliasson is highly conversant – its capacity to grow and change colour over time, its distinctive aroma, its ability to muffle sound.

Running parallel to his output in sculpture and installation, Eliasson's photographic work clearly manifests his enduring ties to his native environment. He spends several months each year in Iceland, making an ongoing and now near-

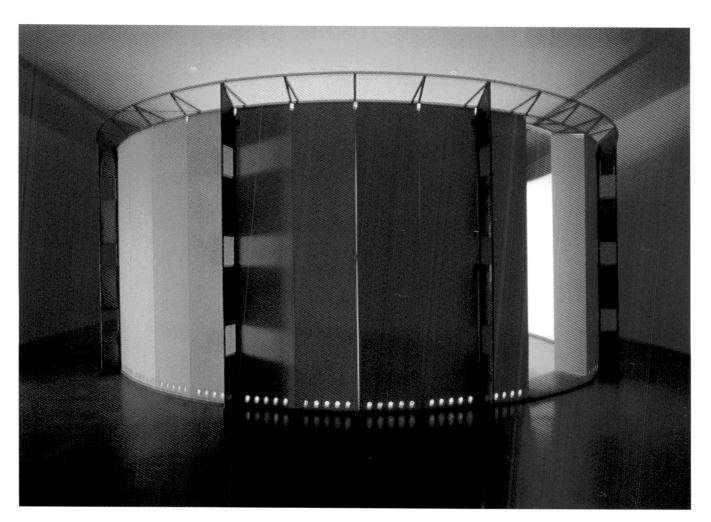

360° room for all colours
2002
Neon tubes, control system,
scaffolding
h. 320 cm, ⌀ 800 cm
Installation, Musée d'art moderne
de la ville de Paris

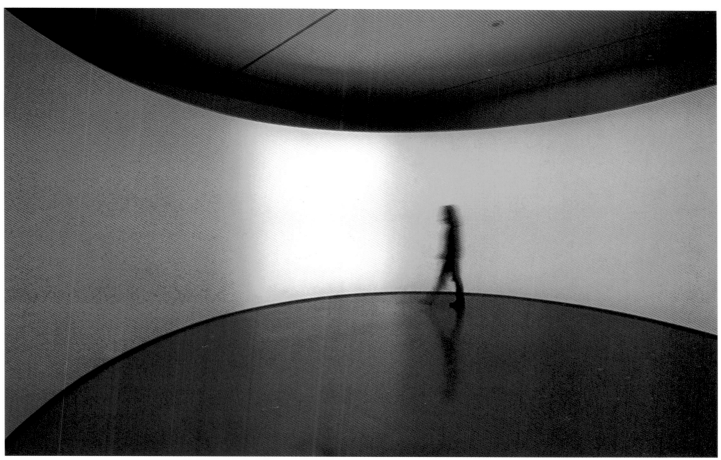

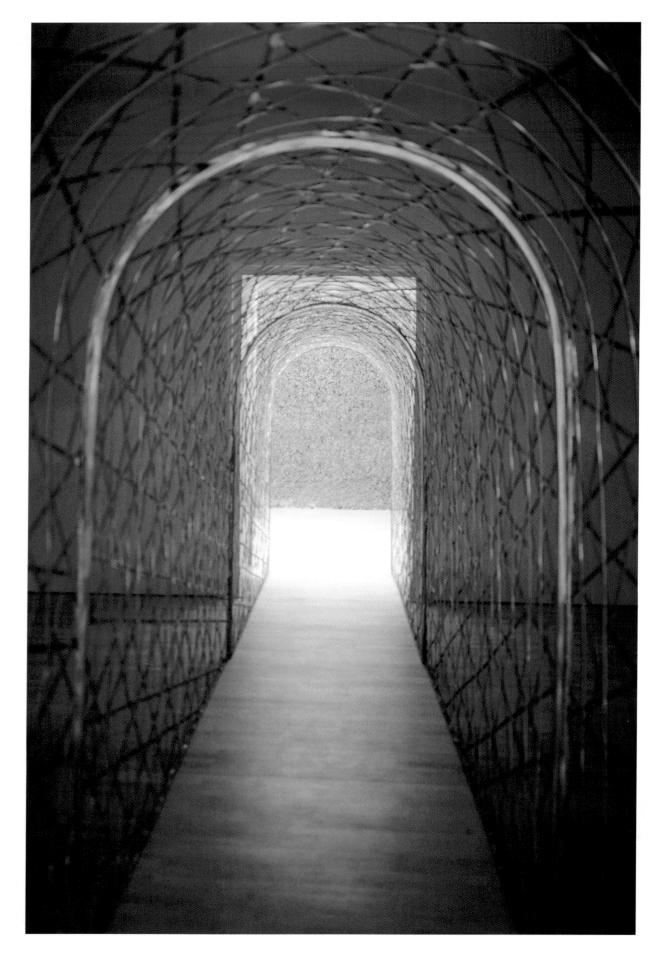

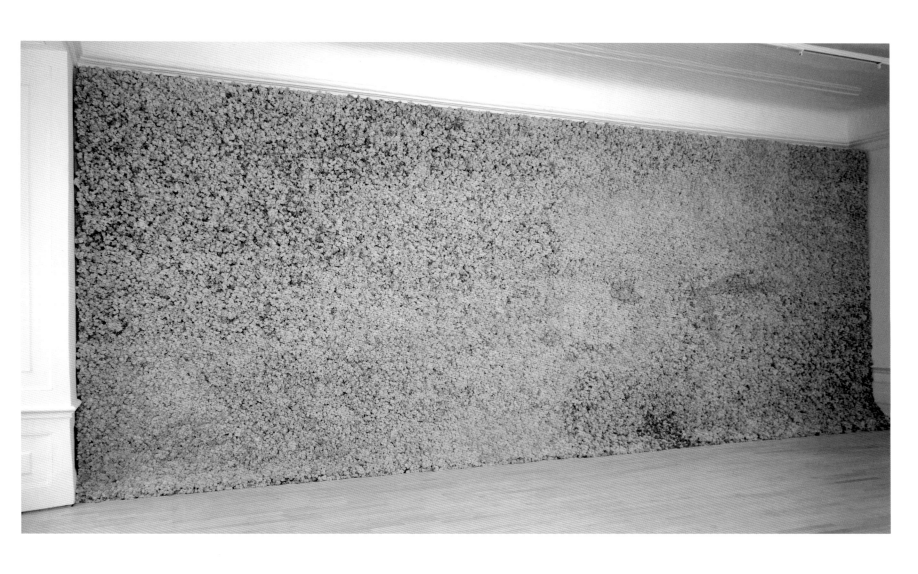

opposite, **Fivefold tunnel**
1998
Stainless steel
220 × 110 × 1100 cm
Installation, Neue Galerie am
Landesmuseum Joanneum, Graz,
Austria

above, **Moss wall**
1994
Wood, moss
Dimensions variable
Installation, Neue Galerie am
Landesmuseum Joanneum, Graz,
Austria

following pages, **Room for one
colour**
1998
Light, control panels
Dimensions variable
Installation, Neue Galerie am
Landesmuseum Joanneum, Graz,
Austria

 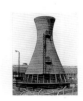
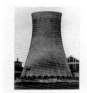 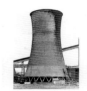 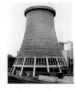

encyclopedic visual inventory of its indigenous formations: glaciers, caves, islands, rivers. In many of these images an individual form, such as an ice patch, is isolated, centred and photographed head-on. The uncropped picture is shown in a plain frame, the straightforward presentation invoking the stylistic language of the objective documentary. Each photograph records with crystalline clarity the bracing details and textures of a particular thing or place seen under the even light of a nebulous sky. As in the sculptures, legibility is crucial here: any dramatic or 'picturesque' potential of the subject matter is purposefully suppressed.

In exhibition, these individual photographs usually function as part of a larger ensemble, being grouped according to subject types and displayed in an overall, non-hierarchical grid pattern. Looked at one at a time, each of them displays in rich detail the idiosyncratic features of a particular aspect of nature. When they are configured as a group, becoming co-dependent, their more formal aspects come to the fore, such as their equality of scale, their generally similar forms and shapes, the overall consistent horizon line that turns the ensemble into a lateral composition of alternating sky-white and earth colours. They thus engage in a continual back-and-forth between individuality and uniformity, expressive subjectivity and purported objectivity. While Eliasson's systematic approach to and serial presentation of his subject matter find clear precedents in the photographs of the German artists Bernd and Hilla Becher, there are differences: where the Bechers work in black and white, Eliasson uses the inherently less austere medium of colour photography, and his subject matter welcomes more eccentric topographic anatomies than the Bechers' industrial sites. *The aerial river series* (2000), for example, is a forty-two-image grid of images that exhaustively documents the entire length of a single river as it winds from its mountain origins to its mouth at the sea. The photos are shot from the air, a perspective that confuses one's sense of scale: one and the same image might document both a vast tract of land and the ground-level, close-up minutiae of a primordial earth. (In the empty Icelandic landscape, buildings or roads that might offer clues to scale are few and far between.) The work also layers seemingly contradictory orders of time: deep geological time is compounded by the lived time spent in the task of bringing the work to fruition, and further by the time made literal and physically present through the artwork's large scale once installed, when duration in effect gains concrete volume.[36]

The systematic bent of the photographs bespeaks a wider disposition on Eliasson's part towards the methods, materials, subject and style of concrete scientific enterprise. As befits a practice – like science – that is driven by research, Eliasson's fundamental approach to art-making is not declarative but interrogatory and speculative; rather than striking a stance, he is following a mode of inquiry. This position is directly acknowledged in the installation *Modelle* (2000–01), which turned the gallery space into a work-study area where models and materials in various stages of development were laid on

Bernd and Hilla Becher
Cooling Towers 1970–1980
1995
Six black and white photographs
115 × 142 cm

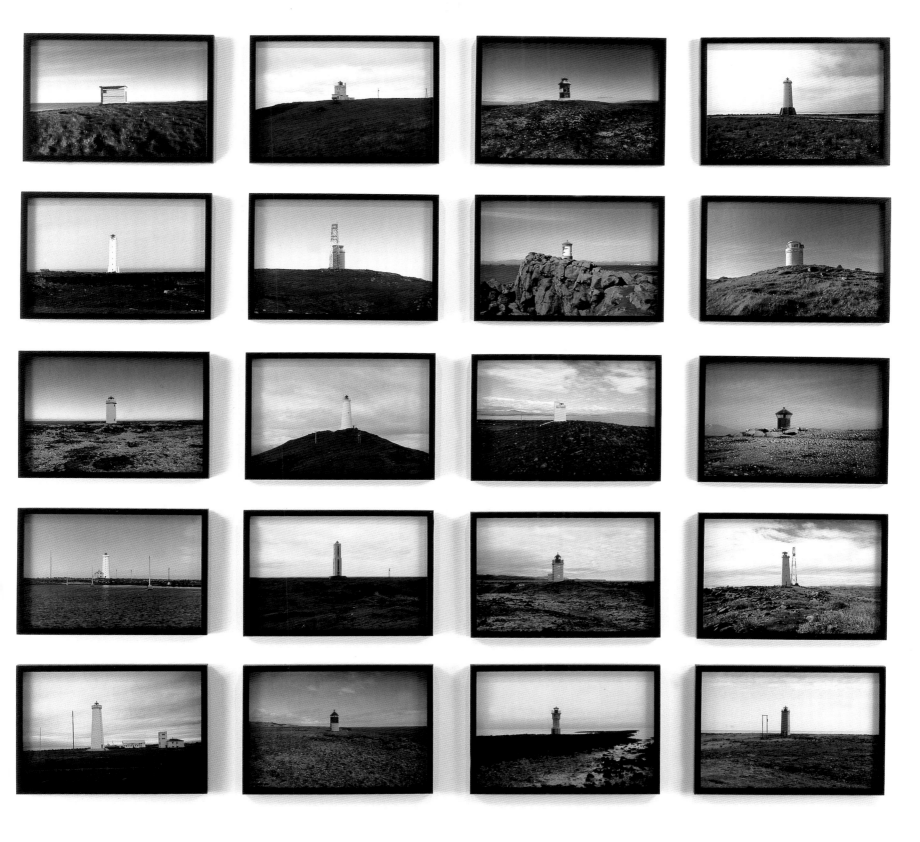

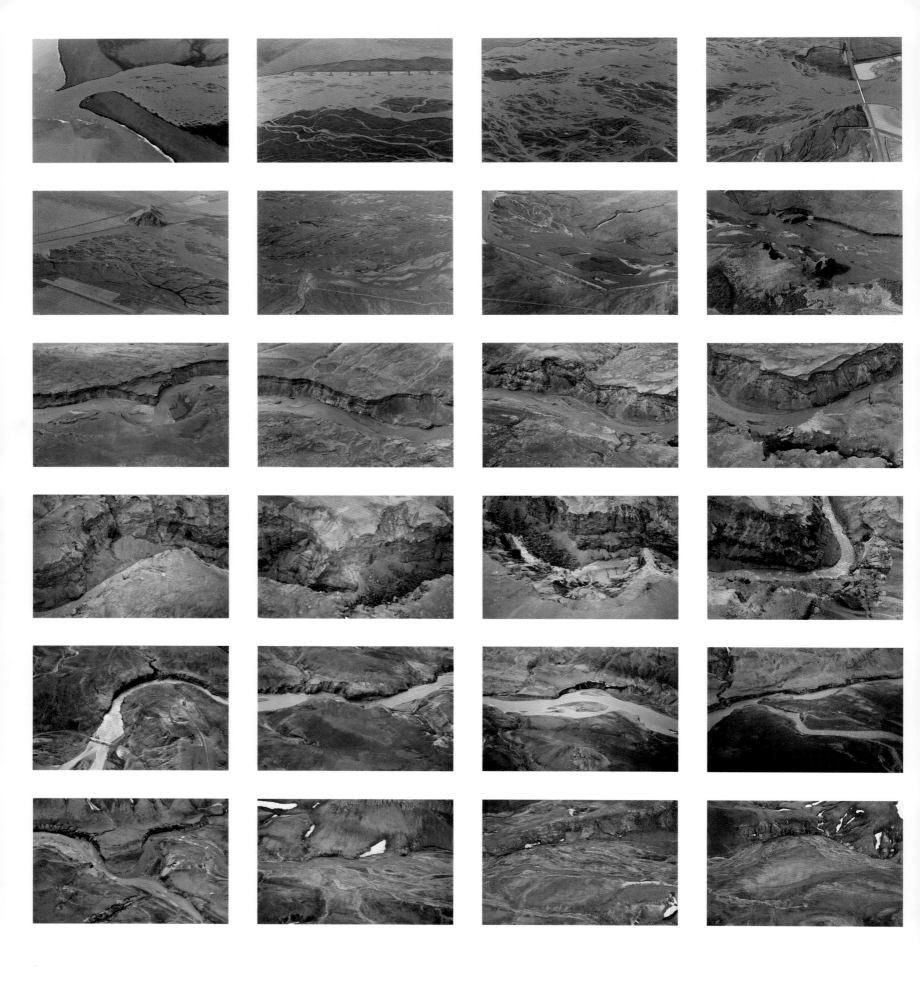

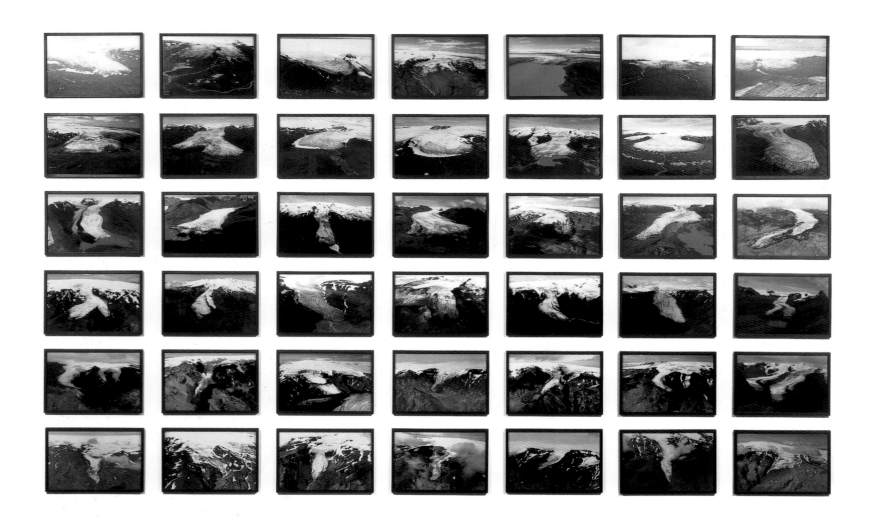

The glacier series
1999
42 C-prints
244 × 404 cm overall

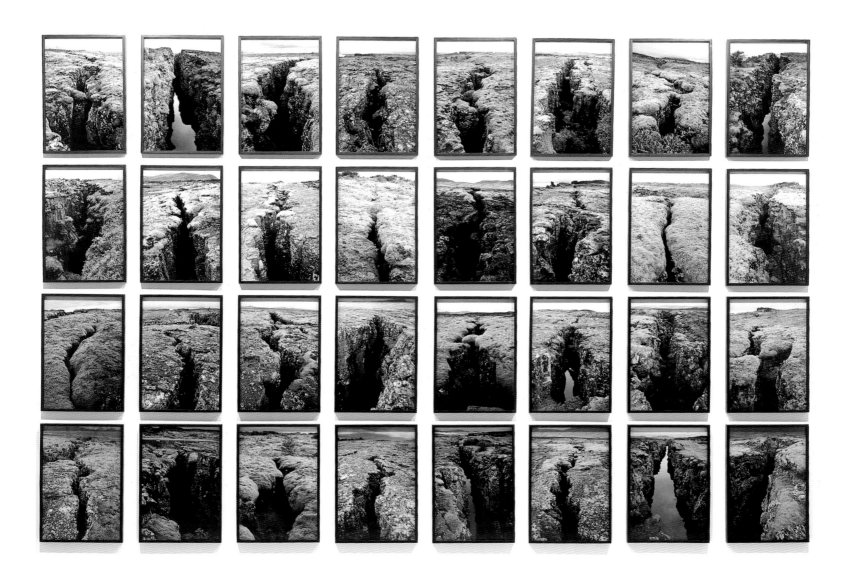

The fault series
2001
32 C-prints
260 × 370 cm overall

Models by Einar Thorsteinn
2000
Paper
80 × 200 cm
Installation, Neue Galerie am
Landesmuseum Joanneum, Graz,
Austria

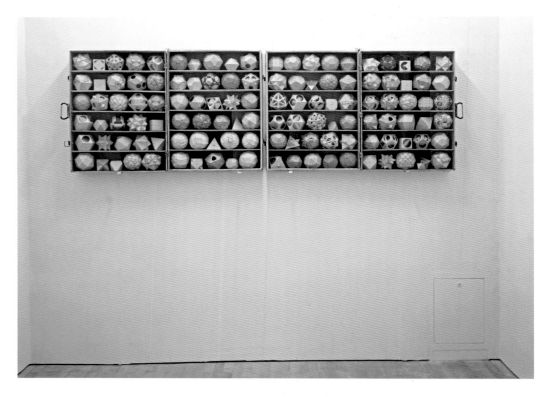

non-scientific processes that let intellectual and emotional sparks fly.

As in science, Eliasson's technical means, usually straightforward and practical, are always made overt, and develop in pragmatic response to a set of given circumstances (such as the parameters of a site). This transparency of structure, which is intrinsic to the work's content, is abetted by an equally literal clarity of materials. The approach is demystifying: works self-reflexively expose their own construction and interrupt their own absorption. The strategy insists on our attentive engagement as we suture together constituent parts. Further, the calculated disclosure of material fabrication reveals the artist's involvement in the work's production, and has the effect of intensifying our perception; by extension, we too become immersed in a process of image-making. With his many titles that use the possessive pronoun 'your', Eliasson openly calls for an actively engaged spectator, casting the viewer in a principal role in terms of image production and image experience.[37] These pieces enlist the beholder as accomplice in the aesthetic functioning of the work of art.

A number of Eliasson's works are pared-down artistic dispatches on the science of vision, and particularly on the branch of physiology that lays bare the operations of the human eye. In *A description of a reflection* (1995), a plain laboratory-like setup is made structurally analogous to the mechanical workings of the eye, allowing the viewer to 'see' such conditions of seeing as

worktables or lined up on shelves shown along with films demonstrating optical experiments. These models, as well as a number of Eliasson's completed sculptures, derive their forms from Möbius strips, quasi-crystals, Penrose tiles and other structures used by scientists and physicists to visualize abstract data. The gallery/laboratory anchored the artist's examinations of phenomena and imagination in a rational milieu dedicated to proven quantifiable fact, bringing the methods of reasoned thought, logical calculation and disciplined organization to bear on fundamentally

filtering, reflection, refraction and distortion – as so often with this art, the mind becomes conscious of its own perceiving.[38] *Room for one colour* (1998) and *Room for all colours* (1999) suggest demonstrations of the productive role of the eye in vision, for they depend for their effects on the observer's own retinal excitations in response to external chromatic stimuli. Installations of pure colour, they undergo transformations in hue that are embedded in the eye's release of complementary colour afterimages, which are projected back into the space of the gallery in a full interweaving of observer and artwork. The work never quite stabilizes, and neither, by extension, does the viewer, who instead engages actively in creating the image. Incomplete and open-ended, work and self resonate precisely because they seem to exist in a perpetual state of becoming – a condition that enlivens them, lending them a sense of absolute presence.

Significantly, making his own visual explorations available to the viewer has only proven that Eliasson's work thus comprehended is no less magical. Over and again, the self-disclosure he exercises at all levels, and the subsequent interruption of the spectator's full absorption or complicity in the experience, neither cancels nor negates the suspension of disbelief. In fact to equate Eliasson's methodology with familiar, reflexive postmodern scepticism would be to misunderstand his enterprise sorely. Although physical demystification operates throughout his art, there is an equal and simultaneous infusion of beauty and wonder; a marked paradox and charged balance is maintained between raw materiality and insubstantial affect. While clearly revealing a contingent mode of production, these works point to a visual language that deviates subtly from the world specifically in order to return to it with greater sharpness and clarity. Eliasson's pieces are all in the end devices for unmooring experience only in order to retell and renew it.

On his first opportunity to display his work in depth, in the exhibition 'The curious garden' at the Kunsthalle Basel in 1997, Eliasson conceived of the space as a *parcours*, a site soliciting a peripatetic observer and an itinerant vision.[39] In his one-person shows he choreographs diverse works into suites of consecutive encounters designed with circumnavigation in mind: exhibitions unwind in and through rooms of ever-changing ambiences, their (non-narrative) unfolding insisting on a self in motion, someone for whom perception involves the movement of the legs as much as the trajectory of the gaze.[40] No longer assigned the fixed point of view on which artworks constructed in solely visual terms so often converge, visitors are invited to be enveloped by, to circulate in and to act on, an installation corresponding to their own immediate experience. These artworks are not experienced as static or finite; on the contrary, they are continually responsive to the unique and manifold itineraries, velocities and temporal impressions of their visitors, who themselves never stabilize into discrete physical entities. The work thus comes to fruition in an open interaction between object and subject, a loosening of the separation between viewer and artwork. The experiential plenitude

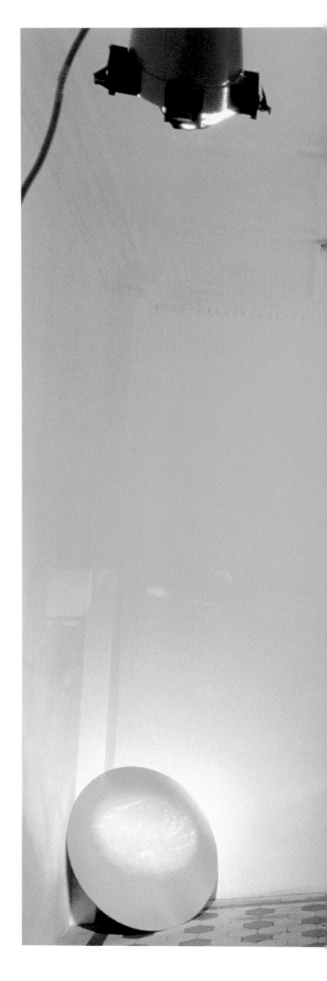

Eine Beschreibung einer Reflexion (A description of a reflection)
1995
Light, mirror, projection foil
Dimensions variable
Installation,
neugerriemschneider, Berlin

promised by this shift is at once intimate (since the effects are internally produced) and social (through the public quality of the architectonic envelope and the vicinity of other spectators/agents).

Within this dialectic steeped in the act of walking-and-looking,[41] perception no longer follows a stationary imagistic model. Instead it is conceived of as something that takes place in *duration*, and this realization is finally inseparable from a heightened intensity of experience in which the subject (redefined as comprising both the individual visitor and his or her surroundings) is actively and continually constructed – an evocation of the open process that Heidegger called 'worldling'. These installations lead ultimately not so much to 'insight' or 'essence' as to an inundating presence that instantiates itself viscerally in each sustained moment. For Eliasson, such presence is instigated by a roving activity facilitated by spaces-as-promenades, which foreground subjective experience as it unfolds in real time and space.

'The curious garden', for example, was deployed across three consecutive galleries, the first of them a large empty room. There were skylights overhead, yet all daylight was excluded; in its place, yellow monochrome lamps – located above the skylights so that their light seemed to come from outside – drenched the inhabitants and the otherwise empty space in a thick acidic hue. The result was a duotone milieu of yellow and shades of black, in which the outlines, surfaces and textures of both architecture and people

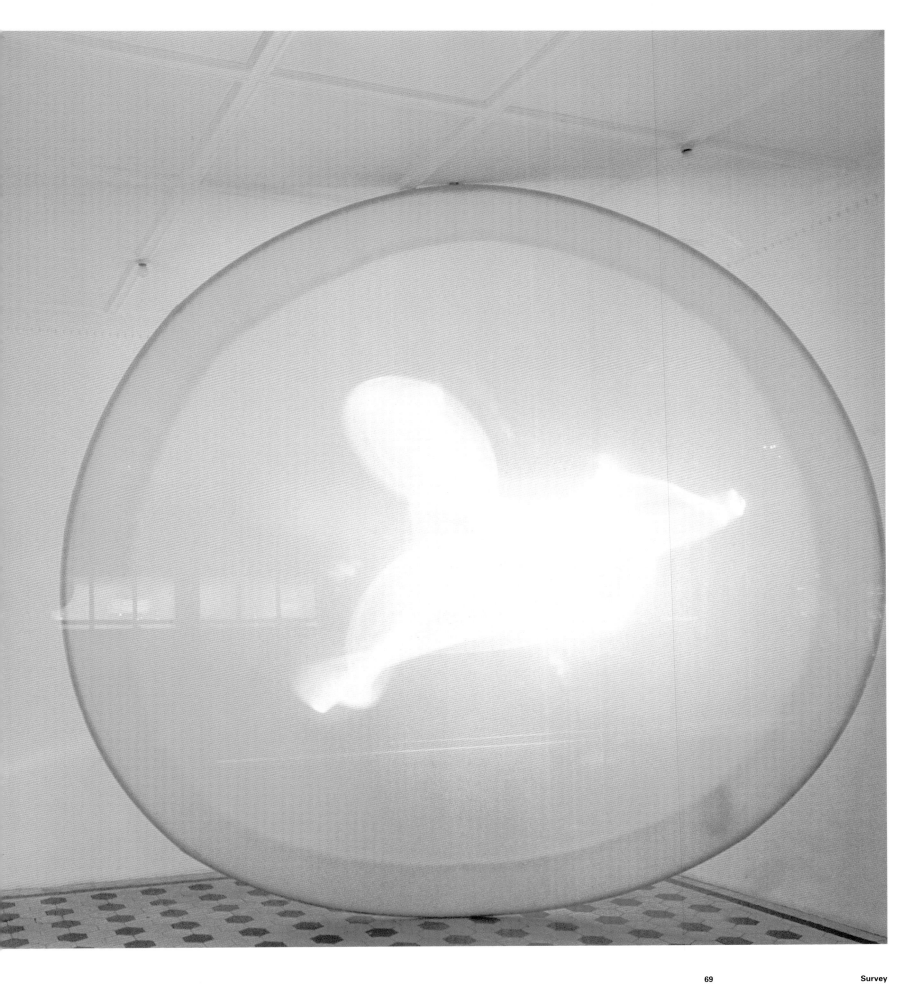

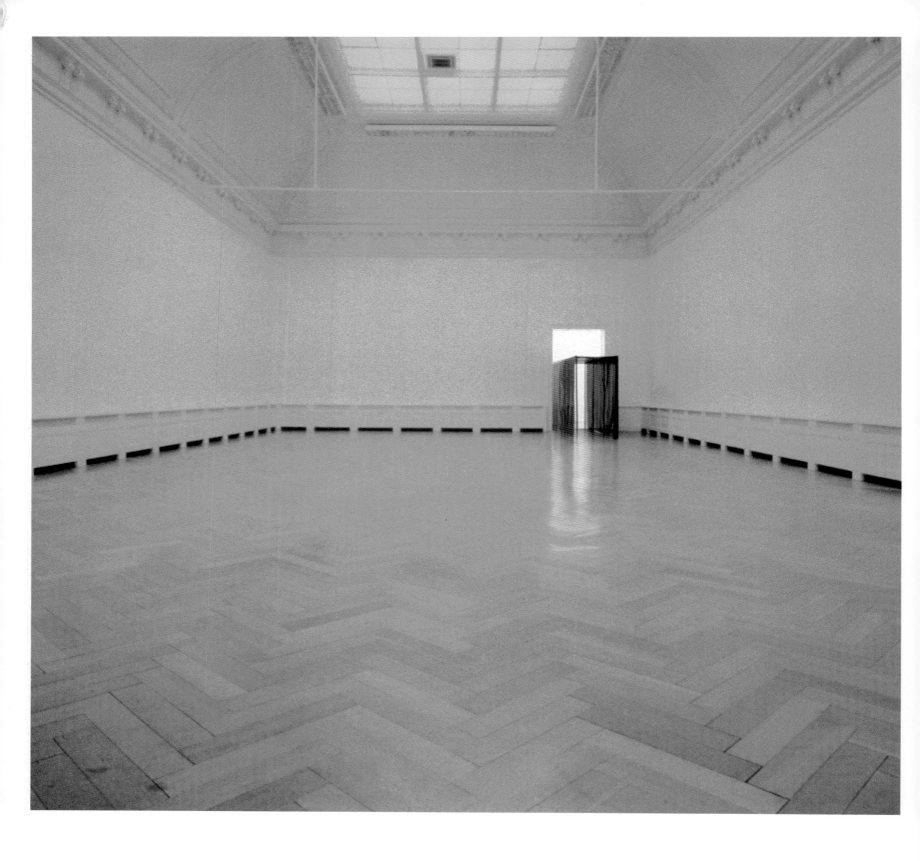

The curious garden
1997
Installation, Kunsthalle Basel

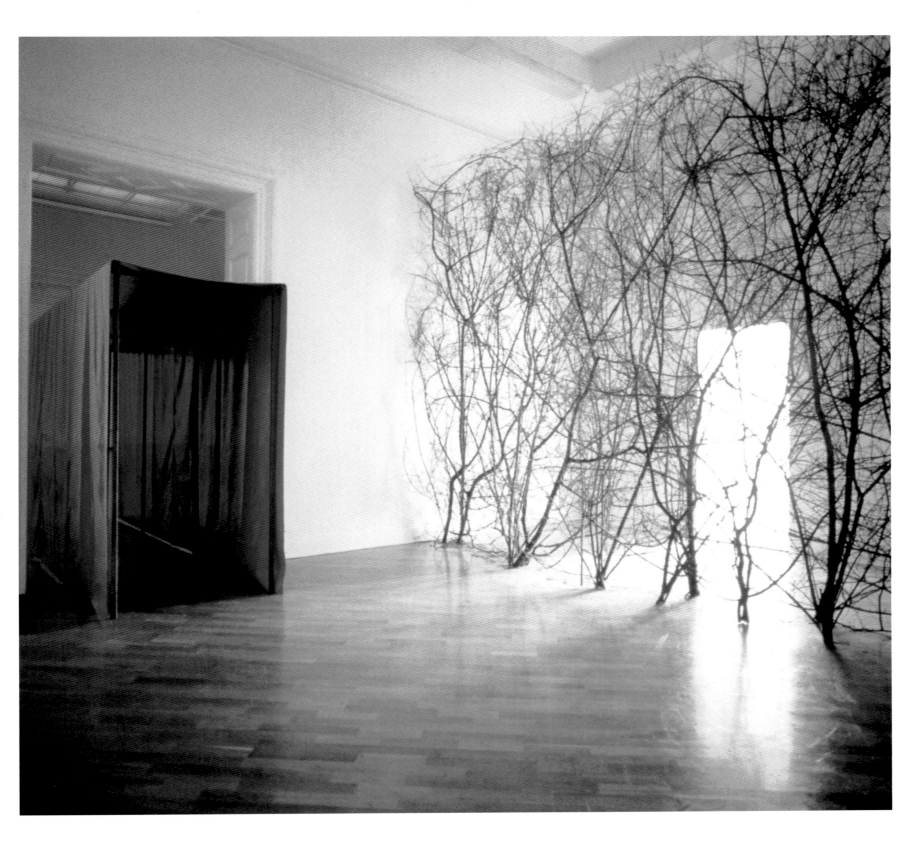

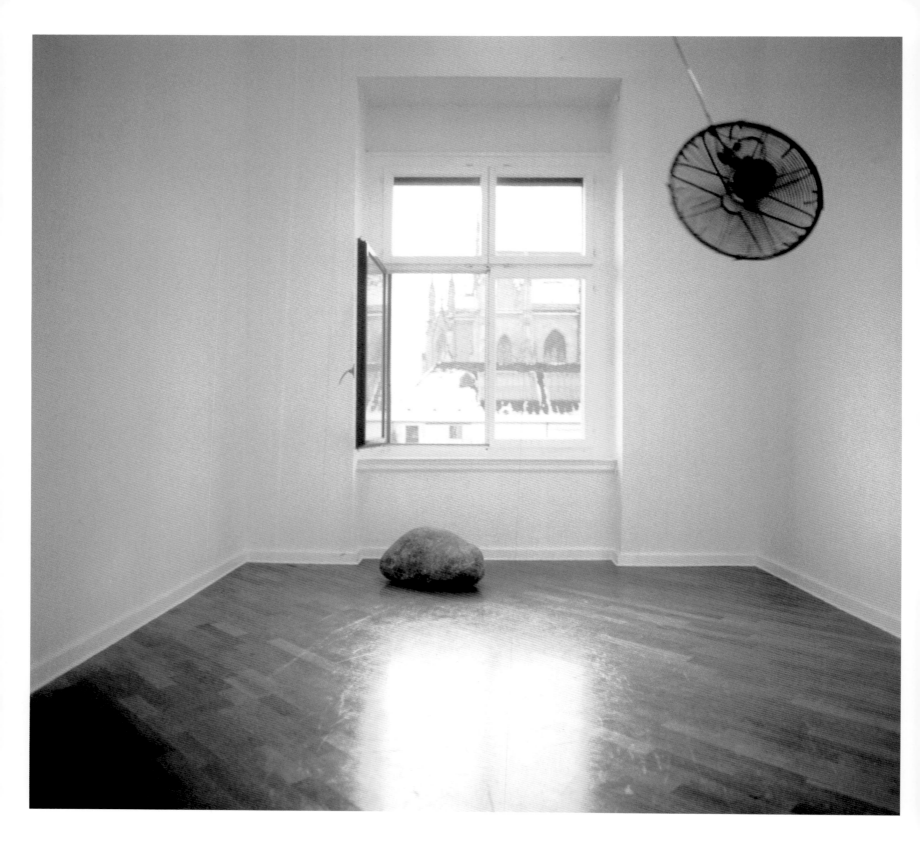

looked sharper, and were put all the more graphically on display. From this room one could look through to the next gallery, which, in the glow of retinal excitement induced by the yellow light, seemed to carry a deep purple colour – though the walls were actually white. Eliasson thus merged 'external' events with 'internal' sensations; his work opened the space to human vision, which in turn opened to the neural workings of the body, interweaving body and room. Another level of coherence ensued as the body's forward movement through space fundamentally altered vision, revealing perception and physical action as inextricably intertwined. Now keenly attuned to the instability and temporality of perception, the wayfarer advanced towards the next room by way of a plastic corridor, an interstitial passage that first appeared black, due to a lingering of the yellow colour on the retina, then changed its hue to blue as the eye adjusted to the full-spectrum universe in the gallery next door. There the entrance was flanked on the right by a row of blackthorn hedges suggestive of a groomed landscape, which guided the spectator to a smaller room where an open window let in the brisk winter air, kept in vigourous circulation by a fan. The full embrace of the exterior world propelled by this experience insisted on a self constituted through an exocentric relationship with his or her surroundings.

As movement is predicated upon the engagement of the spectator, so works such as these restore a provocative attentiveness on the viewer's part. Vehicles of heightened consciousness as much as objects of aesthetic and intellectual strength and beauty, Eliasson's works propose and foster acts of the imagination that return to the viewer the ability to associate creatively with the world, to undertake the movement towards meaning that is at the core of subjective experience. Herein lies their ideological dimension: they call their viewer to agency. Affording instances of intellectual freedom and experiential plenitude, these artworks provoke modes of self-awareness and action that counter the diminishment of self in our advanced technological age.

This hypothesis in part derives from Eliasson's study of the writings of Henri Bergson, among the most influential philosophers to have responded at the dawn of the modern period to the depreciation of human experience in the face of an increasingly automated and standardized culture that was turning perceptual behaviour into a passive and redundant form of spectacular consumption.[42] For Bergson, a sustained '"attention to life" [Bergson's term] is the pre-eminent human capability for … it is what allows an intuition of singularity rather than of the bleak redundancies of representations'.[43] Bergson envisioned attention as an action, physiological, purposeful, voluntary and expressive of an individual's autonomy. To the degree that the self undertakes a wilful and creative apperception of the world, independent of ingrained habit, she or he is (relatively) free of the regulatory imperatives of a modernizing society. Eliasson's work too demonstrates a belief in the extension of individual human agency and private thought via a heightened psychobiological attention. Furthermore, to invite the individual to

intervene in the work as Eliasson does – whether on mental or physical grounds – is to open the work up to multiple avenues of interpretation that necessarily, if provisionally, resist and transgress a prescribed order. Helping the subject regain the ability to bypass predetermined designations and mediations, this strategy points to a more expansive model for being in the world. In his work Eliasson advocates an activation of the imaginative faculties that will return viewers/participants to themselves as less docile members of the world community.

The mediated motion (2001) invited this heightened level of somatic participation through its use of paths, ramps, staircases, bridges and routes that penetrated the building in which it was installed, the Kunsthaus Bregenz, both horizontally and vertically, establishing a one-directional walkabout of a continuously variegated nature. Upon entry into the lobby the viewer was immediately invited to ascend to the second floor, where a wooden walkway floated just above a shallow body of water flooding the gallery. Duckweed, a small aquatic grass that both reproduces rapidly under natural light (provided here by skylights) and has a short life-cycle, was strewn over the surface of this artificial pond so that over the course of the exhibition a thin carpet of tiny leaves, redolent with an odour of humid decomposition, grew increasingly broad while changing from dark green to faded yellow. The esplanade on which the viewer stood traversed the length of the room to an exit staircase, over which the artist had built his own set of roughly hewn and far steeper steps that pressed the visitor

uncomfortably close to the ceiling. On the third floor the visitor was met by a hard, clay-coloured floor of compacted earthen material, its barely perceptible incline and strong dirt smell inducing an internal disorientation more felt than seen. Climbing farther up the stairs, the viewer entered a room filled with artificial fog and spanned by a hanging footbridge whose terminus was hidden in misty haze. The bridge swayed as people crossed it, and the cool fog, pumped in at regular intervals, eddied as it adjusted to their body heat. The parameters of the gallery were made fluid and disappeared, evoking a boundless space. Vision and orientation relinquished their hold, and a feeling of nervous exhilaration set in, on an immediate, 'real' level, as the spectator intervened in and was shaped by the work – which was itself influenced by the visitors' movements on the bridge. The bounds between subject and object were thus loosened, even made (visually) to dissolve.

In his arrangement of autonomous and successive spaces to be discovered while walking, and in his use of natural materials and effects, Eliasson deliberately recalls the urbane European garden, dating back to the Renaissance, in which paths led from vista to vista, each one a 'picture' of nature – a new, unexpected, sometimes astonishing but always calculated panorama. Particularly in English gardens of the eighteenth century, the view was often punctuated by a strategically placed folly or artificial ruin, a cascade carefully groomed as 'torrential', or a picturesquely untamed rock formation, all devised to draw the attention of the flâneur (the observing

stroller). These contrived displays were intended to induce a range of heightened emotions, from sympathy to terror, tied to a meditation on nature – or, more accurately, on man's struggle with it and ultimate conquest of it.⁴⁴ Since the seventeenth century it has been characteristic of the picturesque garden to refuse any axial alignment that would offer an overview, instead variously guiding and interrupting the viewer's gaze by way of a hedge screen here or an *allée* there, and subjecting vision to a rhythm of spatial compressions, intermissions and releases. So too with Eliasson's installations. The artist's knowledge of European garden models extends to a number of his outdoor sculptures, which in form and placement echo the folly and other devices for contemplation intrinsic to a romantic landscape. Invited to create a work for a Roman Renaissance garden following a strict geometric design that provided perspectival 'windows' onto a groomed landscape, Eliasson devised a quintessential folly: a wishing well (*Well for Villa Medici*, 1998) in whose interior he inserted an inverted mirrored cone. The viewer, gazing downward, was confronted with a kaleidoscope interior that multiplied and fragmented everything in its sight into numberless reflections – a panoptic reconfiguration of the visual field that thoroughly contravened the classic Cartesian co-ordinates proposed by the surrounding garden. The beholder, too, was visually broken up into countless reflections, a picture of a self radically antithetical to the unified being that the Renaissance, and this garden, presupposed.

Eliasson has placed other structures in garden

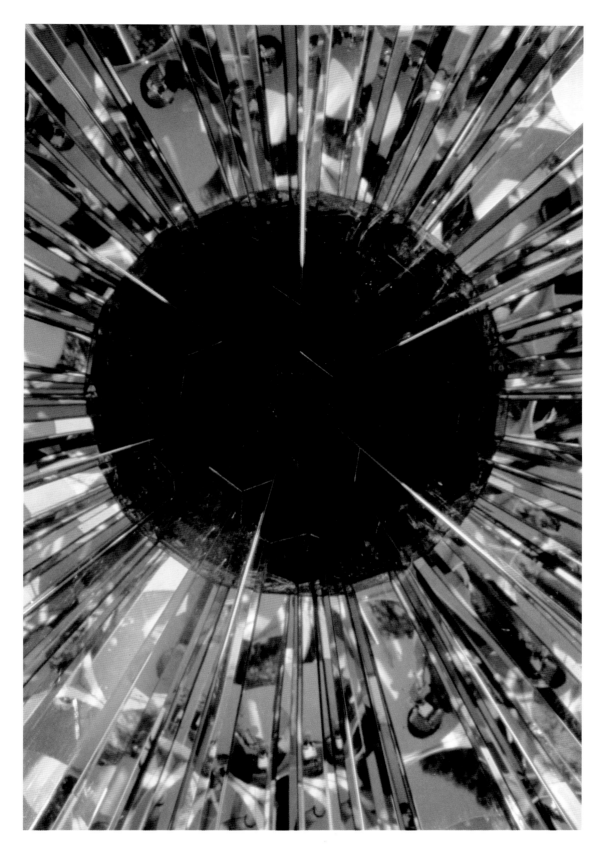

opposite, **Well for Villa Medici**
1998
Concrete, metal, mirror
h. 200 cm, ⌀ 100 cm
Installation, Villa Medici, Rome
above, detail

Der drehende Park (The turning
park)
2000
Stones, metal
h. 400 cm, ⌀ 1200 cm
Installation, Sammlung
Kunstwegen Nordhorn, Germany

**By means of a sudden intuitive
realization**
1996
Water, strobelight, pump, plastic
sheets, fibreglass
h. 300 cm, ⌀ 510 cm
Installation, Manifesta,
Rotterdam

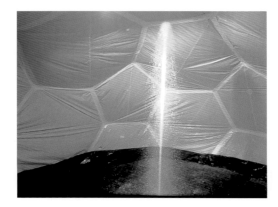

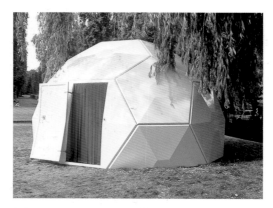

settings with similar success: appropriating a
fountain in a romantic English-style garden in
Rotterdam (*By means of a sudden intuitive
realization*, 1996), he covered it with a walk-in,
ready-made, igloo-shaped dome that he brought
from Iceland (where such structures are used to
yoke natural steam geysers). Inside the darkened
interior a strobe light visually froze the fountain's
jet of water for the viewer's delectation. *Spiral
pavilion* (1999), located at the end of a circuitous
route through exhibition halls and gardens at the
Venice Biennale, and *The five-fold pavilion*
(1998–2000), installed in a park in Holbæk,
Denmark, are structures of steel bands recalling
the visual language of science – the spiral designs
of the double helix, or the five-pointed star
formations of some quasi-crystalline structures. In
both objects the open-weave structure introduces
a complex interweaving of foreground and
background, interior and exterior, and the glinting
overlapping planes additionally shift in density
and transparency as the viewer moves relative to
the work. Perhaps most touchingly, Eliasson's *Ice
pavilion* (1998), situated in an outdoor courtyard
in Reykjavik, was a barely visible and rather artless
structure composed of thin metal legs surmounted
by a metal circle lined with a perforated garden
sprinkler hose that released a light trickle of water.
As the outside temperature descended below
freezing point, the gentle flow of water
condensed, canopying the pavilion and papering
its circumference in translucent sheets of thin
ice that slowly descended towards the floor,
making the sculpture, and the cold winter,
fully manifest.

Consonant with the pliant definitions of site-
specific art formulated in the 1990s, Eliasson's
works respond to the given parameters of the sites
in which they are situated – not only their literal
space, but also their atmospheric conditions and
conceptual contexts – without being utterly
dependent on them. The site is not the subject of
his art so much as one of the materials he employs,
its affective capacities – its unique circumstances
and distinctive conditions – being among the
qualities that his art unveils or makes newly
present. *The drop factory* (2000), for example,
was thoroughly conceived in relation to the vast
Beaux-Arts lobby of the St. Louis Art Museum,
but is also a sculptural object capable of being
reinstalled elsewhere. In response to the
harmonious and perfectly proportioned basilican
hall and the decorative fountainhead that stands
at its centre, Eliasson fabricated a monumental
geodesic dome that encased the fountain and
appropriated its workings for its own effects of
water and light.[45] Mirrored on its exterior surface,
the dome was emblazoned with reflective images
of its surroundings, its form thus visually opening
onto its setting. Conversely, the lobby's
neoclassical architecture imploded as it was
captured in a web of reflections that fractured
its rational underpinnings and folded its real,
symmetrical contours into a fictive baroque
vortex.

Earth wall (2000) snapped the geometry
of the extensive Hamburger Banhof in Berlin
into sharp focus, the sculpture's lengthwise
proportions both delineating and exaggerating
the elongated features of its architectural

8900054
1998
Steel
2 parts, h. 2.05 m, ⌀ 9 m; h. 0.26
m, ⌀ 3.5 m
Copenhagen

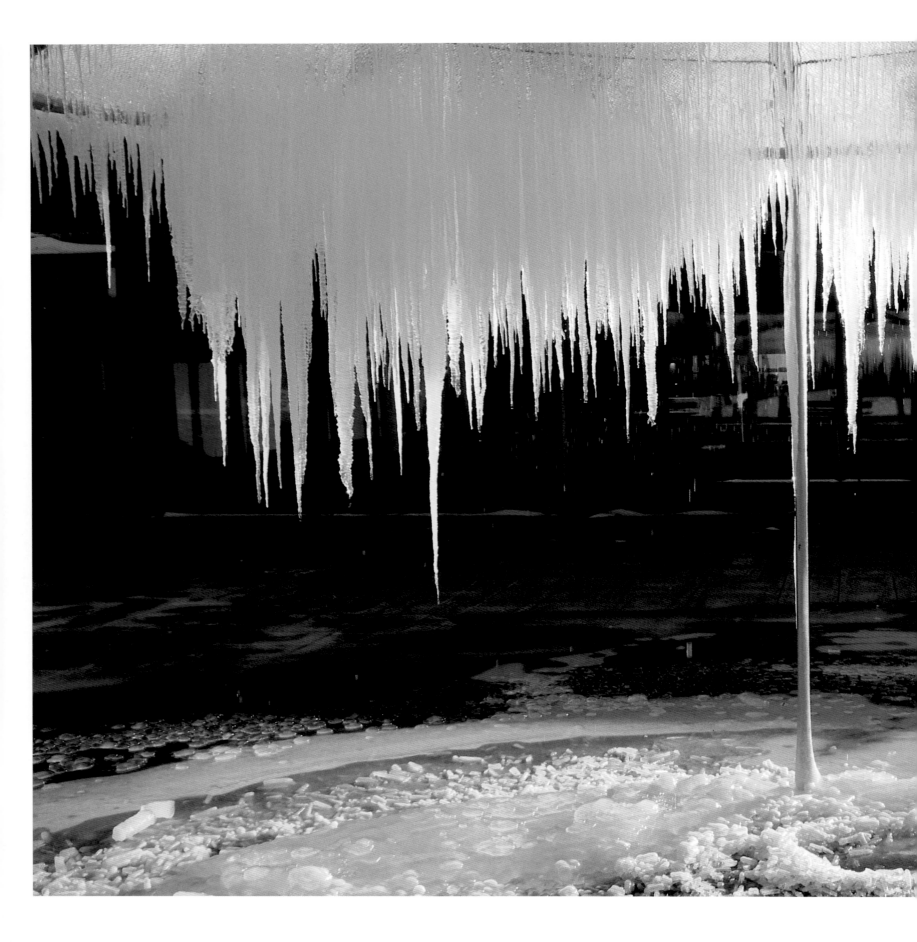

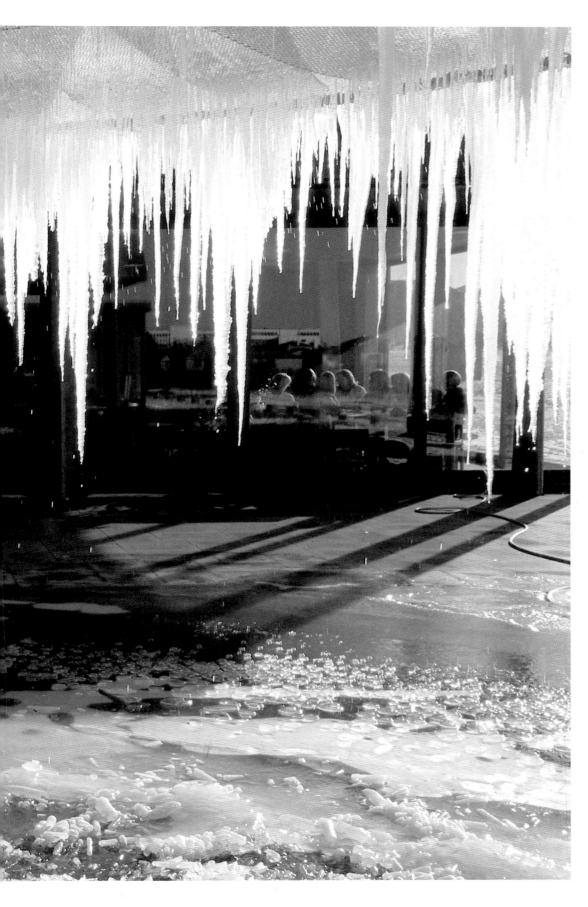

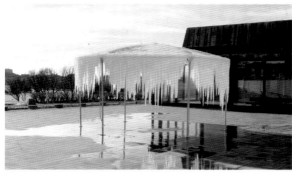

Ice pavilion
1998
Steel, water, sprinkler
h. 250 cm, ∅ 300 cm
Installation, Kjarvalstadir
Museum, Reykjavik

The drop factory
2000
Aluminium mirror, steel
h. 650 cm, ⌀ 1,050 cm
Installation, St. Louis Art Museum
below, exterior
opposite, interior

Robert Smithson
A Nonsite, Franklin, New Jersey
1968
Wood, limestone
41 × 208 × 279.5 cm

container. Eliasson's sculpture derived its power as much from its grand scale as from its material, an impenetrable block of forcefully compressed earth extracted from the grounds immediately beyond the gallery. Further tying work to context, the negative impress left by the dirt's removal was visible through the large windows at one end of the gallery, connecting the sculpture to its material origins and establishing a relationship between indoors and out. The strategy is of course indebted to Robert Smithson, whose 'Site/Nonsite' sculptures from the 1960s established a dialectic between the site (the source of material, or the place of a physical alteration of the land, often a marginalized and post-industrial zone) and the

nonsite (the site's parallel representation in the gallery via sculptures made from materials transported from it, assembled in containers or in arrangements of mirrors, and often accompanied by cartographic representations).[46] These works by Smithson's tied together and interpenetrated exterior and interior, 'nature' and 'culture'. To read his writings on his *Spiral Jetty* (1970) is better to understand the implications of Eliasson's *Earth wall*: '*Both sides are present and absent at the same time. The land or ground from the Site is placed in the art (Nonsite) rather than the art placed on the ground. The Nonsite is a container within another container – the room. The plot or yard outside is yet another container … Large scale becomes small. Small scale becomes large. A point on a map expands to the size of the land mass. A land mass contracts into a point. Is the Site a reflection of the Nonsite … or is it the other way around?*'[47]

Eliasson's riff on the Earthwork and Land art movements finds further amplification in *Green river* (1998), an intervention that has been staged, unannounced, in several different cities. In a temporary inscription on the urban landscape, an environmentally safe, neon-green coloured dye is poured into a river running through the heart of the city. The result is a simple highlighting of what is already at hand; the water's specific viscosity, its unique crosscurrents, eddies and back flows, are all made evident to passers-by. While in part an adaptation of Smithson's 'spills' and 'pours', wherein the work's formless contours evoke the natural processes of entropy and gravity, Eliasson's piece seems deliberately less muscular and assertive, more willing to unfold at the slippery,

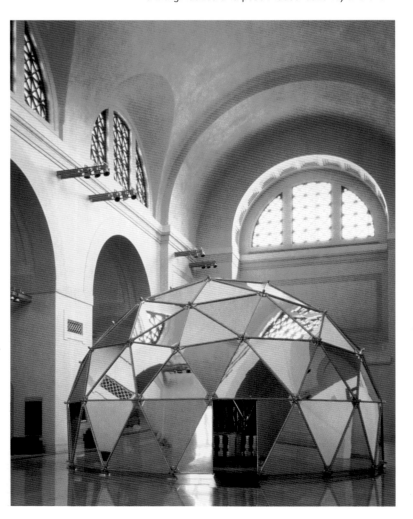

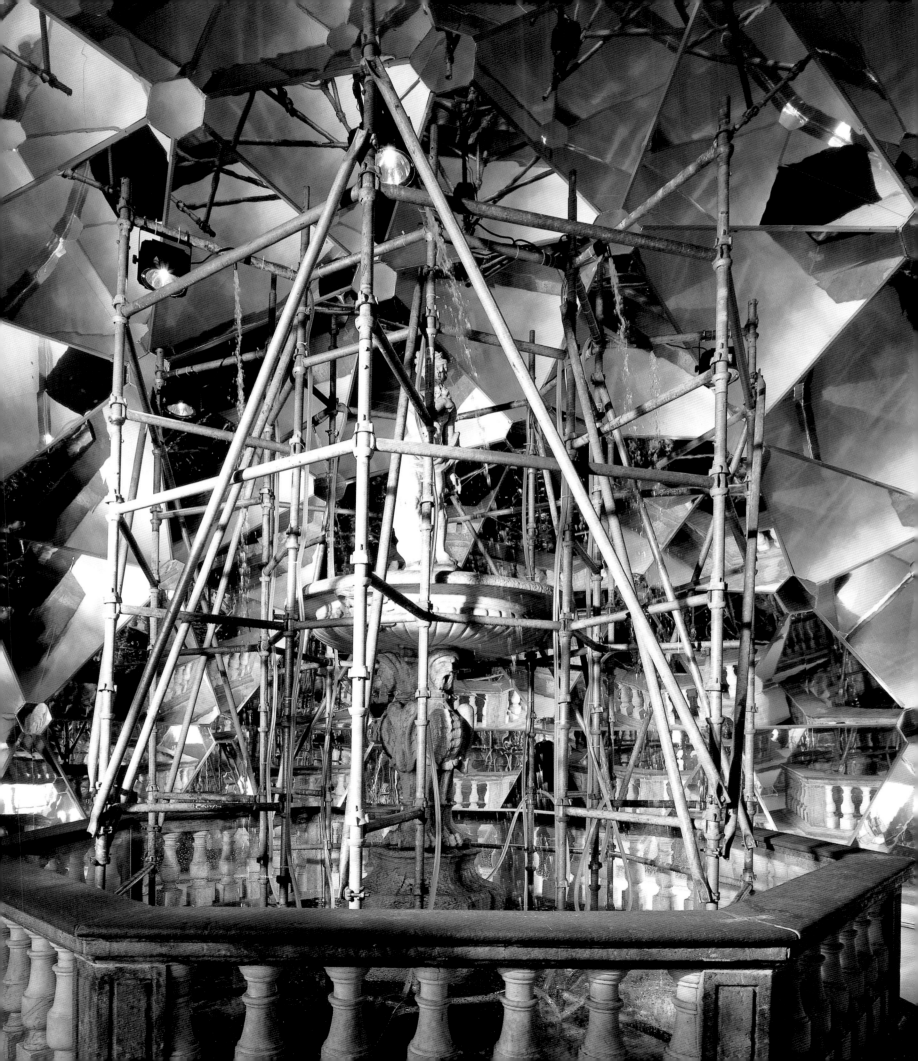

Five orientation lights
1999
Light, steel, colour filter
200 × 70 × 70 cm each
Installation, Arte Continua, San
Gimignano, Italy

Robert Smithson
Glue Pour
1969
Glue
Vancouver

open-ended margins where the artwork is fully absorbed into life.

For *Erosion* (1997), Eliasson emptied out a rainwater reservoir and simply, slowly spilled its contents onto the streets of Johannesburg, where it insinuated itself silently and almost invisibly as a temporary brook running through the urban centre. The work manifested itself less through its object-formation than in the way people responded to it – pedestrians improvising makeshift alternative routes, urbanites being caught unawares, jostled out of the discipline of the city grid and into a creative reinvention of the

habitual activity of walking. This gently subversive action reinscribed the social space of the city with new, if temporary, byways that lent a revived attentiveness to a 'practice of everyday life'.[48] Such transitory conceptual remappings of presumably fixed axes (explored further by Eliasson in *Five orientation lights*, 1999 and *Movement meter for Lernacken*, 1999) are like a gentle but effective twist on the Situationist Guy Debord's call for the creation, not of individual art objects relegated to the aesthetic sphere, but 'of *situations*, that is to say, the concrete construction of momentary ambiances of life and their transformation into a superior passional quality'.[49] A key tactic in this reordering and revitalization of the quotidian is the *dérive* (drift), defined by Debord as 'a mode of experimental behaviour linked to the conditions of urban society: a technique of transient passage through varied ambiances'.[50] Eliasson's 'playful, protesting, fugitive'[51] action indeed instigated creatively lived moments of everyday life among its (sometimes unwitting) participants, insinuating subjective personal experience into the anonymous social plane, in a city then

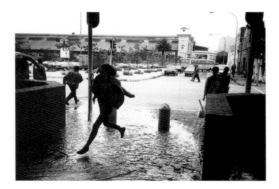

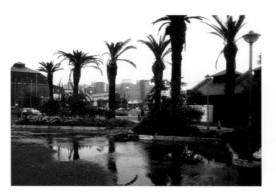

Erosion
1997
Water, pump
Johannesburg Biennale

experiencing enormous social change.

With *Your natural denudation inverted* (1999), Eliasson's site-responsive and system-specific installations reached a new level of complexity. Working in the large outdoor sculpture courtyard of the Carnegie Museum of Art, Pittsburgh, Eliasson built a vast but shallow water basin atop a conspicuous framework of scaffolding erected over the courtyard's stepped contours. Four small apertures in the lake-like structure allowed the trees in the granite courtyard to be integrated into Eliasson's design as a dynamic compositional element: when the exhibition opened, their late-fall leaves were reflected in the dark water, then floated as a layer of dark orange over the liquid ground, before finally coming to rest on the basin's expansive floor, preserved for the season and still visible when not frozen over by ice or covered with snow. The work distilled and made graphically clear the surrounding weather, as every change in the wind, every cloud movement or glint of sunshine, every ice storm or snowfall registered on the water's surface. Using the building's own heating system, Eliasson also piped hot steam under the scaffold structure to the lake's centre, where it was released in a continual white cloud that billowed skyward and echoed, not only the hot springs in far-off Iceland (the work's inspiration) but also two rolling steam clouds fabricated by a boiler plant visible in the near distance beyond Eliasson's installation.

Your natural denundation inverted was located immediately outside a glass curtain wall that allows a view from the interior of the museum onto

The movement meter tower for Lernacken
2000
Steel, light, colour spectrum
h. 12.63 m, ⌀ 4 m
Installation, Malmö, Sweden
Collection, City of Malmö, Sweden

the sculpture courtyard. Approached from outside, the work's scaffold underpinning was clearly visible, and its visual apprehension was compounded by the visceral sensations of wind, cold and wetness, as well as the loud noise of Eliasson's artificial geyser. But as one came upon the piece from inside the museum, the scaffolding was hidden from view, and one saw only a quiescent steam cloud amid a capacious body of water. Thus fully captured on visual terms but deprived of sound, touch or sense impressions, the work was turned into a 'picture', literally and metaphorically 'framed' within the rectangular outlines of the glass window, whose gridded design furthermore inscribed on the depicted world beyond it a lattice armature reminiscent of those classic perspectival devices by which the artist organized the world into a composition to paint. Thus the 'real' and its picturesque representation sat side by side, separated solely by a slim plate of glass. The viewer was either physically immersed in the work or cast in the role of isolated voyeur, cut off from the scene outside – two radically different relationships to reality of which Eliasson made us mindful.

Eliasson has always been drawn to the complex functions of boundaries – the ways in which borders or outlines, membranes or sheaths, not only separate but join. He has used boundaries as conceptual devices for upsetting rather than reinforcing the old dichotomies of inside/outside, viewer/viewed and nature/culture, often insisting that his work itself occupy a fertile realm between. Eliasson's interest in these conceptual thresholds has drawn him to the use of solid interfaces such as glass walls, windows and building facades, redeploying them away from their conventional roles as dividers and separators, and towards tasks of blurring and interpenetration. The ensuing 'zone of indetermination'[52] is precisely what Eliasson seeks out, and what so deeply recommends his work to us. Ultimately his art proposes an evocative cancellation of the literal and conceptual boundaries between self and world, a diminution of that very line along which each body normally experiences itself as apart from and discontinuous with its surroundings, a reduction of our estrangement from a now more fully enveloping universe.

The simultaneous demarcating and blurring of caesuras has not been Eliasson's project alone; it owes a historical debt to Marcel Duchamp's 'infra-slim', his term for the imperceptible yet irrefutable borderline that is the arena of interpenetration and reciprocal exchange between subject and object: 'When / the tobacco smoke / also smells / of the mouth / which exhales it / the two odours / are married by / infra-slim.'[53] In the same spirit, in Eliasson's *The very large ice floor* (1998), artwork and viewer register on each other in a dynamic, indeterminate cross-infiltration. Improbably situated in São Paulo, Brazil, the piece consisted of a large, low platform of thin ice seemingly broaching a glass partition wall that physically divided and visually linked a museum-going public and its counterpart strolling in the neighbouring city park. While the ice floor outside was under constant threat of melting in the tropical heat, inside it became an arena of frolicsome activity, as viewers/participants were invited to interact with

Albrecht Dürer
Draftsman Drawing a Reclining
Nude
c. 1527
Woodcut
7.5 × 21 cm

The very large ice floor
1998
Water, ice-machine, basin
Dimensions variable
Installation, São Paulo Biennale

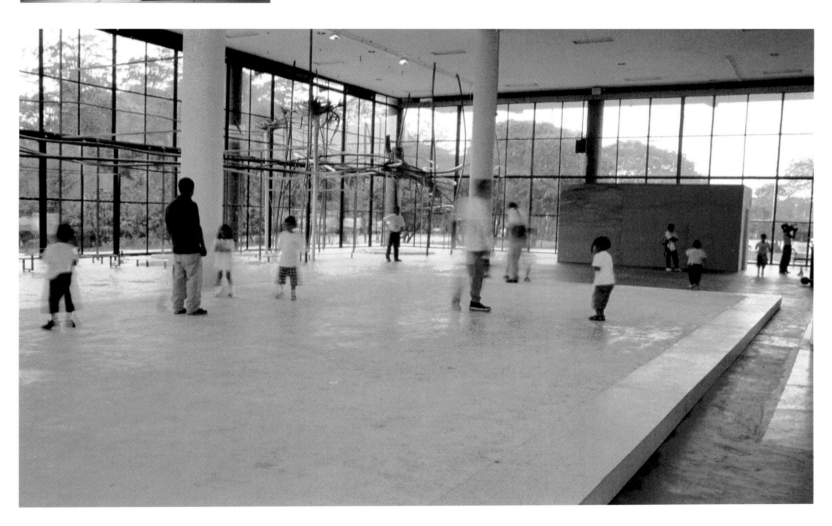

it kinetically. As the ice was physically marked, in infinite variations, by its users' bodily traces, the work became inseparable from the people who literally put it into play, granting it a perpetually renewed life and relevance. In its turn, the sculpture instilled in its public an undeniable and immediate emotional enjoyment, prompted by an amplification of bodily movement inserted into unpredictable flux. In a profound and pleasurable way, the viewer was absorbed into the act of making.[54] Located neither in the concrete object nor in the consciousness of the subject, the piece ultimately lay somewhere in the elastic unfolding 'between the spectator and the machine'.[55]

Thoka
1995
Light, fog-machines, yellow filter,
timer
Dimensions variable
Installation, Kunstverein
Hamburg

Eliasson has devised other works in which solid boundaries become suddenly insubstantial. *Thoka* (1995) filled a giant glass cube of a building with fog and yellow light. Activated at twilight and visible only in the evening and from outdoors, the piece softened the rigid architectonic enclosure while convincingly embodying the lambent light of a protean sun. At the invitation of a New York City museum housed in a former mansion, Eliasson again mitigated the physical barrier between exterior and interior, public and private. Using spotlights and dry-ice machines installed just beneath sidewalk grills along the stately ex-manor's facade, *Untitled* (1998) wrapped the building in a fluid yellow mist that changed the way the building and its visitors related to each other at street level. While these works sought to dematerialize a concrete threshold, an untitled 1998 installation in Leipzig strongly underscored it: Eliasson mirrored both sides of the glass windows lining a museum facade, highlighting the window as an architectural divider rather than as a visual hinge between indoors and out. A transparent boundary was thus made opaque, and, sandwiched between mirrored layers, turned into a negative space of pure demarcation – an invisible, 'infra-slim', but decisive membrane, much like Duchamp's 'hollow … between the front and back of a thin sheet of paper'.[56] Meanwhile the windows mimetically recapitulated both the space – whether of the exhibition gallery or of the gardens outside – and anyone situated within it, and, in so doing, visually fused the viewer with the topic of her or his attention. Observers were unavoidably captured in the work, which 'observed' them as

they saw themselves reflected in its mirror surface.

Eliasson has often used the window as format and the mirror as material – not surprisingly, given the charged symbolic meaning and material effect of both forms. The window is a fixture in the history of art, painting having long been theorized as 'a window on the world' whose image bespoke a relation of the self to a world conceived as perfectly clear and rational, and before which one would be cast in a literally and spiritually enlightening glow. By contrast, a work such as *Yellow double hung windows* (1999) fabricates the window's mullions, shadows and light-streams yet refuses to represent anything beyond or outside of itself. In *Your repetitive view* (2001), the window aperture was telescoped out: a long wooden shaft, open at one end, stretched through a New York

Caspar David Friedrich
View Through a Window
1805-06
Sepia ink on paper
31 × 24 cm
Collection, Kunsthistorisches Museum, Vienna

dimensions as a gallery skylight situated directly above it. The skylight's glass panes had been removed from their iron framework, opening the installation out to the city's sights, sounds and early winter weather. At the base of the skylight and encircling the four chamber walls, a rectangular frieze of mirrors hung at just above eye level; its reflections sent sky, building details and the skylight's metal lattice into a kaleidoscopic explosion of mirrors-mirroring-mirrored images. The mirrors were also set high enough so that the body of the viewer between them was visible only in part – a detail of a fragmented and multiplied reflection, its integrity and solidity dispersed in an abyss of ricocheting cross-reflections that lent weight to the sensation of an essentially disembodied experience. Meanwhile the sting of real cold, wind and sometimes rain paradoxically returned the viewer to the corporeal realm. Any conventional visual logic was challenged as the viewer's gaze met an endlessly receding field of recursive, unsynthesizable views. The space within which this now-bodiless spectator moved was real and virtual in equal measure: a physical, three-dimensional volume and an equally 'present yet unenterable' fictive double combined to create an impossibly infinite and ever-changing environment available to the eye alone.[57]

gallery's administrative offices (disrupting daily functions in its wake) to exit in the gallery's open window, extending and emphasizing the window's role as hinge between interior and exterior. This role was further highlighted by the shaft's mirrored interior, which magically accommodated both outside and observer in its reflections.

For the same exhibition Eliasson produced *Your now is my surroundings* (2000), an exhilarating embrace of inside and outside, perceiver and perceived, real and simulacrum. Through an industrial grey-steel door, the spectator entered a chamber cut to the same

The visceral appeal of this vertiginous and ambiguous image-world lay ultimately in the notion of self that it impelled: a sedimentary being located 'in the interstices between fragmentation and unity',[58] between the visual and the haptic, at

Your now is my surroundings
2000
Mirrors, air, metal frame
Dimensions variable
Installation, Tanya Bonakdar
Gallery, New York

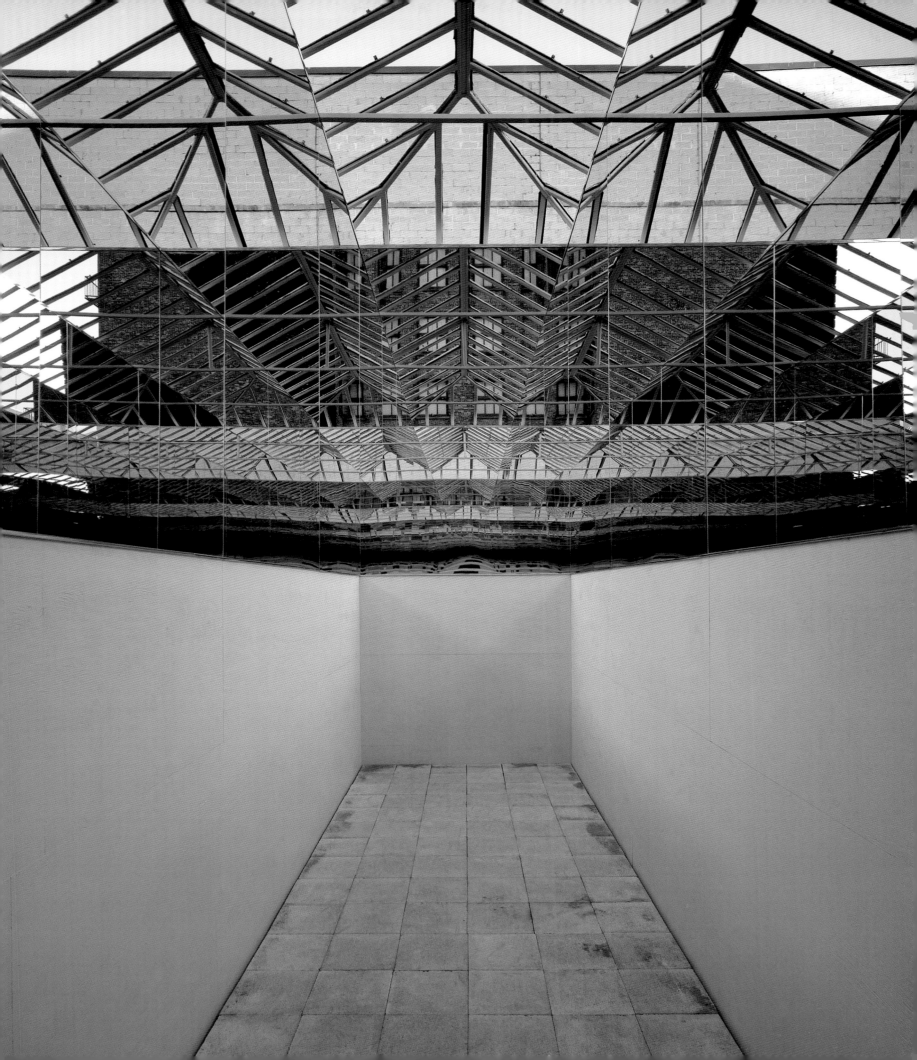

the very interface of various subject conditions, without being fully absorbed by any of them. For two recent works Eliasson produced a surface material that is a simple and brilliant physical transcription of this subject condition: constructed as a window shape (*Seeing yourself seeing*, 2001), or stretching across the glazed wall of a vast lobby hall (*Seeing yourself sensing*, 2001), it consists of a perfectly aligned sequence of alternating mirrored and transparent glass stripes that function simultaneously as window and mirror. Across this surface plane, two or more distinct and often incompatible realities – reality and representation, inside and outside, perceiving subject and perceived object – are pictorially merged. With the beholder's perambulations the eye trips across the field, making the surface shimmer and move in a dyadic rhythm similar to the jittery fidgeting of early cinema.

Within this restless plane, the self cannot come to rest *except* as an actively created and continually reinvented composite, for the striping is too thin either to reflect a fully integrated being or to allow a wholesale, passive immersion in the environs visible beyond the pellucid bandings, which in any case reflect back an image of the spectator in even more ghostlike form. The effect is that of a layered and fugitive self floating imagistically between presence and absence, and provisionally anchored at the site of a continual flux, as contingent as the world within which it unfolds. By extension, this work argues for a cultural identity that refuses either an irreducible and unmediated wholeness or an utter dissolution of core subjecthood, manifesting instead the

vulnerabilities of a fleeting yet durable self who, like each of us, is located at the threshold between concrete reality and an increasingly widely distributed and weightless electronic milieu. Renouncing any conventional humanist notion of coherent wholeness, the work instead proposes, literally and ideationally, a self in relation to a surrounding and unfolding universe that is itself perpetually in formation. Eliasson's works make of the discontinuous being a steady, moral condition and a site for agency – no small accomplishment in our disjunctive contemporary world.

The interspace described by *Seeing yourself sensing* is finally the location to which all of Eliasson's works to some extent refer – at the living edge of the physical and the virtual, of a disembodied and haptic self, of the real and the fictive, all within an actively generated in-between. Like experience itself, Eliasson's art is built around a series of coexisting and incommensurate oppositions that demarcate the territory and the terms of larger ideological debates: the virtual versus the material, fiction versus reality, wilful attention versus passive absorption. Over and again, these works are phenomenologically based, rely on the spectator's psychosomatic response, and construct compelling emphatic worlds while exposing their means of fabrication. In prompting us towards an extensive and intensive engagement with the world, an engagement that reawakens us to a fresh consideration of everyday life, Eliasson's works move us towards an experience 'so rich and intense as to be an antidote to forms of alienation or reification in a contemporary social world'.[59] This

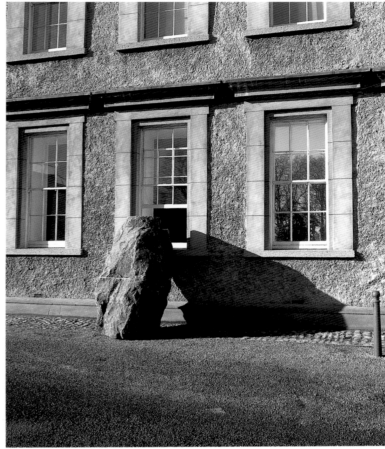

aesthetic is at the same time an epistemology: constantly in formation, its refusal to synthesize into a unified whole or absolute 'truth' is coextensive with the circumscribed dimension of 'universals' at the present time, and by extension has its human correlative in 'a "weakening" of immutable or Heideggerian Being, then giving shape to metamorphic Becoming'.[60] It is this unfixed and sedimented Becoming that is encouraged by Eliasson's oeuvre, which insists on corporeal and emotional experience – unfolding in relation to a richly dynamic and intensely lived outside world – as the ground on which meaning must be formed.

Objects such as Eliasson's that solicit a shared vacillation and fleeting integration with the subject shake us to the core because they impel human choice. One must actively extend oneself intellectually, psychologically, emotionally. In the process, the artwork, the viewer and authentic experience – reality itself in fact – are potentially transformed. Eliasson's work is finally the aesthetic outgrowth of a deeply personal mode of being in the world, an outward vision that comes into immediate focus in each present instant of the spectator's viewing. From phenomenology to interpretation to engagement: for both artist and viewer, to stay with the work in the space of transition and translation is to free the continued workings of the imagination.

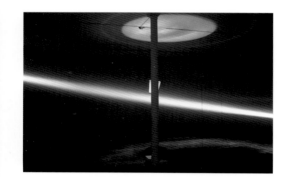

360° expectations
2001
Wood, lens, lamp
⌀ 10 m
Installation, Institute of
Contemporary Art, Boston

Grateful thanks are extended to Olafur Eliasson for undergoing numerous conversations and interviews with unstinting thoughtfulness and grace; to Tom Shapiro for his unflagging and essential support; and to David Frankel for his sage and elegant intellectual contributions.

According to Jonathan Crary, the phrase 'Attention Universe', used as the title of this essay, is cited by some authorities as the first words telegraphed by Samuel F. B. Morse. See Crary, *Suspensions of Perception: Attention, Spectacle, and Modern Culture*, The MIT Press, Cambridge, Massachusetts, 1999, p. 33, footnote 57.

1 I am describing Olafur Eliasson's exhibition 'Surroundings Surrounded', at the ZKM, Karlsruhe, in the summer of 2001. See Peter Weibel (ed.), *Olafur Eliasson: Surroundings Surrounded*, Neue Galerie, Graz/ZKM, Karlsruhe, 2000.

2 In fact the image is of the waterfall whose powerful currents are clearly heard.

3 The assessment of the camera obscura here is indebted to the writings of Crary and of Rosalind E. Krauss. See in particular Crary, op. cit., and 'Modernizing Vision', in Steve Yates (ed.), *Poetics of Space: A Critical Photographic Anthology*, University of New Mexico Press, Albuquerque, 1995, pp. 85–97, and Krauss, *The Optical Unconscious*, The MIT Press, Cambridge, Massachusetts, 1993, pp. 128–34.

4 Eliasson, 'The Weather Forecast and Now', *Cabinet*, No. 3, Summer 2001, pp. 64-65. See in this volume pp. 140-41.

5 Edmund Husserl, quoted in Krauss, op. cit., p. 215.

6 Jacques Lacan, quoted in ibid., p. 87. Krauss' paragraph containing this quote played a formative role in my understanding of the position occupied by the viewer within Eliasson's installation.

7 Hal Foster, 'The Un/Making of Sculpture', in *Richard Serra: Sculpture 1985–1998*, Museum of Contemporary Art, Los Angeles, 1998, p. 17.

8 Ibid.

9 Eliasson, in Markus Wailand, 'Olafur Eliasson, Neue Galerie, Graz', *frieze*, September–October 2000, p. 127.

10 Jean Fisher, 'The Syncretic Turn: Cross-Cultural Practices in the Age of Multiculturalism', *New Histories*, Institute of Contemporary Art, Boston, 1996, p. 38.

11 Eliasson, communication with the author, March 2002.

12 Husserl, quoted in Yve-Alain Bois and Krauss, *Formless: A User's Guide*, Zone Books, New York, 1997, p. 135.

13 Krauss, op. cit., p. 214.

14 Ibid., p. 217. Nevertheless, as Jacques Derrida argues in critiquing the work of Husserl, 'The presence of the perceived present can appear as such only inasmuch as it is *continuously compounded* with ... primary memory and expectation.' See ibid., p. 215, and Crary, *Suspensions of Perception*, p. 288, footnote 18.

15 Husserl, quoted in Bois and Krauss, op. cit., p. 273.

16 Lawrence Weschler, *Seeing Is Forgetting the Name of the Thing One Sees: A Life of Contemporary Artist Robert Irwin*, University of California Press, Berkeley, 1982, p. 180. Eliasson has cited this book as influential in the formative stage of his artistic development.

17 Husserl, quoted in Krauss, op. cit., p. 214.

18 Weschler, op. cit., p.185.

19 Crary, summarizing Husserl in op. cit., pp. 285–86.

20 Husserl, quoted in ibid.

21 Maurice Merleau-Ponty, *Phenomenology of Perception*, Colin Smith (trans.) Routledge/Kegan Paul, London, 1962, pp. 304, 92.

22 On the relevance of Merleau-Ponty's writings for the art and criticism of the 1960s, see James Meyer, 'The Uses of Merleau-Ponty', *Minimalisms*, Cantz Verlag, Ostfildern, 1998, pp. 178–89.

23 For a discussion of how Minimalism inaugurated but did not fully complete a 'shift in focus from object to subject', due to its retention of the sculptural object, see Foster, op. cit., p. 14.

24 Robert Morris, 'Notes on Sculpture, Part 2', 1966, reprinted in *Continuous Project Altered Daily: The Writings of Robert Morris*, The MIT Press, Cambridge, Massachusetts/Solomon R. Guggenheim Museum, New York, 1993, p. 15.

25 Morris, 'The Present Tense of Space', 1978, in ibid., p. 176.

26 Eliasson, quoted in 'Conversation between Olafur Eliasson and Hans

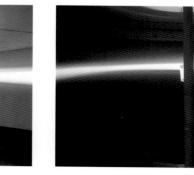

Ulrich Obrist – Berlin, October 2001', *Olafur Eliasson: Chaque matin je me sens différent - chaque soir je me sens le même*. Exhibition catalogue Musée d'art moderne de la Ville de Paris, Paris-Musées, 2002, n.p.

27 Robert Irwin, quoted in Sally Yard, 'Deep Time', in *Robert Irwin*, Museum of Contemporary Art, Los Angeles, 1993, p. 67.

28 James Turrell, notes on the 1967–1971 collaboration with Irwin, Turrell and Ed Wortz, quoted in Weschler, op. cit., p. 127.

29 Russell Ferguson, 'Freezing and Melting', in *Olafur Eliasson: Your position surrounded and your surroundings positioned*, Dundee Contemporary Arts, Dundee, 1999, p. 37.

30 Jean Fisher, 'Art's Caress', *Beyond Ethics and Aesthetics*, Ine Gevers and Jeanne van Heeswijk (eds.), Sun Press, Amsterdam, 1997, p. 166.

31 The legitimacy of beauty in art practice began to be restored in 1993 (the same year Eliasson produced his interior rainbow) with the publication of Dave Hickey's *The Invisible Dragon: Four Essays on Beauty*, Art Issues Press, Los Angeles, 1993.

32 Michael Newman, quoted in Lynne Cooke, 'Andreas Gursky: Visionary (Per)Versions', in *Andreas Gursky: Photographs from 1984 to the Present*, Kunsthalle Düsseldorf, 1998, p. 13.

33 Cooke, in ibid., p. 14.

34 Crary, 'Olafur Eliasson: Visionary Events', in *Olafur Eliasson*, Kunsthalle Basel, 1997, n.p.

35 Ina Bloom, 'The Bind of the Vernacular', 1998, unpublished text.

36 Eliasson's focus on time in this piece is underscored by the title of his 2001 one-person exhibition *Your only real thing is time*, at the Institute of Contemporary Art, Boston, in which this photo-suite was first shown. See Jessica Morgan (ed.), *Your only real thing is time*, Institute of Contemporary Art, Boston/Hatje Cantz Verlag, Ostfildern, 2001.

37 Eliasson's use of the second person in his titles bears a superficial resemblance to the language of the American artist Barbara Kruger, who often incorporates such phrases in her work – 'Memory is your image of perfection', for example. In developing his practice, however, Eliasson was unaware of Kruger's example. Communication with the author, March 2002.

38 As Eliasson has written, 'exposing the representational layer ... clears the experience and makes it possible for us to see our self seeing – or knowing that we are seeing and seeing that we know'. In Eliasson in co-operation with Günther Vogt, *The Mediated Motion*, Kunsthaus Bregenz, 2001, p. 32.

39 I owe this notion to Bois, 'A Picturesque Stroll Around *Clara-Clara*', *October*, Summer 1984, p. 34.

40 See ibid., p. 36.

41 Here I paraphrase Richard Serra speaking on his own work: 'The dialectic of walking and looking into the landscape establishes the sculptural experience.' In Serra and Clara Weyergraf, *Richard Serra: Interviews, Etc. 1970–1980*, The Hudson River Museum, New York, 1980, p. 72.

42 I owe my observations on Henri Bergson to Crary, op. cit., chapter 4, especially pp. 316–27.

43 Ibid., p. 323.

44 For a general overview of the history of European gardens, see Marie Louise Gothein, *A History of Garden Art*, J. M. Dent and Sons, London, n.d.

45 Eliasson's dome sculpture also responded to the presence in St. Louis of the Climatron Conservatory in the Missouri Botanical Garden, a geodesic-dome structure inspired by the designs of R. Buckminster Fuller.

46 Gary Shapiro, *Earthwards: Robert Smithson and Art After Babel*, University of California Press, Berkeley, 1995, p. 2.

47 Robert Smithson, 'The Spiral Jetty', in Nancy Holt (ed.), *The Writings of Robert Smithson*, New York University Press, 1979, p. 115.

48 This term is borrowed from the philosopher Michel de Certeau, whose work examines subtle tactics of resistance and private practices that can make daily living a subversive act. See *The Practice of Everyday Life*, Steven Randall (trans.), University of California Press, Berkeley, 1984.

left, **Double window projection**
1999
Spotlights, tripods
Dimensions variable
Installation, Marc Foxx Gallery,
Los Angeles

following pages, **Proposal for a park**
1997
Chalklines
Dimensions variable
Installation, '3e Symposium en arts visuels de l'Abitibi-Témiscamingue', Quebec, Canada

49 Guy Debord, 'Report on the Construction of Situations and on the International Situationist Tendency's Conditions of Organization and Action', in Ken Knabb (ed. and trans.), *Situationist International Anthology*, Bureau of Public Secrets, Berkeley, 1981, p. 22. Italics are mine.

50 Debord, 'Definitions', in ibid., p. 45.

51 De Certeau, op. cit., p. 175.

52 This is Bergson's term to describe where, as Crary puts it, 'the richest and most creative forms of living occur', op. cit., p. 317.

53 Marcel Duchamp, 'Infra-Slim', in Michel Sanouillet and Elmer Peterson (eds.), *Salt Seller: The Writings of Marcel Duchamp*, Oxford University Press, New York, 1973, p. 194.

54 This strategy too was heralded by Duchamp, who wrote that 'the creative act is not performed by the artist alone' but is a matter of collaboration with the spectator. Duchamp, 'The Creative Act', in ibid., p. 140.

55 Eliasson, quoted in Obrist, op. cit.

56 Duchamp, op. cit., p. 194.

57 Morris, 'The Present Tense of Space', in op. cit., pp. 204–7. Morris is describing works by himself and by Smithson using mirrors.

58 Maurice Berger, 'Wayward Landscapes', *Robert Morris: The Mind/Body Problem*, The Solomon R. Guggenheim Foundation, New York, 1994, p. 30. For the sake of clarification it is worth noting the similarity here to Lacan's language in describing his famed 'mirror stage' (*Ecrits*, trans. Alan Sheridan, Norton, New York, 1977), which charts the child's development from an undifferentiated self towards a coherent selfhood, a stage of identity formation prompted by the reflected image. I mention this concept only to point out that it is not at all Eliasson's concern. Writings on the 'mirror stage' as it relates to art practice are extensive, the most useful expositions having been written by Krauss, as in her 'Notes on the Index', in *The Originality of the Avant-Garde and Other Modernist Myths*, The MIT Press, Cambridge, Massachusetts, 1985.

59 Crary, op. cit., p. 327.

60 Barbara Maria Stafford, *Good Looking: Essays on the Virtue of Images*, The MIT Press, Cambridge, Massachusetts, 1996, p. 10.

Contents

Michelangelo Antonioni's film *Red Desert* (1964) coloured in brilliant petrochemical hue the stark, desiccated urbanscapes of post-war Europe favoured by Italian neo-realist cinema[1] and featured so prominently in his previous work. Regarded by many as a masterpiece of colour filmmaking, *Red Desert* opens with a languid sectional survey of Ravenna, an industrial town in northern Italy. It is a survey, however, that despite its deliberation reveals no evidence of reality save that the real itself has been vapourized and dispersed so completely that it can never be reassembled as a whole and viewed from above as with a Modernist plan. Even cinema, with all that montage promised, is unable to give a full account of the real. In the opening title sequence, Ravenna is exchanged for a simulacrum of a seemingly once-existent real Ravenna, truth or the pretension to truth, for artful creation. A rich perceptual milieu is built up from blocks of yellow, blue, red, green, brown and grey percepts and affects that, along with Antonioni's first use of long-range telephotography, blur the distinction between natural and artificial, between characters and the background from which they emerge and into which they recede; between any discrete element and the surreal ether. Every seemingly hard and fixed thing in this banal urbanscape – smokestack, power line, factory, ship, even the earth – is softened and liquefied into an aerosol haze of astonishing beauty.

Rather than adding an element of reality to the black-and-white world of neo-realism, Antonioni's use of colour intensifies the artificial reality of post-war life that cinema could no longer keep at bay and that Antonioni would contemplate in greater detail in his next colour film, *Blow-Up* (1966). Colour is an artificial agent introduced into neo-realism that ultimately creates an even greater appreciation of the real. But it is a real – or 'hyperreal', as Jean Baudrillard and others would later call it – that engenders in those caught between these two worlds an overwhelming sense of alienation and longing for the

Michelangelo Antonioni
Red Desert
1964
120 mins., colour, sound
Film stills

simpler, black and white past where natural and artificial, real and artifice knew their proper places. In an emergent world governed by violent market surges and falls (*The Eclipse*, 1962) and by images and spectacle (*Blow Up*), it is fitting (and for many disturbing) that the most beautiful, most real, most natural things are artificial: the wispy though deadly yellow puffs of smoke spouting from the factories, the green pools of sludge and chemical run-off, even the damaged beauty of Giuliana (Monica Vitti), suicidal protagonist of *Red Desert*, who wanders the poisonous lunar landscape of Ravenna in search of meaning.

In the 'red desert' of post-war Europe, Antonioni discovers the impossibility of disclosing the real, creating in the process some of the most stunning images in cinematic history. His is a lesson (and one he did not learn sufficiently well) in the power of artful creation, in the triumph of Nietzschean perceptions over those of Marx and Freud, who sought in their different ways to reveal a pre-existent reality or truth. Despite this recognition, Antonioni continued to search for the real, revealing – in each failure to secure its adequate depiction – the angst of an artist and indeed of an entire generation who believed in the possibilities of redemption gained by access to the real. Following the opening sequence in *Red Desert*, Giuliana and her son emerge first as specks of colour and then as full-blown characters from the amorphous petrochemical haze. She is dressed in a beautiful, vivid green coat that distinguishes her from the drab industrial wasteland which ultimately is nothing more than a backdrop for her tormented psyche. The film closes as it opens, as Giuliana, again dressed in green and accompanied by her son, walks towards us and then off camera into an unknown future. Appearing in all scenes but one, Giuliana is the thin green thread that weaves together Antonioni's narrative. But she also delineates the threshold that prevents Antonioni from crossing over completely into the freedom promised by Nietzsche. Though often criticized for being overly concerned with artful experimentation, Antonioni almost always subordinates his art to characters and to the expression of their alienation. As Giuliana remarks: 'There is something terrible about reality and I don't know what.' Antonioni leads us to believe that if Giuliana – and by extension, if we – could only understand what that terrible thing is, if we could portray it accurately even if that portrayal is all the more ghastly because beautiful, then we might be able to redress the ill and make the alienated whole again.

Enter, from Northern Europe, Olafur Eliasson, a different kind of natural colourist. Though the comparison between him and Antonioni may at first seem strained, on closer view

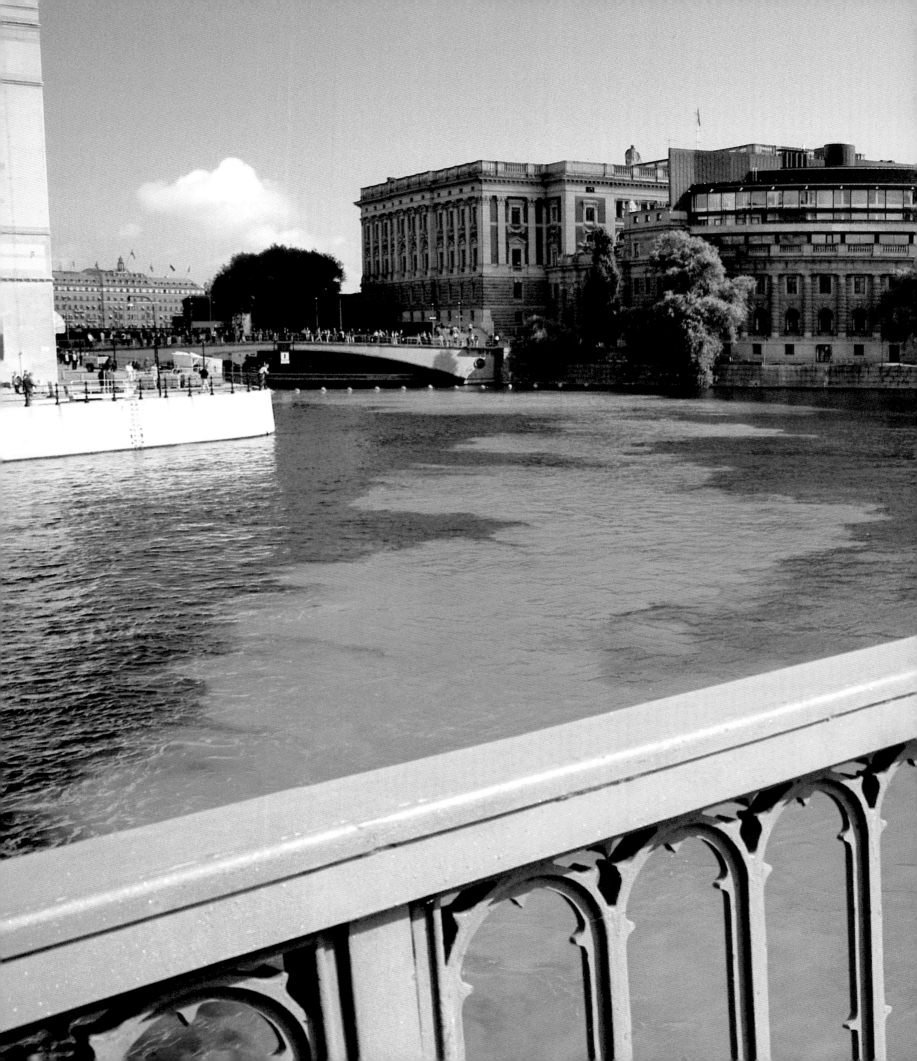

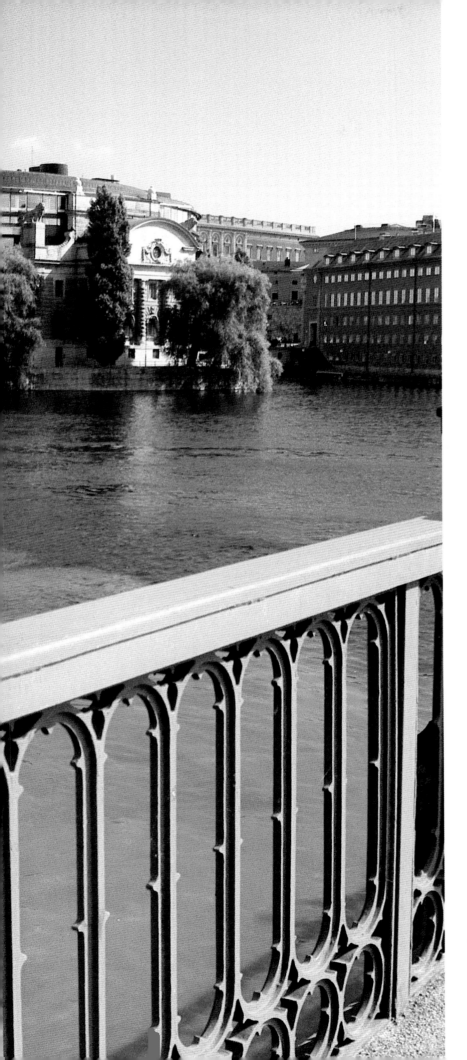

Green river
1998–
Green colour, water
Realization, Stockholm, 2000

it presents two distinct artistic dispositions towards the blurring of natural and artificial, the real and simulacra. It might be clarifying to call Antonioni modern and Eliasson postmodern, but that would be too easy, even if we still believed in such historicist categories. If Antonioni's *Red Desert* stands on the front edge of an emergent and, for Antonioni's generation, ominous hyperreality in which the natural and the artificial, the real and simulacra have exchanged essences and become two aspects of the same single substance, the work of Eliasson presents a more sanguine, even affirmative view of this condition. Eliasson does not see paradox and alienation in the liquid, coloured world that Antonioni artfully portrays at its dawn. On the contrary, he delights in creating simple, artificial ecologies of uncommon beauty, many of which rival the affective power of Antonioni's colourscapes, only without the *ennui*. Among the most powerful are the sensory microclimates of *The curious garden* (1997/2000), created by manipulating temperature and by employing a special artificial light, used on autobahns, that bleaches all colour from objects; the aptly titled *Beauty* (1993), a 'rainbow machine', as one critic astutely observed when it appeared in Los Angeles in 1999 as an off-site installation; and the evocative, though benign, fog-and-yellow-light outdoor installation *Yellow fog* (1998) at the Jewish Museum, New York.

It is green, however, that most strongly connects and simultaneously distinguishes Eliasson from Antonioni. Green is the most natural colour, the colour of progressive politics, environmentalists, and indeed, the colour of life itself. But in the hands of Eliasson, green undergoes a fundamental change. For the past several years he has exhibited an expanding photographic series entitled *Green river series* (1999). Shown in blocks, image by image, the series portrays a preternatural scene of startling beauty whose syntax is a liquid green effluvium that cascades over rocks creating waterfalls that glow with apparent toxicity; that overtakes as it pollutes with impunity small pools and eddies; that hangs like a poisonous cloud on the surface of larger bodies of water; and that, despite its effervescent glow, gives every appearance of a swarming, mutant life-form returning to the ocean from its fresh water spawning grounds. The images are exquisite and recall nothing so vividly as the petrochemical beauty of Antonioni's Ravenna. But unlike in the later's 'red desert', on Eliasson's 'green river' there is no anguish, no sense of alienation; there are, in fact, no people to be found at all. Unlike Antonioni's industrial desert, the post-industrial river is not

Green river
1998–
Green colour, water
Realization, Moss, Norway, 1999

reduced to a scenographic backdrop for character studies, nor is it the means by which grand narratives or fundamental truths are revealed. No ironic 'wink' signals a political, moral or ideological interpretation. The 'green river' is simply beautiful.

Green river designates not only a series of photographs but also series of environmental interventions that are the ostensible 'subject' of the photographs. In 1998 Eliasson began to introduce uranin, a non-toxic green dye used by naval forces to test ocean currents, into several rivers in Europe and America. Uranin, contrary to our natural image of green, emits a sickly, toxic glow. On 4 July 1998, as part of what would later become an exhibit at the Marc Foxx Gallery, Los Angeles, Eliasson introduced uranin into the Los Angeles River, the man-made concrete channel that snakes its way through the vast sectional expanse of the city, emptying finally into the Pacific Ocean near Long Beach. In appearance more freeway than river, populated by a variety of adaptive plant and animal species, site of chemical spills and movie car-chase scenes, the Los Angeles River is one of the most unnatural rivers imaginable. Eliasson's use of colour dye in this river site does not disclose a true reality but instead, as with Antonioni, artfully creates a reality that is more real than the real itself. Though uranin appears toxic, it is actually less toxic than the river water into which it is introduced, and with which it mixes. Artificial (non-toxic) dye commingles with natural (polluted) river water to form a new, hyperreal, 'green river' teaming with life. In the surrounds of this 'greened' river that flows with vigour only on occasion, there exists a vibrant ecosystem populated by a variety of new unnatural life forms – derelict and leisure-seeking human, mutant animal and plant, auto-machinic chemical and televisual – that are no less legitimate because they are not indigenous. Eliasson's introduction of uranin into

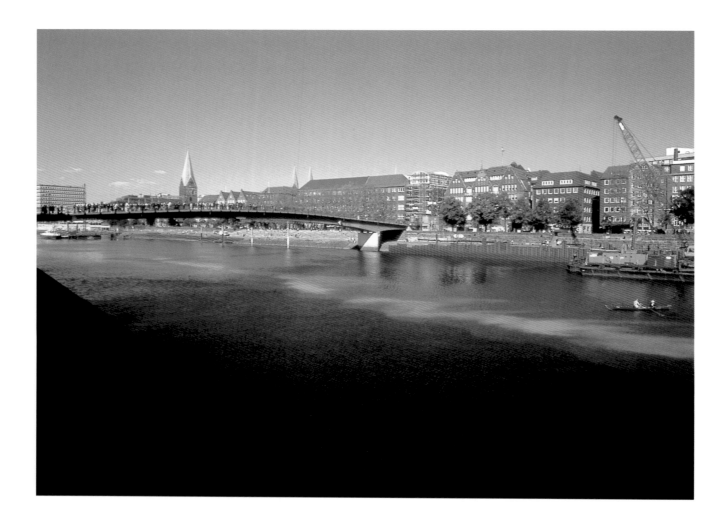

this unnatural river is ultimately transformative rather than additive. 'Greening' the Los Angeles River creates an event, a new 'green river' that is more Nietzschean experimentation than Marxian or Freudian interpretation. It does not make a political statement, nor does it moralize about its own artificiality or romanticize its history and subjugation to the needs of the metropolis. Instead, Eliasson's 'green river' brings into relief a hyperreality in which natural and artificial, real and simulacra have blurred one into the other.

Green river is both a photographic series and a series of environmental interventions. It also designates a 'greening' which encourages us to reconsider all our assumptions about the natural world. This greening connects Eliasson to an emergent artistic and intellectual disposition that embraces a super-ecological view wherein both natural and artificial are considered part of the same incomprehensibly complex ecosystem. One of the most notable examples of this disposition can be found in the architectural and cultural critic Reyner Banham's brilliant study Los Angeles: Architecture of Four Ecologies, which signalled in the 1970s an growing ecological approach to architecture and urbanism that argued, among

other things, for the collective intelligence of automobile traffic. Banham took the view that automobile traffic was a life form in the larger ecosystem of Los Angeles and that it seemed to organize itself in patterns and exhibit behaviour far more complex than any transportation planner with his computer models could imagine. More recent examples of this super-ecological approach can be found in Jane Jacobs' *The Nature of Economies* (2000) and Paul Hawken, Amory Lovins and L. Hunter Lovins' *Natural Capitalism* (1999), both of which argue for a new understanding of the relationship between natural and artificial, and between closed systems, which shut off the possibility for the development of new life, and open systems, which foster the emergence of new life.

This super-ecological view distinguishes Eliasson's work from his peers and from the clichéd view that critics often have of his work. Many have, in fact, focused a great deal of attention on Eliasson's own biography, and his portrayal of natural Icelandic beauty. One is led to infer that Eliasson is concerned principally with documenting and reproducing pristine, natural phenomena – rocks, light, water, vegetation – for exhibition in the commercial art market. On this view, Iceland is a figure or code for the authentic, and Eliasson's work compelling because it introduces authenticity into a gallery system saturated with inauthenticity. At another level, this is how many critics understand Eliasson's installations. They are devices, it is suggested, that allow us, the viewers, to see the world in a new way; to renew – in the language of Modernism – our perceptions. The focus is on human experience, on the phenomenological subject and its perceptions of a world from which it stands distinctly apart and which, consistent with Enlightenment thinking in general, it views as something to be conquered. Art is compelling to the extent that it allows the phenomenological subject to see the world objectively, as was Descartes' dream at the dawn of our modern period. Echoing Giuliana's exclamation in *Red Desert*, these critics seem to cry out: 'There is something *wonderful* about reality, and I don't know what.' Art, like Eliasson's, must reveal the truth of that 'what', and when it does, it is praised for renewing our perceptions and for giving us naive glimpses into the prelapsarian world of geysers, ice and light so reminiscent of the dream world into which Giuliana retreats to escape the hyperreal, colour-saturated world of Ravenna.

Eliasson's *Green river* can only be a disappointment to such critics and viewers, who, were they to look more carefully, would also be disappointed by Iceland, one of the most

Green river
1998–
Green colour, water
Realization, Bremen, 2000

wired and technologically sophisticated countries in the world. Antonioni creates in *Red Desert* a beautiful art environment yet one that is always subordinate to his characters who, almost by structural necessity, never become part of it. There is in all of his films a divide that separates characters from their external world. The phenomenological critic agrees that such a divide exists, but asks art to serve these characters, and us, by providing a more realistic, more authentic view of the external world so that we may better control and manipulate it. Enlightenment man remains at the centre of life. Eliasson asks that we instead understand art as an environment in and for itself, a pool or eddy connected to a river connected to an ocean connected to oceans. Art, like his wonderful *Moss wall* (1994), is a microclimate, not a reproduction of a real microclimate. We enter this microclimate not to be enlightened but to become part of it, to become literally an inhabitant. Thus *Your compound view* (1998), *Your windless arrangement* (1997) and *Your sun machine* (1997) name your inhabitation and connection to an environment and not your experience of an object that stands distinctly apart from you. It is as if in the *Green river* series Eliasson pulls the green Giuliana thread straight from Antonioni, liquefies and then serializes it, subordinating character, phenomenological subject, and mankind itself to another order of life. Like his other photographic series which feature caves, rocks and other natural formations, the *Green river* connects us to a hidden order, a natural intelligence revealed only when we view it in repetition, in series, an order that supersedes man's limited capacity to comprehend the complexity of the world he inhabits. It was the failure of Modernism, and of the Enlightenment from which it developed, to believe that any device, any technique, any art form could offer a total, comprehensive view. Many of us, like Giuliana, and like the phenomenological critic, see nature as a disordered chaos that we can and must conquer and bring to order. Accepting the futility of this Modernist dream, Eliasson's photographs and installations offer instead connection to a super-ecology where man is no longer in control, no longer the centre, but is instead one among many forms of intelligent life. Green, then, is more than coloured water, more than an event, more even than the wondrous micro-ecologies of moss, grass, light and smell. Green, in Eliasson's hands, is always a 'greening', a movement, a connection between colour and event, between one image and the next in series. Experimental movement along such series reveals an order that is never present all at once, never spatial, but which can only be experienced in the flow of time. Nietzsche,

Green river
1998–
Green colour, water
Realization, Los Angeles, 2000

Banham, Jacobs and Eliasson all prove that our world is as friendly to the empiricist experimenting with the relation between things as it is unfriendly to the rationalist intent on discovering the essence of things themselves. It is for you, however, to make such discoveries for yourself. That is, if you choose to travel your own path from your own red desert to your own green river.

1 Gilles Deleuze, in his brilliant two-volume study of the cinema, *Cinema 1: The Movement Image* (1983) and *Cinema 2: The Time Image* (1985), delineates a break that occurs after the Second World War with Italian Neo-realism in which the real and the imaginary, the subjective and the objective are no longer distinguishable. As he writes in *Cinema 2*, 'We run in fact into a principle of indeterminability, of indiscernability: we no longer know what is imaginary or real, physical or mental, in the situation, not because they are confused, but because we do not have to know and there is no longer even a place from which to ask.' It is precisely this world that Antonioni paints for us in the opening sequence, one in which people become flecks of colour and the landscape becomes a living thing.

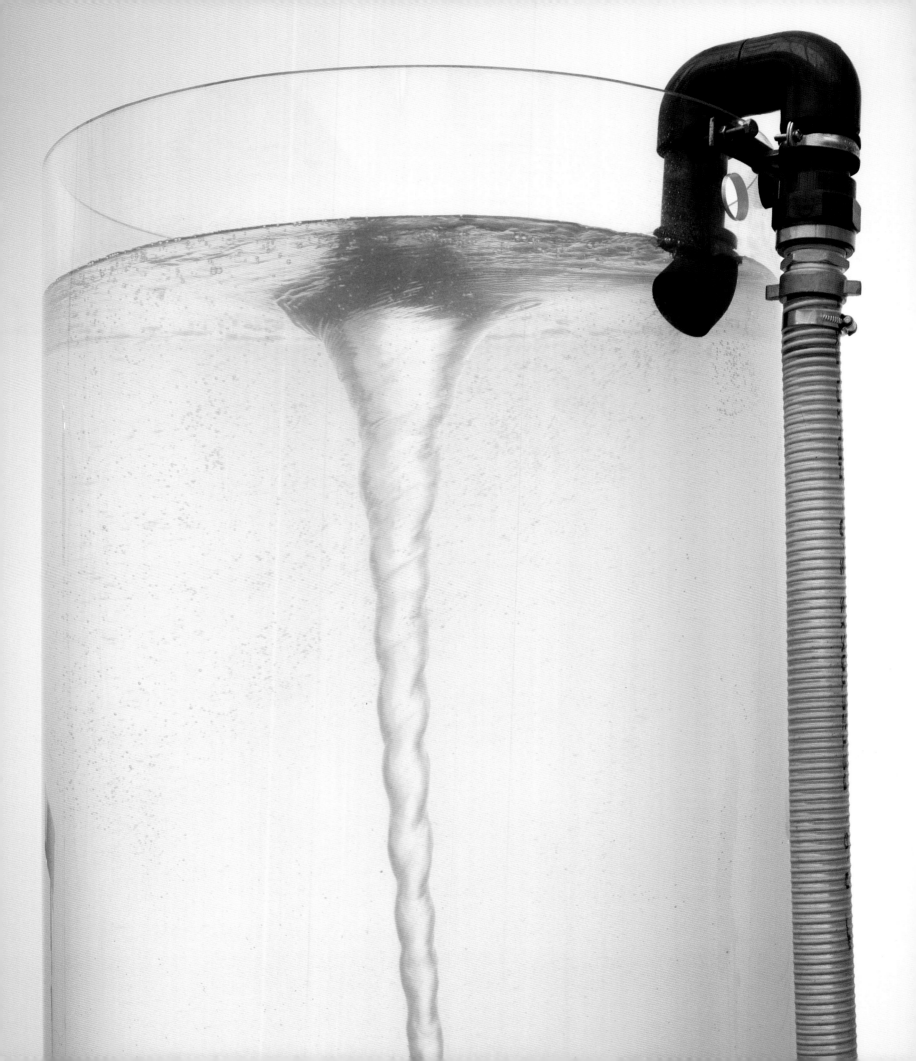

Contents

Your inverted veto
1998
Monofrequency light, flute light,
plastic
Dimensions variable
Installation, Tanya Bonakdar
Gallery, New York

[...] Two points are equally striking in an organ like the eye: the complexity of its structure and the simplicity of its function. The eye is composed of distinct parts, such as the sclerotic, the cornea, the retina, the crystalline lens, etc. In each of these parts the detail is infinite. The retina alone comprises three layers of nervous elements – multipolar cells, bipolar cells, visual cells – each of which has its individuality and is undoubtedly a very complicated organism: so complicated, indeed, is the retinal membrane in its intimate structure, that no simple description can give an adequate idea of it. The mechanism of the eye is, in short, composed of an infinity of mechanisms, all of extreme complexity. Yet vision is one simple fact. As soon as the eye opens, the visual act is effected. Just because the act is simple, the slightest negligence on the part of nature in the building of the infinitely complex machine would have made vision impossible. This contrast between the complexity of the organ and the unity of the function is what gives us pause.

A mechanistic theory is one which means to show us the gradual building-up of the machine under the influence of external circumstances intervening either directly by action on the tissues or indirectly by the selection of better-adapted ones. But, whatever form this theory may take, supposing it avails at all to explain the detail of the parts, it throws no light on their correlation.

Then comes the doctrine of finality, which says that the parts have been brought together on a preconceived plan with a view to a certain end. In this it likens the labour of nature to that of the workman, who also proceeds by the assemblage of parts with a view to the realization of an idea or the imitation of a model. Mechanism, here, reproaches finalism with its anthropomorphic character, and rightly. But it fails to see that itself proceeds according to this method – somewhat mutilated! True, it has got rid of the end pursued or the ideal model. But it also holds that nature has worked like a human being by bringing parts together, while a mere glance at the development of an embryo shows that life goes to work in a very different way. *Life does not proceed by the association and addition of elements, but by dissociation and division*.

We must get beyond both points of view, both mechanism and finalism being, at bottom, only standpoints to which the human mind has been led by considering the work of man. But in what direction can we go beyond them? We have said that in analyzing the structure of an organ, we can go on decomposing for ever, although the function of the whole is a simple thing. This contrast between the infinite complexity of the organ and the extreme simplicity of the function is what should open our eyes.

In general, when the same object appears in one aspect and in another as infinitely complex, the two aspects have by no means the same importance, or rather the same degree of reality. In such cases, the simplicity belongs to the object itself, and the infinite complexity to the views we take in turning around it, to the symbols by which our senses or intellect represent it to us, or, more generally, to elements *of a different order*, with which we try to imitate it artificially, but with which it remains incommensurable, being of a different nature. An artist of genius has painted a figure on his canvas. We can imitate his picture with many-coloured squares of mosaic. And we shall reproduce the curves and shades of the model so much the better as our squares are smaller, more numerous and more varied in tone. But an infinity of elements infinitely small, presenting an infinity of shades, would be necessary to obtain the exact equivalent of the figure that the artist has conceived as a simple thing, which he has wished to transport as a whole to the canvas, and which is the more complete the more it strikes us as the projection of an indivisible intuition. Now, suppose our eyes so made that they cannot help seeing in the work of the master a mosaic effect. Or suppose our intellect so made that it cannot explain the appearance of the figure on the canvas except as a work of mosaic. We should then be able to speak simply of a collection of little squares, and we should be under the mechanistic hypothesis. We might add that, beside the materiality of the collection, there must be a plan on which the artist worked; and then we should be expressing ourselves as finalists. But in neither case should we have got at the real process, for there are no squares brought together. It is the picture, i.e. the simple act, projected on the canvas, which, by the mere fact of entering into our perception, is decomposed before our eyes into thousands and thousands of little squares which present, as recomposed, a wonderful arrangement. So the eye, with its marvelous complexity of structure, may be only the simple act of vision,

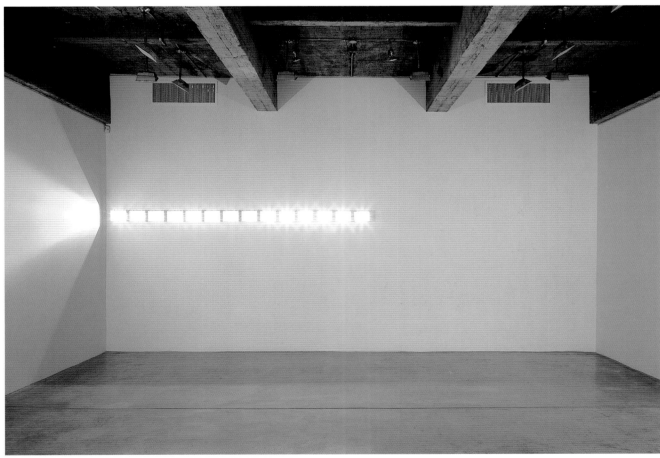

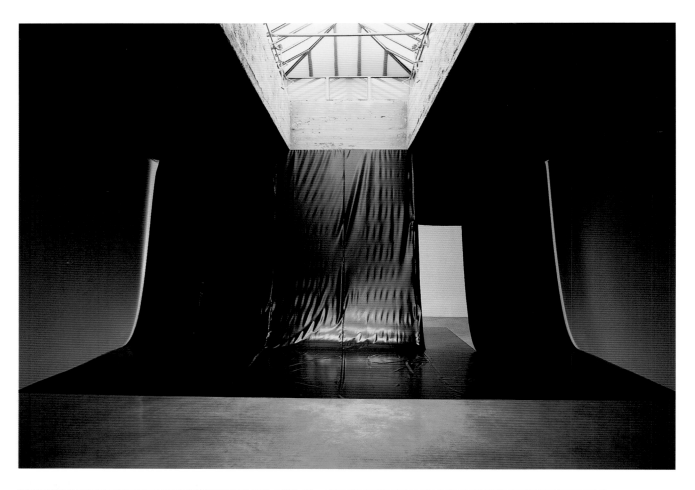

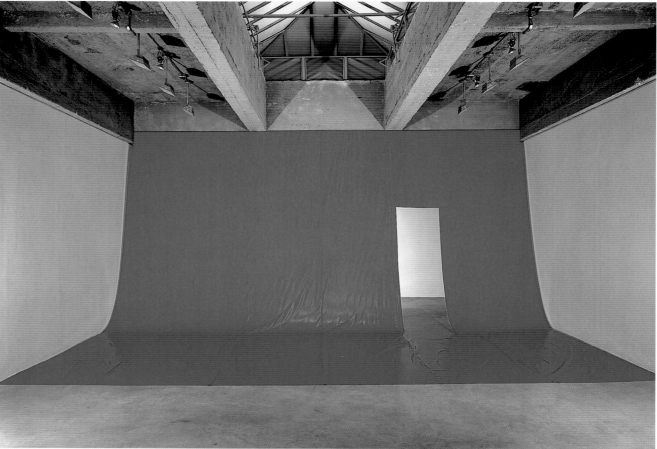

divided for us into a mosaic of cells, whose order seems marvelous to us because we have conceived the whole as an assemblage.

If I raise my hand from A to B, this movement appears to me under two aspects at once, Felt from within, it is a simple, indivisible act. Perceived from without, it is the course of a certain curve, AB. In this curve I can distinguish as many positions as I please and the line itself might be defined as a certain mutual co-ordination of these positions. But the positions, infinite in number, and the order in which they are connected, have sprung automatically from the indivisible act by which my hand has gone from A to B. Mechanism, here, would consist in seeing only the positions. Finalism would take their order into account. But both mechanism and finalism would leave on one side the movement, which is reality itself. In one sense, the movement is more than the positions and than their order; for it is sufficient to make it in its indivisible simplicity to secure that the infinity of the successive positions as also their order be given at once-with something else which is neither order nor position but which is essential, the mobility. But, in another sense, the movement is less than the series of positions and their connecting order; for, to arrange points in a certain order, it is necessary first to conceive the order and then to realize it with points, there must be the work of assemblage and there must be intelligence, whereas the simple movement of the hand contains nothing of either. It is not intelligent, in the human sense of the word, and it is not an assemblage, for it is not made up of elements. Just so with the relation of the eye to vision. There is in vision more than the component cells of the eye and their mutual co-ordination: in this sense, neither mechanism nor finalism go far enough. But, in another sense, mechanism and finalism both go too far, for they attribute to Nature the most formidable of the labors of Hercules in holding that she has exalted to the simple act of vision an infinity of infinitely complex elements, whereas Nature has had no more trouble in making an eye than I have in lifting my hand. Nature's simple act has divided itself automatically into an infinity of elements which are then found to be co-ordinated to one idea, just as the movement of my hand has dropped an infinity of points which are then found to satisfy one equation.

We find it very hard to see things in that light, because we cannot help conceiving organization as manufacturing. But it is one thing to manufacture, and quite another to organize. Manufacturing is peculiar to man. It consists in assembling parts of matter which we have cut out in such manner that we can fit them together and obtain from them a common action. The parts are arranged, so to speak, around the action as an ideal centre. To manufacture, therefore, is to work from the periphery to the centre, or, as the philosophers say, from the many to the one. Organization, on the contrary, works from the centre to the periphery. It begins in a point that is almost a mathematical point, and spreads around this point by concentric waves which go on enlarging. The work of manufacturing is the more effective, the greater the quantity of matter dealt with. It proceeds by concentration and compression. The organizing act, on the contrary, has something explosive about it: it needs at the beginning the smallest possible place, a minimum of matter, as if the organizing forces only entered space reluctantly. The spermatozoon, which sets in motion the evolutionary process of the embryonic life, is one of the smallest cells of the organism; and it is only a small part of the spermatozoon which really takes part in the operation. But these are only superficial differences. Digging beneath them, we think, a deeper difference would be found.

A manufactured thing delineates exactly the form of the work of manufacturing it. I mean that the manufacturer finds in his product exactly what he has put into it. If he is going to make a machine, he cuts out its pieces one by one and then puts them together: the machine, when made, will show both the pieces and their assemblage. The whole of the result represents the whole of the work; and to each part of the work corresponds a part of the result.

Now I recognize that positive science can and should proceed as if organization was like making a machine. Only so will it have any hold on organized bodies. For its object is not to show us the essence of things, but to furnish us with the best means of acting on them. Physics and chemistry are well advanced sciences, and living matter lends itself to our action only so far as we can treat it by the processes of our physics and chemistry. Organization can therefore only be studied scientifically if the

**Die organische und kristalline
Beschreibung**
1996
Lightprojector, wave effect-
machine, colour filter, convex
mirror
Dimensions variable
Installation, Neue Galerie am
Landesmuseum Joanneum, Graz,
Austria

organized body has first been likened to a machine. The cells will be the pieces of the machine, the organism their assemblage, and the elementary labours which have organized the parts will be regarded as the real elements of the labour which has organized the whole. This is the standpoint of science. Quite different, in our opinion, is that of philosophy.

For us, the whole of an organized machine may, strictly speaking, represent the whole of the organizing work (this is, however, only approximately true), yet the parts of the machine do not correspond to parts of the work, because *the materiality of this machine does not represent a sum of means employed, but a sum of obstacles avoided*: it is a negation rather than a positive reality. So, as we have shown in a former study, vision is a power which should attain *by right* an infinity of things inaccessible to our eyes. But such a vision would not be continued into action; it might suit a phantom, but not a living being. The vision of a living being is an *effective* vision, limited to objects on which the being can act: it is a vision that is *canalized*, and the visual apparatus simply symbolizes the work of canalizing. Therefore the creation of the visual apparatus is no more explained by the assembling of its anatomic elements than the digging of a canal could be explained by the heaping-up of the earth which might have formed its banks. A mechanistic theory would maintain that the earth had been brought cart-load by cart-load; finalism would add that it had not been dumped down at random, that the carters had followed a plan. But both theories would be mistaken, for the canal has been made in another way.

With greater precision, we may compare the process by which nature constructs an eye to the simple act by which we raise the hand. But we supposed at first that the hand met with no resistance. Let us now imagine that, instead of moving in air, the hand has to pass through iron filings which are compressed and offer resistance to it in proportion as it goes forward. At a certain moment the hand will have exhausted its effort, and, at this very moment, the filings will be massed and co-ordinated in a certain definite form, to wit, that of the hand that is stopped and of a part of the arm. Now, suppose that the hand and arm are invisible. Lookers-on will seek the reason of the arrangement in the filings themselves and in forces within the mass. Some will account for the position of each filing by the action exerted upon it by the neighbouring filings: these are the mechanists. Others will prefer to think that a plan of the whole has presided over the detail of these elementary actions. They are the finalists. But the truth is that there has been merely one indivisible act, that of the hand passing through the filings: the inexhaustible detail of the movement of the grains, as well as the order of their final arrangement, expresses negatively, in a way, this undivided movement, being the unitary form of a resistance, and not a synthesis of positive elementary actions. For this reason, if the arrangement of the grains is termed an 'effect' and the movement of the hand a 'cause', it may indeed be said that the whole of the effect is explained by the whole of the cause, but to parts of the cause parts of the effect will in no wise correspond. In other words, neither mechanism nor finalism will here be in place, and we must resort to an explanation of a different kind. Now, in the hypothesis we propose, the relation of vision to the visual apparatus would be very nearly that of the hand to the iron filings that follow, canalize and limit its motion.

The greater the effort of the hand, the farther it will go into the filings. But at whatever point it stops, instantaneously and automatically the filings co-ordinate and find their equilibrium. So with vision and its organ. According as the undivided act constituting vision advances more or less, the materiality of the organ is made of a more or less considerable number of mutually co-ordinated elements, but the order is necessarily complete and perfect. It could not be partial, because, once again, the real process which gives rise to it has no parts. That is what neither mechanism nor finalism takes into account, and it is what we also fail to consider when we wonder at the marvellous structure of an instrument such as the eye. At the bottom of our wondering is always this idea, that it would have been possible for *a part only* of this co-ordination to have been realized, that the complete realization is a kind of special favour. This favour the finalists consider as dispensed to them all at once, by the final cause; the mechanists claim to obtain it little by little, by the effect of natural selection; but both see something positive in this co-ordination, and consequently something fractionable in its cause – something which admits of every possible degree of achievement. In reality, the cause, though more or less intense, cannot produce its effect except in one piece, and c

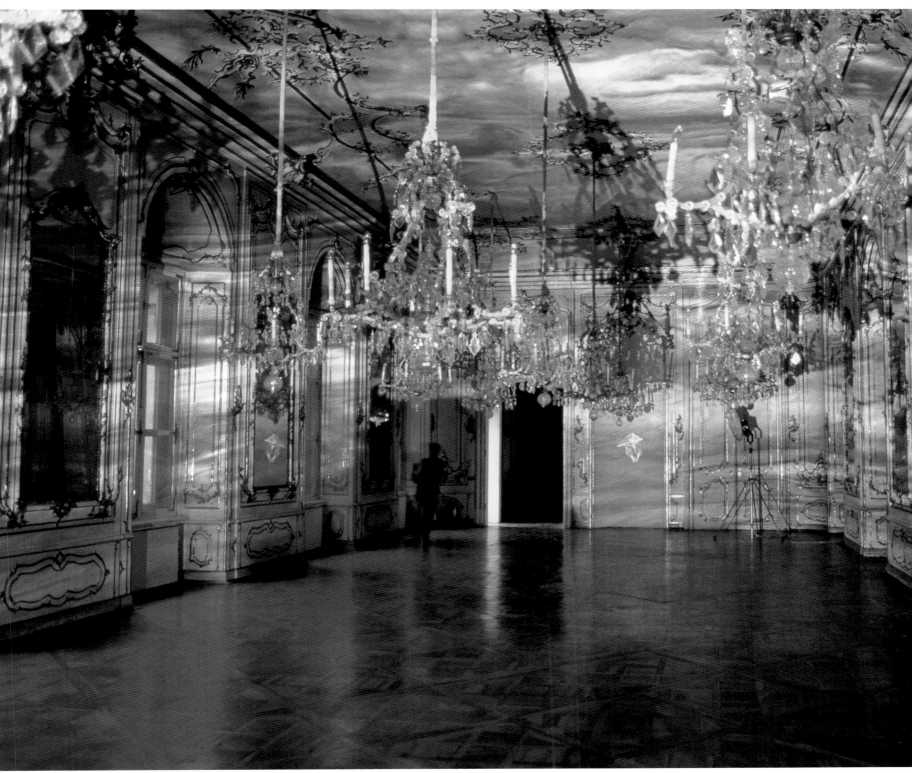

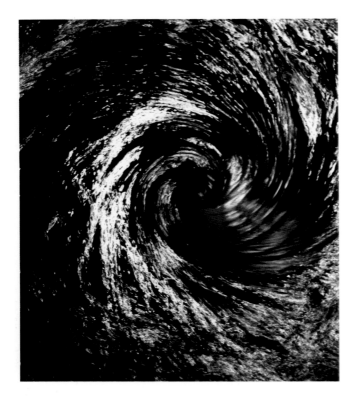

completely finished. According as it goes further and further in the direction of vision, it gives the simple pigmentary masses of a lower organism, or the rudimentary eye of a Serpula, or the slightly differentiated eye of the Alciope, or the marvellously perfected eye of the bird; but all these organs, unequal as is their complexity, necessarily present an equal co-ordination. For this reason, no matter how distant two animal species may be from each other, if the progress toward vision has gone equally far in both, there is the same visual organ in each case, for the form of the organ only expresses the degree in which the exercise of the function has been obtained.

But, in speaking of a progress toward vision, are we not coming back to the old notion of finality? It would be so, undoubtedly, if this progress required the conscious or unconscious idea of an end to be attained. But it is really effected in virtue of the original impetus of life; it is implied in the movement itself, and that is just why it is found in independent lines of evolution. If now we are asked why and how it is implied therein, we reply that life is, more than anything else, a tendency to act on inert matter. The direction of this action is not predetermined; hence the unforeseeable variety of forms which life, in evolving, sows along its path. But this action always presents, to some extent, the character of contingency; it implies at least a rudiment of choice. Now a choice involves the anticipatory idea of several possible actions. Possibilities of action must therefore be marked out for the living being before the action itself. Visual perception is nothing else: the visible outlines of bodies are the design of our eventual action on them. Vision will be found, therefore, in different degrees in the most diverse animals, and it will appear in the same complexity of structure wherever it has reached the same degree of intensity [...]

Translated by Arthur Mitchell

The inventive velocity
1998
100 x 84 x 84 cm
Pump, water, plastic container, hose
Installation, Tanya Bonakdar Gallery, New York

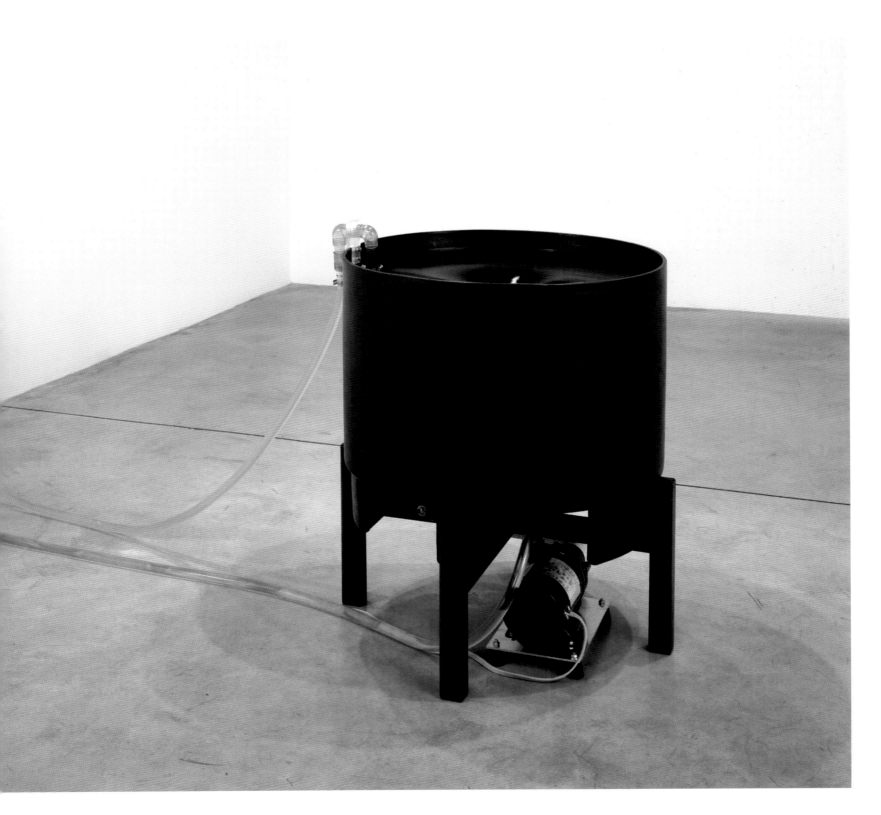

now/expectations

NU NU

Flod

NU

Bevisthed = $\overset{5}{\longrightarrow}$ (fortid)

~ fremtid

~ er fortid og fremtid

~ er "nu" i verden
└→present

= tilstedeværelse

land → tid

(landskab p...

nutid

pkt 1) Sted
2) Relatione
3) Differente = pr...
4) Rammer (home
└→ Brugeren

Frederik Jameson

Return of the Re...

AHA / Arman / = Re...

Cesay = Horsonth

Contents

'Hi there landscape!', I say, and look before me. In the foreground, a flat dark area with water or marshy spots, then a jump-wide stream delimits the small brown hills with knee-high birches. Behind them, more hills and more colours. A few small trees, but mostly moss. Further away, different light, higher slopes and more yellowy colours. Shadows from the mountains shade the valleys. Finally the mountains themselves, furthest away, bright with colour and lit by the sun, not that high but distinctly organized into a background panorama, fitting well under the white sky. 'Hi Olafur!', I decide the landscape answers.

By now I can tell approximately how far it is to the second row of hills, or to the mountains further away. I can estimate how much time and what effort it would take to go from here to there. I can tell if the water in the stream runs faster than I can walk, and whether by the time I get to the mountain the sun will be low, so it would have been better to walk up the western side of the mountain to enjoy the evening heat. If I want to take photos while walking up the mountain I should go up the eastern, shaded side, so that the landscape is lit from behind. I believe that at the foot of the mountains, not visible from here, there is a glacier river, which I would have to wade through. I don't look forward to the cold water, but I have some sense of where, and where not, to cross. If the river is too wide and deep to wade through, I imagine that further away, at the outspring, there is a small glacier tongue, and envisioning it (although I could be wrong) I can see the safest path up and down the ice, which offers the smallest crevices, and so forth.

I am not trying to advertise what little experience I have had over the years. In the hiking and trekking world I am an absolute novice and will probably remain one forever. What I want to say here is that after repeatedly visiting the same type of landscape, I have achieved a level of orientation. I can determine the approximate height of the hills and their slope, estimate how long it would take to get there, and try to use the weather to my benefit. With a cityscape, I can relate to the landscape not as an image, but as a space.

So what is it that I know? Is it nature? Nature as such has no 'real' essence – no truthful secrets to be revealed. I have not come closer to anything essential other than myself and, besides, isn't nature a cultural state anyway? What I have come to know better is my own relation to so-called nature (i.e., my capacity to orient myself in this particular space), my ability to see and sense and move through the landscapes around

Seeing yourself sensing
2001
Glass, mirror
Dimensions variable
Installation, 'Projects 73: Olafur
Eliasson', The Museum of Modern
Art, New York

opposite and following pages,
Seeing yourself sensing
2001
Glass, mirror
Dimensions variable
Installation, 'Projects 73: Olafur
Eliasson', The Museum of Modern
Art, New York

me. Looking at nature, I find nothing ... only my own relationship to the spaces, or aspects of my relationship to them. We see nature with cultivated eyes. Again, there is no truthful nature, there is only your and my construct of such. Just by looking at nature, we cultivate it into an image. You could call that image a landscape.

The museum presents itself to us as a place for art. For a while now it has been meaningless to speak of objective, autonomous conditions in the museum. This is not only vis-à-vis art objects, but also the exhibitions themselves and the museum's position in society more generally. As in many other fields, the acknowledgment of this has meant that the whole notion of orientation and observation has changed. Even in physics the subatomic particles can no longer be subjected to a causal description in time and space. Exercising the integration of the spectator, or rather, the spectating act itself, as part of the museum's undertaking has shifted the weight from the thing experienced to the experience itself. We stage the artefacts, but more importantly, we stage the way in which the artefacts are perceived. We cultivate nature into landscapes. So, to elude the museum's insistence that there is a nature (if you look hard enough for it), it is crucial not only to acknowledge that the experience itself is part of the process, but more importantly, that experience must be presented undisguised to the spectator. Otherwise, our ability to see ourselves seeing, to evaluate and criticize ourselves and our relation to space, has failed, and thus so has the museum's socializing potential.

The Museum of Modern Art in New York, one of the most highly esteemed museums in the world today, is at the moment partly a construction site. I would like to think of the awareness of this architectural intervention, including the construction site, as part of my project, and use this moment of megamuseomanic instability as an occasion for visitors to take their eyes off the museum and look back at themselves. Reverse the perspective: the museum as the subject, and the spectator, the object. Like a landscape, the museum is also a construct; in spite of its comprehensive and far-reaching role as a truthful myth, it can indeed have social potential. See yourself sensing.

Projects 73: Olafur Eliasson (brochure), The Museum of Modern Art, New York, 2001. Revised 2002.

your spiral view
2002
Steel
⌀ 320 cm, l. 800 cm
Installation, Fondation Beyeler,
Basel

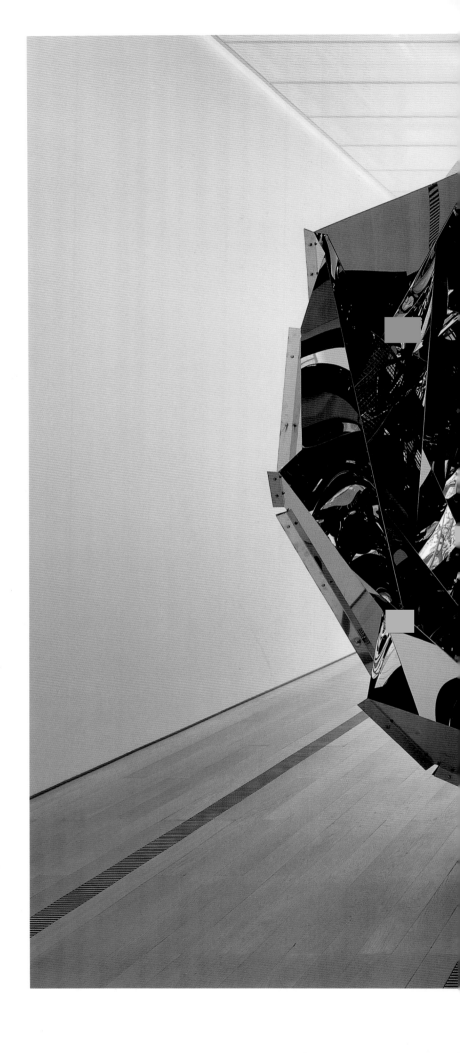

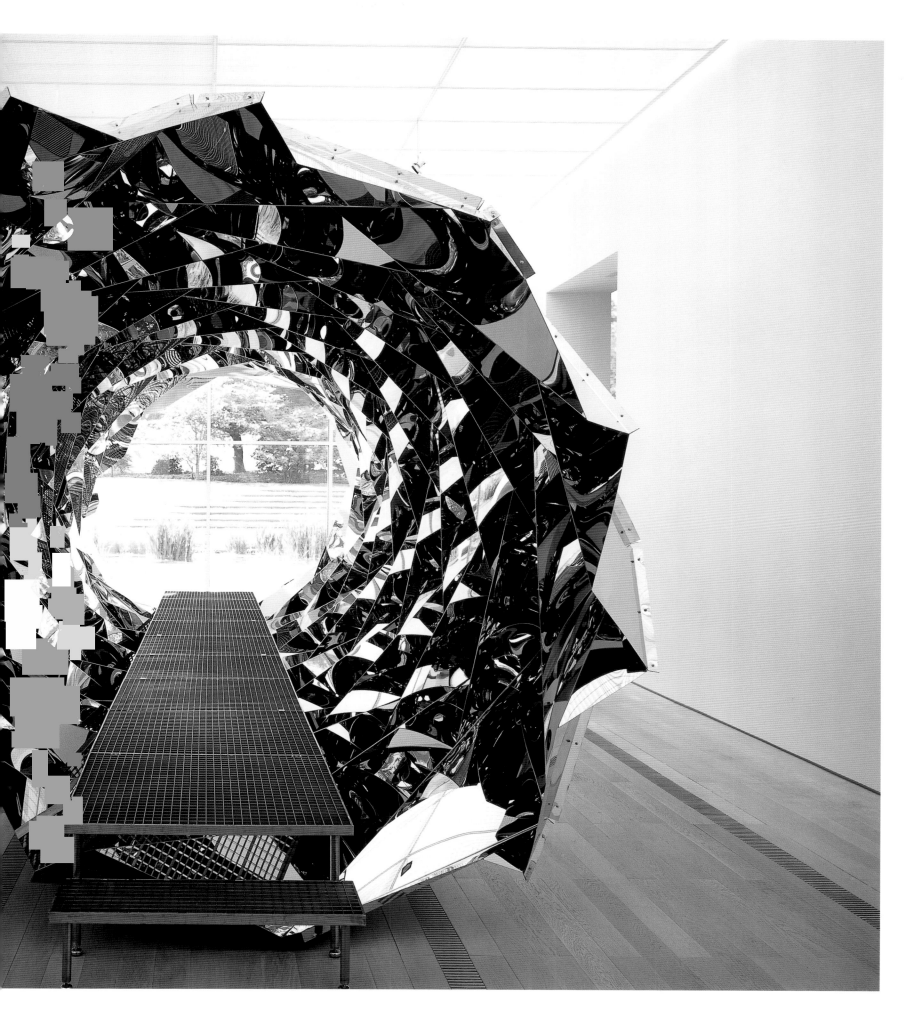

When I shine my lamp onto a white wall and then increase its brightness, this would doubtless be described as a change in the level of brightness – not as a change in the colour of the wall. This is so because, without thinking about it, we attribute the effect of change to its cause. Through a kind of representational perception, our experience is filtered and re-organized, and this determines our abillity to see and to sense. In my work called *Room for one color*, we actually see only one colour. The wavelength of the lights in the space is in the yellow area of the visible spectrum, resulting in the fact that all colours in the room submit to the yellow domain and organize themselves in the duotone scale from yellow to black. Like a black-and-white image with shades of grey in between, this yellow space organizes a green sweater and purple shoes into a monochrome field of shades from yellow to black. The experience of being in the monochrome space varies, of course, from one person to the next, but the most obvious impact of the yellow light is that a certain perception is acquired. We become aware of this representational filter and with that we acquire an abillity to see ourselves in a different light.

The experience of colour is a matter of cultivation. As much as our senses and perceptions are linked with memory and recognition, our relation to colour is closely derived from our cultural habitat. The Eskimos have one word for red but thirty for white. The colour white is now equated with cleanliness because lime, which is a disinfectant and was thrown into mass graves to prevent diseases, was also used in hospitals to whitewash and disinfect the walls. The Modernists believed that an open, clean, white space was the best platform for artistic self-realization. Imagine if lime had been yellow, rather than white. Perhaps the now-proverbial white-cube gallery would be yellow too. The Yellow Cube.

Even though one of our main, common intercultural constructions is the agreement about colour (time, however, being the all-time most important!), there is still a great deal of individual opinion about colour (unlike time). Colour has in its abstraction enormous psychological and associative potential, and even though this has been collectively cultivated to the extreme, individual differences in experiencing colours is extreme. Colour doesn't exist in itself, only when looked at. The fact that 'colour', uniquely, only materializes when light bounces off it into our retina indicates that analyzing colours is in fact about analyzing ourselves.

Symposium, 'Bridge the Gap: Science - Art - Humanity', Science Park Kitakyushu, Japan, 2001. Revised 2002.

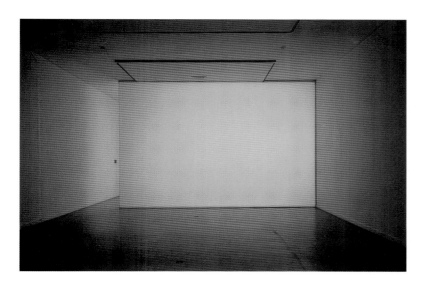
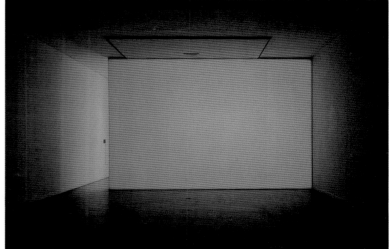
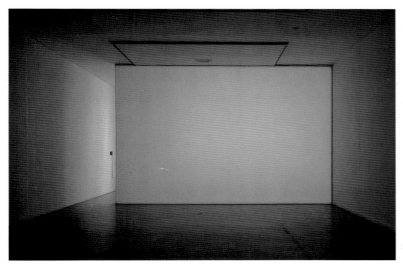
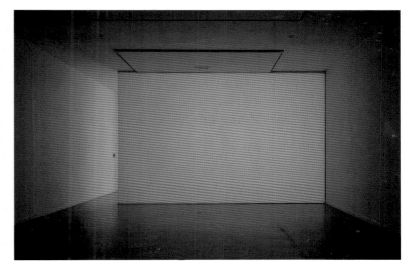

Room for all colours
1999
Lights, dimmer, control unit
Dimensions variable
Installation, Neue Galerie am
Landesmuseum Joanneum, Graz,
Austria

following pages, **Tell me about
your miraculous invention**
1996
Light, mirror, colour filter
Dimensions variable
Installation, De Appel,
Amsterdam

Dear Everybody 2001

The mediated motion (Water)
(with landscape architect, Günter
Vogt)
2001
Water, foil, wood, duck weed,
smog, compressed soil,
mushrooms
Installation, Kunsthaus Bregenz

Now the show is up. When you read this you will have most likely already walked
through each floor of the building. Before entering the exhibition, did you notice the
weather outside? If I were to tell you that the weather in Bregenz is a part of the
exhibition – an extra piece in the show – would you believe me? The question is not
whether I created the weather; in fact, I made nothing in this show – I only decided
what should be included and what shouldn't. In my desire to decide where the show
begins and ends, I realized (as always) that the question 'is the weather part of the
show?' is irrelevant, because I have no choice in the matter anyway. The weather will
always be part of the show, whether I want it to be or not – just as the show, in turn, is
part of the weather.

Of course this whole story started a long time ago, some time in the 1960s with the
end of objecthood in art, when art assumed its own autonomous existence. Since then,
an artist like myself has had to think about he location for art, in this case Peter
Zumthor's building at the Kunsthaus in Bregenz, which, like the weather, must now be
considered part of the show. This particular building makes an especially big point
about being there. Why? I don't know; I should ask Zumthor.

Dear Peter (assuming you understand that your building is now part of this
exhibition), I want to ask you about the people visiting this building (now reading this
text). What do you think happens when people occupy and move in these spaces? What
do they see ? Do they see themselves – sensing their own presence, activated through
their surroundings? Or do they forget themselves (and their bodies) because of the non-
reflecting surroundings?

A year ago, when I first started to think about this exhibition, such questions were
the first to emerge. It took me a while to understand that both possibilities – the
visitor's sense of self-presence, and the less fortunate scenario, forgetting yourself in
non-presence – seemed to exist in different conditions. When the visitor perceives the
building as an icon (of architecture), that is, as a static representational image of good
taste or an objectifying sacred hall, his or her engagement with the building is reduced
to the formal. The sense of self-presence is absorbed in a suspended narration of
knowledge – just as the visitor displaces his acknowledgment of the weather outside.
They are willing to relate and enter into dialogue with the building without bearing in
mind the most relevant component: duration, or time. The visitor's time – your time.

It takes a while to walk up to the third floor; to get there you must pass through
every single exhibition space in the building. Experiencing these spaces, moving

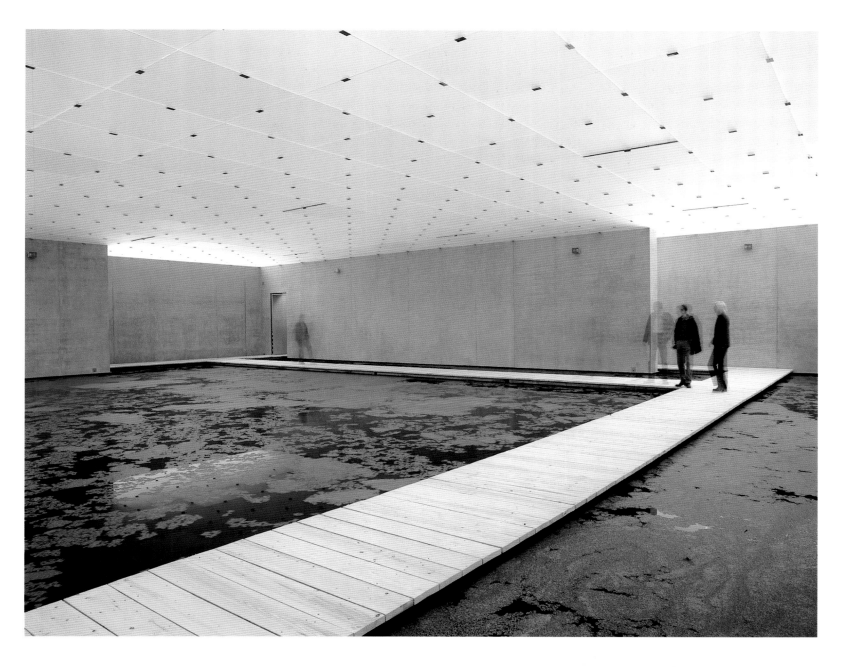

The mediated motion(with landscape architect, Günter Vogt)
2001
Water, foil, wood, duck weed, smog, compressed soil, mushrooms
Installation, Kunsthaus Bregenz
left, detail
following pages, left, top, **The mediated motion (earthfloor)**
following pages, left, bottom and right, **The mediated motion (bridge)**

through them, allows you to sense the passing of time, I believe, and allows you to sense your own presence – your having a body – when moving in and engaging with your surroundings. This sense is, eventually, what constitutes a space (and you in it).

In this idea I was happy to discover the key to how I should approach this exhibition. Movement. Motion: the component that enables you (and me) to see the building not as a totalitarian monolith but as a subjective, transparent construction. With this notion as my basis I could begin to think how I would make this exhibition; that is, what specific media could mediate this motion.

Mediating the motion: exposing and integrating our movements into the exhibition space in a way that enables you to sense what you know and to know what you sense.

Every movement has some level of mediation, or should I call it cultivation? Moving through a city or a landscape always implies a certain level of staging or mediation. Our city surroundings have been planned by others to mediate us. They take advantage of our memory to organize our expectations. Outdoor landscapes and city spaces have a long tradition of using movement to generate space. The city is mediated by issues of safety, eliminating surprises (traffic control) and creating predictable surroundings (shopping malls); the city's socializing potential is less predictable. Multipurpose surroundings let you enjoy the hospitality of the presence of others.

For the exhibition on the four floors at the Kunsthaus Bregenz I wanted to involve somebody experienced in cultivating motion. Understanding that the process behind the making of this show – like the weather and the Zumthor building – is inevitably part of the show, I chose to look for somebody experienced with working with outdoor spaces. This led me to landscape architect Günther Vogt and his studio, whose interdisciplinary collaborations use the nature of the city to engineer areas in which motion is essential.

The spaces are mediated with a garden-like structure, combining wood with mushrooms; a wooden *parcours* across a small pond filled with growing duckweed; a sloped plane of contaminated earth; and finally a smoky room with a hanging bridge. Each floor, with the stairs between them, presented a different platform on which to move. This is mediated motion.

The mediated motion: Olafur Eliasson, Kunsthaus Bregenz, 2001. Revised 2002.

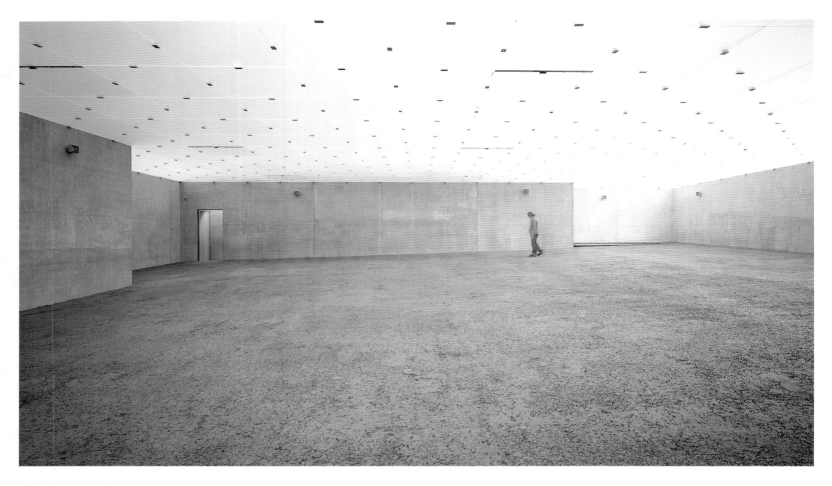

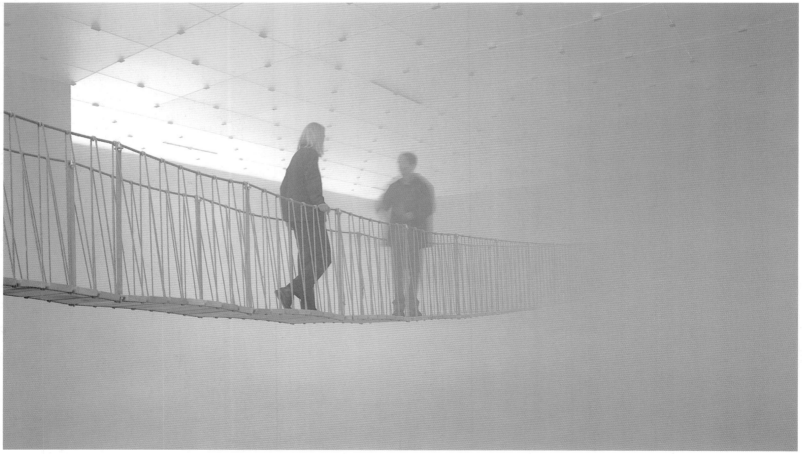

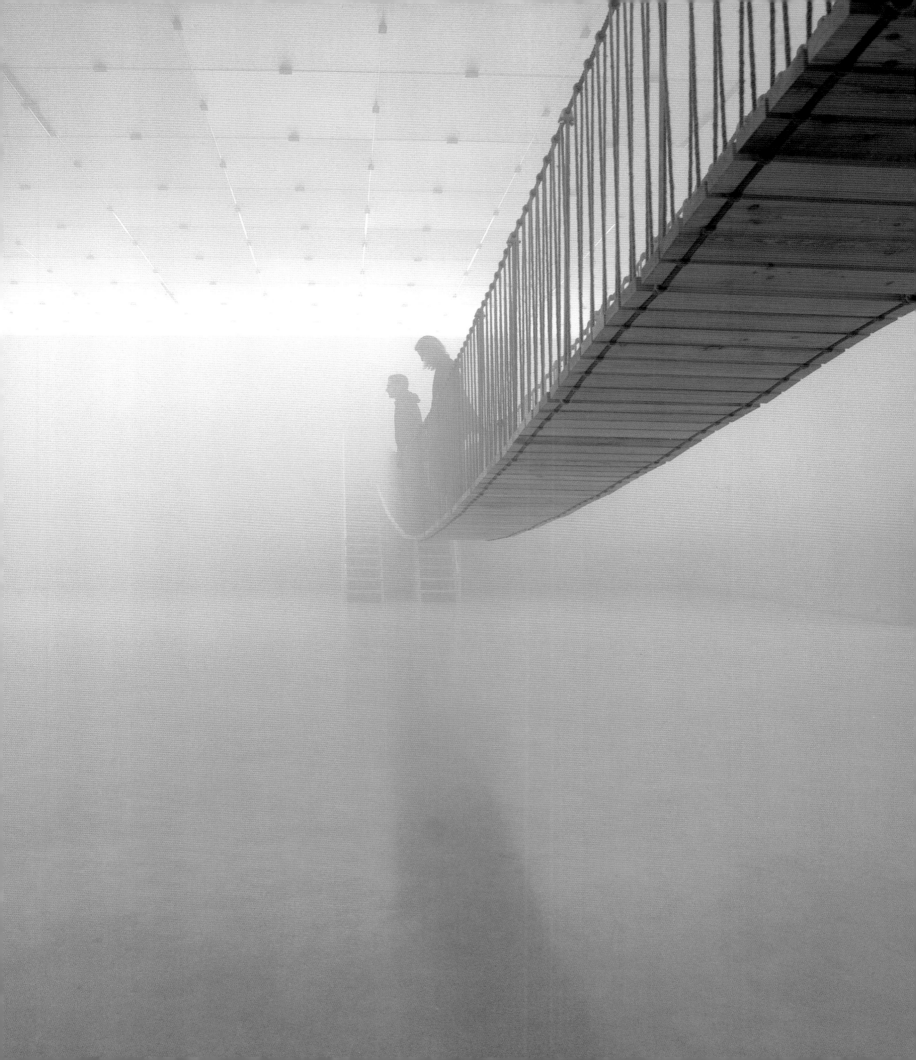

The Weather Forecast and Now 2001

Think with me about your extension of now.

'Now' has been stretched to last longer and longer. Unlike most animals, we (the human race) have the ability to link one moment to the next, creating our sensation of presence. Time flows continuously in a single motion, so to speak, with each moment naturally relating to the next. Edmund Husserl added that our expectations of the coming moment and the memory of the one just passed are all part of our sense of 'now'. If this were not the case, our remarkable ability to orient ourselves would probably not have developed to the extent that it has. Husserl's assumption was that 'now' can only be linked to a subject whose expectations and memory set the parameters of experience and orientation – in a space.

So, if you are still thinking with me, we can say that my understanding of 'our' time is necessarily within my 'own' time; my 'now' is inside yours, or, your 'now' is my surroundings (and vice versa). So, since our 'now' has been extended in time, a discussion about 'here' must follow, particularly with reference to spatial issues such as what constitutes our immediate surroundings.

The familiar 'now and here' (also known as 'nowhere') might just as well be 'now and there'. Since the subject moves around (in a space), there should be no doubt regarding our ability to orient ourselves not only in the near past and future, but also in the space we will enter in a moment – or that exists on a map of yesterday's activities. Our society is laid out to cope with this extended orientation, organized in accordance with principles of predictability (think, for example, of traffic safety). Our surroundings are organized to be moved in without necessarily just being 'here' or 'there' but rather with a sense of having come from up there, now being here, and soon being down there.

Imagine if we were only to orient ourselves in relation to a Barnett Newman painting. Our brain would work intermittently like a strobe lamp, and we would experience our world as an infinite number of suspended, static moments. This does not, as Newman assumed, bring you closer to some shared primordial state whilst maintaining your strange sense of certainty. In fact there is nothing 'real' outside us, only cultural constructs. Your time, my time – even Einstein's attempt to encapsulate us in objective time – was nothing but a then-practical way to cultivate our surroundings. It was practical in the sense that we now know time is gravitational, so that when standing on top of the world's tallest building, so-called time is one second longer in a

left and following pages, **Your position surrounded and your surroundings positioned**
1999
Installation, Dundee Contemporary Arts, Scotland

right, **The movement meter tower for Lernacken**
2000
Steel, light, colour spectrum
h. 12.63 m, ⌀ 4 m
Installation, Malmö, Sweden
Collection, City of Malmö, Sweden

hundred million years than when standing down in the street. The practicality of the collective cultivation of our surroundings is beyond discussion. Otherwise, we would be like Truman in the film *The Truman Show*, each living in our own separate reality.

So how long *is* 'now', and where does 'here' *end*? One frontier of 'now and here' is the weather forecast, with all its people and predictions. In feudal times meteorology was a matter of life and death. The prediction of the weather originated from a real need to prolong 'now' to include tomorrow's weather, taking our overly suspended reality for a joyride into the future. Like time travellers, weather predictions can draw a small part of the future back to be included in our cultivated sense of 'here and now'.

By turning farmers' needs into a science, the weather – the broadest of all sources of collective awarenesses – cultivates complexity and unpredictability. If anything is collective, it's the weather map; its only international competition is the rise and fall of the stock market. In the West, the significance of weather forecasts has decreased in proportion to the declining importance of an agricultural economy. On network newscasts, the stock-market report (often show immediately afterwards) has eaten its way into the ever-shortening, faster-spoken weather forecasts. The daily stock-market update followed by the weather forecast forms a perfect (time)frame of reference, informing us 'officially' that the recent past and the recent future belong to your now. The recent past (the daily state of the stock markets) and the immediate future (the prediction of the weather) form today's perfect collective, cultivated Now. 'Now' is eating calendar pages and digesting the upcoming weather into the daily dump of stock-market rates.

Cultivation of a collective sense of time and space works, as we can see, through representation. The weather forecast is our mediated experience thermostat letting us know if we are freezing and in which direction the wind is blowing. Through these representational layers, our immediate, tactile sensation of time and space ('now and here') is evacuated, replaced by TV and thermostats. This enables us to orient ourselves more productively as long as we are aware of the level of representation at work. Our sense of cold is activated by the temperature reading on the thermostat, not by a chill on the skin. Such mediations can be infinite; they only form a threat when you mistakenly believe that time and space are objective. Like when you are elsewhere and assume that you are here. Just like Truman.

Cabinet, No.3, Summer 2001, pp. 64-65. Revised 2002.

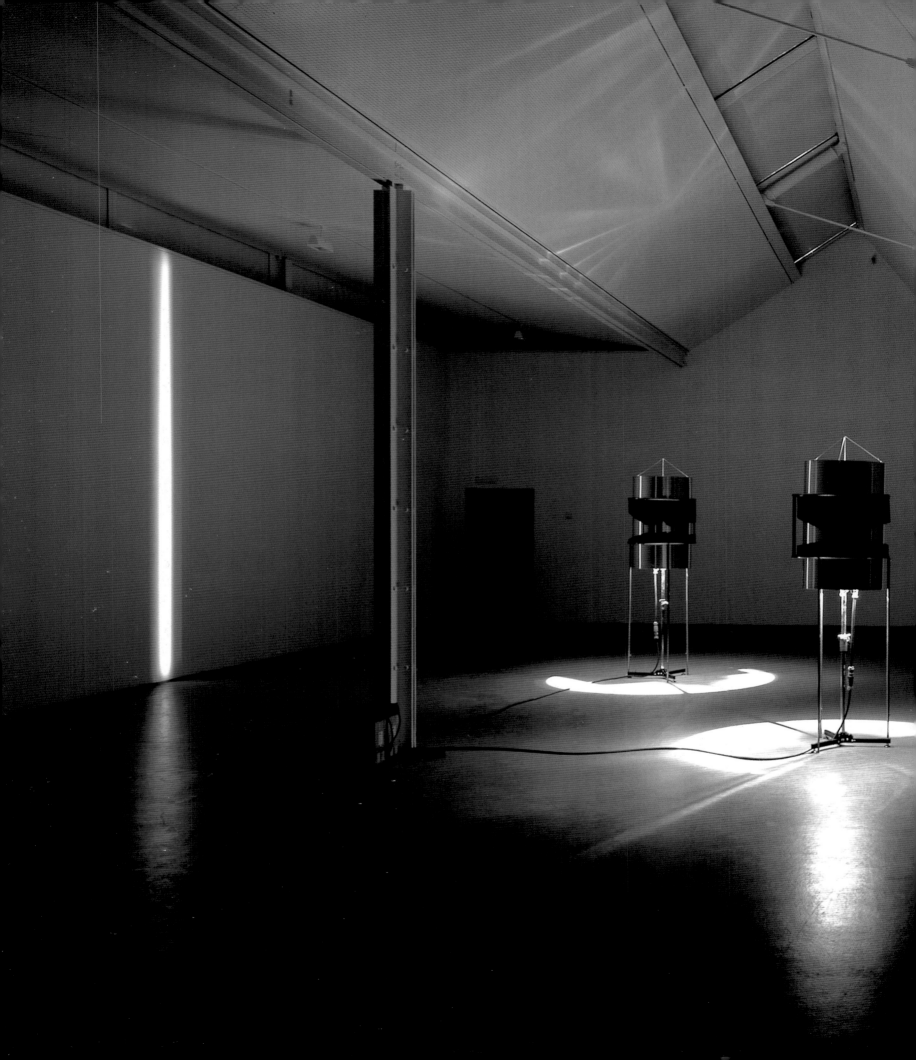

Contents

Selected exhibitions and projects
1989–94

1989
Studies, Royal Academy of Arts, Copenhagen

'Ventilator Projects',
Charlottenborg Konsthall, Copenhagen (group)

1990
Billboard project, 'Street Signs',
BIZART, Copenhagen (group)

Artist's project, '31 Days of News',
Krasnapolsky, Copenhagen

1991
Overgarden Galleri, Copenhagen (solo)

'Young Scandinavian Art',
Stalke Out of Space, Copenhagen (group)

1992
'Overdrive: 10 Young Nordic Artists',
Copenhagen (group)

'Lightworks'
Demonstrationslokalet for Kunst, Copenhagen
(group)

Billboard project, 'Paradise Europe',
Copenhagen (group)

Artist's project, 'Expectations',
Lichtprojekt, Copenhagen

1993
'1700 CET',
Stalke Out of Space, Copenhagen (group)

'Black Box',
GLOBE Kuratorengruppe, Copenhagen (group)

1994
Stalke Out of Space, Copenhagen (solo)

'Some People Remember Walking That Night',
Lukas & Hoffmann, Cologne (solo)

'No Days in Winter, No Nights in Summer',
Forumgallereit, Malmo (solo)

'Europa',
Ausstellung Münchner Galerien, Munich (group)

Artist's project, 'Beauty',
Regenbogen, Lukas & Hoffmann, Cologne

Selected articles and interviews
1989–94

Selected exhibitions and projects
1995–96

1995

'Beschreibung einer Reflexion oder aber eine
angenehme Übung zu deren Eigenschaften',
neugerriemschneider, Berlin (solo)

Künstlerhaus, Stuttgart (solo)

'Thoka',
Kunstverein, Hamburg (solo)

Tommy Lund Galerie, Odense, Denmark (solo)

'Landschaft',
MittelrheinMuseum, Koblenz, Haus am Waldsee,
Germany (group)

'Campo 95',
XLVI Venice Biennale
Corderie dell'arsenale, Venice, toured to **Fondazione
Sandretto Rebaudengo Per l'Arte**, Turin;
Konstmuseet, Malmo (group)
Cat. *Campo 95*, Fondazione Sandretto Rebaudengo per
l'arte, Turin, text Francesco Bonami

'Kunst & Ökologie',
Kunstverein Schloss Plön, Germany (group)

1996

'Your foresight endured',
Galleria Emi Fontana, Milan (solo)

'Your strange certainty still kept'
Tanya Bonakdar Gallery, New York (solo)

'Tell me about a miraculous invention',
Galeri Andreas Brändström, Stockholm (solo)

Kunstmuseet, Malmo (solo)

'Manifesta 1',
Rotterdam (group)
Cat. *Manifesta 1*, Idea Books, Amsterdam, texts Rosa
Martinez, et al.

'Glow: Sublime Projected and Reflected Light',
New Langton Arts, San Francisco (group)

Selected articles and interviews
1995–96

1995

Metzel, Tabea, 'Olafur Eliasson', *zitty*, No. 25, Berlin

1996

Bonami, Francesco, 'Olafur Eliasson', *Flash Art*, Milan,
May–June
Levin, Kim, 'Galleries', *Village Voice*, New York, May
Schneider, Christiane, 'Olafur Eliasson', *frieze*, London,
January–February
Smith, P.C., 'Olafur Eliasson at Tanya Bonakdar', *Art in
America*, New York, December
Smith, Roberta, 'Enter Youth, Quieter and Subtler',
New York Times, 17 May

Rapko, John, '"Glow" at New Langton Arts', *Artweek*,
San Jose, July

Selected exhibitions and projects
1996–97

'Prospect 96',
Kunstverein, Frankfurt (group)
Cat. *Prospect 96*, Edition Stemmle, Frankfurt, text
Peter Weiermair

'Alles was modern ist',
Galerie Bärbel Grässlin, Frankfurt (group)

'Provinz-Legende',
Samtidsmuseet in Roskilde, Denmark (group)

'Summer Show',
Tanya Bonakdar Gallery, New York (group)

'nach weimar',
Kunstsammlungen zu Weimar, Germany (group)
Cat. *nach weimar*, Hatje Cantz Verlag, Ostfildern, text
Rolf Bothe

'Remote Connections',
Neue Galerie, Graz, toured to **Wäino Aaltonen
Museum of Art**, Turku, Finland; **Artfocus**, Tel Aviv
(group)

'Views of Icelandic Nature',
Kjarvalsstadir Museum, Reykjavik (group)

'The Scream: Nordic Fine Arts 1995–96',
Arken Museum, Ishøj, Denmark (group)

'tolv',
Schaper Sundberg Gallery, Stockholm (group)

Artist's project, 'The Mukkepark Project',
Hvidovre, Copenhagen

1997
'Your sun machine',
Marc Foxx Gallery, Santa Monica (solo)

'The curious garden',
Kunsthalle, Basel (solo)

Stalke Out of Space, Copenhagen (solo)

'Sonnenfenster',
Kunsthalle Levyn, Vienna (solo)

'Heaven',
P.S. 1 Contemporary Art Center, New York (group)

Selected articles and interviews
1996–97

Herbstreuth, Peter, 'Schauder des Glücks', *Der
Tagesspiegel*, Berlin, 25 June

1997

Reust, Hans Rudolf, 'Reviews', *Artforum*, New York,
Summer

Selected exhibitions and projects
1997–98

'été 97',
Centre genevois de gravure contemporaine, Geneva
(group)

'Kunstpreis der Bottgerstraße in Bremen',
Kunstverein, Bonn (group)

'On life, beauty, translation and other difficulties',
5th International Istanbul Biennial (group)
Cat. *On life, beauty, translation and other difficulties:*
5th International Istanbul Biennial, texts Rosa
Martinez, et al.

Artist's project, *Erosion, Water-project*,
'Trade Routes: History and Geography',
2nd Johannesburg Biennale (group)
Cat. *Trade Routes: History and Geography*, 2nd
Johannesburg Biennale, texts Okwui Enwezor, et al.

'Truce: Echoes of Art in an Age of Endless Conclusions',
SITE Sante Fe, New Mexico (group)
Cat. *Truce: Echoes of Art in an Age of Endless*
Conclusions, SITE Sante Fe, New Mexico, texts
Francesco Bonami, Collier Schorr

'Alikeness',
Centre for Contemporary Photography, Fitzroy,
Austria (group)

'New Scandinavian Art',
Louisiana Museum, Humlebaek, Denmark (group)

'3rd Symposium on Visual Arts',
LANDART, Amos, Canada (group)

Vilnius Centre of Art, Lithuania (group)

'The Scream',
Borealis 8, Arken Museum, Copenhagen (group)

'Platser',
Public Space Projects, Stockholm (group)

Kunsthalle, Vienna (group)

'The Midnight Sun Show in Lofoten',
Lofoten, Norway (group)

Artist's project, 'Your windy corner',
Galleri Andreas Brändström, Stockholm

Artist's project, *The very large curve*,
Amos, Canada

Selected articles and interviews
1997–98

Mitchell, Charles Dee, 'Reports From Santa Fe: New
Narratives', *Art in America*, New York, November

Bonami, Francesco, 'Psychological atmospheres', *siksi*
No. 3, Helsinki, Autumn

Selected exhibitions and projects
1998

1998
Museum for Contemporary Art in Leipzig (solo)

neugerriemschneider, Berlin (solo)

'Tell me about a miraculous invention',
Arhus Kunstmusuem, Denmark (solo)

'Photoworks',
Bildmuseet, Umea, Sweden (solo)

'Aquarium',
Galerie Enja Wonnenberger, Kiel (solo)

Bonakdar Jancou Gallery, New York (solo)

Invitation card, Museum for Contemporary Art in Leipzig

Kjarvalstadir Museum, Reykjavik (solo)
Cat. *Olafur Eliasson*, Kjarvalstadir Museum, Reykjavik

Galerie Peter Kilchmann, Zurich (solo)

'Light x Eight: The Hanukkah Project',
The Jewish Musuem, New York (group)

'Auf der Spur',
Kunsthalle, Zurich (group)

'Sharawadgi',
Felsenvilla, Baden, Austria (group)

'The 7th Triennial of Contemporary Art: Cool Places',
Contemporary Art Centre, Vilnius, Lithuania (group)

'New Photography 14',
The Museum of Modern Art, New York (group)
Cat. *New Photography 14*, The Museum of Modern Art,
New York, text M. Darsie Alexander

'Round About Ways',
Ujazdowski Castle, Warsaw (group)

'The Edstrand Foundation Art Prize 1998',
Rooseum, Centre for Contemporary Art, Malmo
(group)

Invitation card,' The Edstrand Foundation Art Prize 1998',
Rooseum, Centre for Contemporary Art, Malmo

'The Erotic Sublime (Slave to the Rhythm)',
Galerie Thaddeus Ropac, Salzburg (group)

XXIV Bienal de São Paulo (group)
Cat. *XXIV Bienal de São Paulo*, Fundação Bienal de São
Paulo

Selected articles and interviews
1998

1998

Levin, Kim, 'Voice Choices: Short List', *Village Voice*,
New York, 2 June
Arning, Bill, 'Camera Shy', *Time Out*, New York, 19–26
November

OLAFUR ELIASSON
30 April – 4 June 1998
Reception Thursday 30 April from 6 to 8

BONAKDAR
JANCOU
GALLERY
521 WEST 21 STREET, NEW YORK, NY 10011
TEL 212 414 4144 FAX 212 414 1535
EMAIL BJGALLERY@AOL.COM

Fortes, Márica, 'XXIV São Paul Biennal', *frieze*, London,
January–February, 1999
Leffingwell, Edward, 'Report From São Paulo:
Cannibals All', *Art in America*, New York, May, 1999

Selected exhibitions and projects
1998

'Waterfall',
11th Sydney Biennial (group)
Cat. *Every Day, Catalog for the 11th Biennale of Sydney*,
Sydney, text Simon Grant

'Something is Rotten in the State of Denmark',
Fridericianum, Kassel (group)

'Brytningstider',
Norrkopings Konstmuseum, Sweden (group)

'StadtLandschaften',
Sabine Kunst Galerie & Edition, Munich (group)

'Pakkus: Momentum',
Nordic Festival of Contemporary Art, Moss, Norway
(group)

'La Ville, le jardin, la mémoire',
Villa Medici, Academie de France de Rome (group)

'Do All Oceans Have Walls?',
Kunstlerhaus, Bremen, Germany (group)

'Mai '98',
Kunsthalle Koln, Cologne (group)

'Transatlantico',
Centro Atlantico de Arte Moderno, Las Palmas, Canary
Islands (group)

'Nuit blanche, La jeune scène nordique',
Musée d'art moderne de la ville de Paris; toured to
Reykjavik Municipal Art Musuem; **Bergen
Billdegalleri**; **Porin Taidemuseo**, Finland; **Goteborg
Konstmuseum**, Sweden (group)
Cat. *Nuit blanche, La jeune scène nordique*, Musée d'art
moderne de la ville de Paris, texts Sophie Grélé, Carrie
Pilto, et al.

'Warming',
The Project, a space in Harlem, New York (group)

Invitation card, 'Warming', The Project, a space in Harlem,
New York

'Interferencias',
Museo de Arte Contemporaneo, Madrid (group)

'Seamless',
De Appel Foundation, Amsterdam (group)
Cat. *Seamless*, De Appel Foundation, Amsterdam, texts
Edna van Duyn, et al.

'Sightings: New Photographic Art',
Institute of Contemporary Arts, London (group)

'underground',
Copenhagen (group)

Selected articles and interviews
1998

MOSS, NORWAY MAY 23 - JUNE 21 1998

MOMENTUM
nordic festival of contemporary art

Berrebi, Sophie, 'Nuit Blanche, Musee d'art moderne
de la ville de Paris', *frieze*, London, May

Selected exhibitions and projects
1998–99

'Stalke Anniversary Show',
Stalke Out of Space, Copenhagen (group)
Artist's project, **Galerie Ingolsstraeti**, Reykjavik

Artist's project, 'Raum fur eine Farbe',
Kunsthalle, Bremen

Berlin Biennale
Cat. *Berlin Berlin*, Hatje Cantz Verlag, Ostfilern, texts
Mirjam Wiesel, Klaus Biesenbach, Hans Ulrich Obrist

1999
'Your position surrounded and your surroundings
positioned',
Dundee Contemporary Arts (solo)
Cat. *Your position surrounded and your surroundings
positioned*, Dundee Contemporary Arts, texts Katrina
Brown, Olafur Eliasson, Marianne Krogh Jensen, Katja
Sander, Jakob Jakobsen, Russell Ferguson

De Appel Foundation, Amsterdam
(solo, with Job Koelewijn)

Kunstverein, Frankfurt (solo)

Kunstverein, Wolfsburg, Germany (solo)

Marc Foxx Gallery, Santa Monica (solo)

Emi Fontane, Milan (solo)

Castello di Rivoli, Turin (solo)

Galleri Ingólfsstraeti, Reykjavik (solo)

Selected articles and interviews
1998–99

Cotter, Holland, 'Update on Berlin Since the Wall', *New
York Times*, 12 November
Eliasson, Olafur and Steiner, Barbara, 'Gegen die Zeit
gehen', *Kunst Bulletin*, Kriens, January–February
Hannula, Mika, 'Berliner Romanze', *Neue Bildende
Kunst*, No. 7, Berlin, December
Jensen, Marianne Krogh, 'Biennial, Art Fair and Danish
Initiatives in Berlin', *Newsletter from the Danish
Contemporary Art Foundation*, No. 2, November
Verwoert, Jan, 'Berlin Biennale', *frieze*, London,
January–February, 1999
Winkelmann, Jan, 'Project: Olafur Eliasson', *Art + Text*,
Sydney, February–April

Birnbaum, Daniel, 'Openings: Olafur Eliasson',
Artforum, New York, April
Grant, Simon, 'Olafur Eliasson: Poetry in Motion', *Tate:
The Art Magazine*, No.19, London, Winter
Haye, Christian, 'The Iceman Cometh', *frieze*, London,
May
Volk, Gregory, 'On the Edge; Olafur Eliasson: Fire and
Iceland', *ARTnews*, New York, April

1999

Giovedì 11 Febbraio 1999
ore 19,00

Olafur Eliasson
Riflessi di una certa importanza

Galleria Emi Fontana　Viale Bligny 42　20136 Milano　tel. 02.58322237　fax 02.58306855

Selected exhibitions and projects
1999

'Carnegie International 1999/2000',
Carnegie Museum of Art, Pittsburgh (group)
Cat. *Carnegie International 1999/2000*, Carnegie
Museum of Art, Pittsburgh, text Madeleine Grynsztejn

'Drawings',
Bonakdar Jancou Gallery, New York (group)

'Aperto'
48th Venice Biennale (group)
Cat. *Olafur Eliasson, Katalog zur Ausstellung
dAPERTutto*, Esposizione Internazionale d'Arte,
La Biennale di Venezia, text Marianne Krogh Jensen,
et al.

'To the People of the City of the Euro',
Kunstverein, Frankfurt (group)

'Photography: An Expanded View,
Recent Acquisitions',
Solomon R. Guggenheim Museum, New York (group)

'Landscape: Outside the Frame',
MIT List Visual Art Center, Cambridge, Massachusetts
(group)

Schöpfung, Diozesanmuseum, Freising, Germany
(group)

'Photography from the Martin Z. Margulies Collection',
Art Museum at Florida International University,
Miami (group)
Cat. *Photography from the Martin Z. Margulies
Collection,* Art Museum at Florida International
University

'Gegenwartskunst in Deutschland',
Kunstmuseum, Wolfsburg (group)

'Arte all' arte',
Arte Continua, San Gimignano, Italy (group)
Cat. *Arte all' arte*, Arte Continua, San Gimignano, Italy,
texts Jerome Sans, Pier Luigi Tazzi

'Sommerens mørke og lyse nætter',
Århus Kunstbygning, Denmark (group)

'Overflow',
Marianne Boesky Gallery, New York; **D'Amelio-Terras**,
New York; **Anton Kern Gallery**, New York (group)

'Panorama 2000',
Centraal Museum, Utrecht (group)

'Nest Stop',
Kustfestivalen, Lofoten, Norway (group)

Selected articles and interviews
1999

Potter, Chris, 'The Carnegie International explores
boundaries in a complicated world', *Pittsburgh City
Paper*, 3 November

Invitation card, 'Photography: An Expanded View, Recent Acquisitions', Solomon R. Guggenheim Museum, New York

Turner, Elisa, 'Photos Capture People Estranged from
Their Surroundings', *Miami Herald*, 10 January

Selected exhibitions and projects
1999–2000

2000

'Your now is my surroundings',
Bonakdar Jancou Gallery, New York (solo)

'Surroundings surrounded',
Neue Galerie Graz (solo)

Invitation card, 'Surroundings surrounded', Neue Galerie
Graz

'The only thing we have in common is that we are
different',
CCA, Kitakyushu, Japan (solo)

'Your orange afterimage exposed',
Gallery Koyanagi, Tokyo (solo)

'Your blue afterimage exposed',
Masataka Hayakawa Gallery, Tokyo (solo)

'The curious garden',
Irish Museum of Modern Art, Dublin (solo)

'Your intuitive surroundings versus your surrounded
intuition',
Art Institute of Chicago (solo)
Cat. *Your intuitive surroundings versus your surrounded
intuition*, Art Institute of Chicago, text James Rondeau

Kunstverein, Wolfsburg (solo)

International Artist's Studio Programme In Sweden,
Stockholm (solo)

Selected articles and interviews
1999–2000

Brenson, Michael; Grynsztejn, Madeliene, 'Fact and
Fiction', *Artforum*, New York, September
Birnbaum, Daniel; Nilsson, Peter, *Like Virginity, Once
Lost: Five Views on Nordic Art Now*, Propexus, Lund
Eller, Thomas E., 'Schön bunt hier', *Der Tagesspiegel*,
Berlin, 15 December
Shearing, Graham, 'Curator Reveals a Bold Theme',
Tribune Review, 28 November

2000

'Olafur Eliasson', *The New Yorker*, 20 November
Jowitt, Deborah, 'Merce's Major Events', *Village Voice*,
21 November
Smith, Roberta, 'Olafure Eliasson', *New York Times*,
November
'Olafur Eliasson, Your now is my surroundings', *Time
Out New York*, 16 November
Levin, Kim, 'Turning the Gallery Inside Out: Natural
Wonder', *Village Voice*, New York, 14 November

Wailand, Markus, 'Olafur Eliasson, Neue Galerie, Graz',
frieze, London
Juthady, Manisha, 'Olafur Eliasson, Neue Galerie Graz',
frame, July–August
Lübbke, Maren, 'Olafur Eliasson: Surrounding
Surrounded', *Camera Austria*, No. 71

Krogh Jensen, Marianne, 'Landscape as an Unwinding
Path', *Naoshima News*, Naoshima Contemporary Art
Museum, July
Akimoto, Yuji, 'Making a Place', *Naoshima News*'
Naoshima Contemporary Art Museum, No. 1

Invitation card, 'The curious garden', Irish Museum of Modern Art,
Dublin

Camper, Fred, 'Nature Containers', *Chicago Reader*, 4
August
Artner, Alan, 'Playing with Perception', *Chicago
Tribune*, 11 June
Hawkins, Margaret, 'Olafur Eliasson', *Chicago Sun-
Tribune*, 10 June

Selected exhibitions and projects
2000–01

Aldrich Museum of Contemporary Art, Ridgefield (solo)

'Preis der Nationalgalerie für junge Kunst',
Hamburger Bahnhof, Berlin (group)

'Raumkörper',
Kunsthalle Basel (group)
Cat. *Raumkörper, Netze und andere Gebilde*, Kunsthalle Basel, text Peter Pakesch

'Vision and Reality',
Louisiana Museum of Modern Art, Humlebaek, Denmark (group)
Cat. *Vision and Reality*, Louisiana Museum of Modern Art, Humlebaek, Denmark

'Photogravüre',
Niels Borch Jensen, Berlin (group)

'Wonderland',
Saint Louis Museum of Art (group)
Cat. *Wonderland*, Saint Louis Art Museum, text Rochelle Steiner

'Naust',
Oygarden, Norway (group)

'ForwArt',
BBL, Brussels (group)

'Over the edges',
Stedelijk Museum voor Actuele Kunst, Gent (group)

'The Greenhouse Effect',
Serpentine Gallery, London (group)

'Wanås 2000',
The Wanås Foundation, Knislinge, Sweden (group)

'Under the same sky',
Kiasma, Helsinki (group)

Selected articles and interviews
2000–01

Kuhn, Nicola, 'Bin ich Jesus? Habe ich Latschen?', *Der Tagesspiegel*, 8 December
Richter, Peter, 'Gewinnen ist auch eine Kunst', *Süddeutsche Zeitung*, 8 December
Meixner, Christiane, 'Kontemplative Baustelle', *Berliner Morgenpost*, 8 December
Müller, Kai 'Wir haben alles richtig gemacht' *Der Tagesspiegel*, 5 December

Invitation card, 'Preis der Nationalgalerie für junge Kunst', Hamburger Bahnhof, Berlin

Clancy, Luke, 'A room with a phew', *Evening Herald*, 17 January

Berg, Ronald, 'Wer wird Millionär?', *Zitty*, No. 20
Grasskamp, Walter, 'Kunst in der Stadt', *frame*, March–April
Groetz, Thomas, '100 000 Mark für junge Kunst', *art Das Kunstmagazin*, October
Hess, Barbara, 'Nase im Wind', *Texte zur Kunst*, September

Selected exhibitions and projects
2000–01

2001
Book, *my now is your surroundings: Olafur Eliasson*,
Verlag der Buchhandlung Walther König, Cologne

'The structural evolution project',
Mala galerija, Ljubljana (solo)

'Die Dinge, die du nicht siehst, die du nicht siehst',
neugerriemschneider, Berlin (solo)

'Olafur Eliasson: your only real thing is time',
Institute of Contemporary Art, Boston (solo)
Cat. *Olafur Eliasson: your only real thing is time*, Hatje
Cantz Verlag, Ostfildern-Ruit; Institute of
Contemporary Art, Boston, text Jessica Morgan

'Projects 73: Olafur Eliasson: Seeing yourself sensing',
The Museum of Modern Art, New York (solo)
Brochure, *Projects 73: Olafur Eliasson*, The Museum of
Modern Art, New York, text Roxana Marcoci, Claudia
Schmucki

'Surroundings surrounded',
Zentrum für Kunst und Medientechnologie,
Karlsruhe (solo)
Book, *Olafur Eliasson: Surroundings Surrounded*, Essays
on Space and Science, MIT Press, Cambridge,
Massachusetts, ed. Peter Weibel

'The mediated motion',
Kunsthaus Bregenz, Austria (solo)
Cat. *The mediated motion: Olafur Eliasson*, Verlag der
Buchhandlung Walther König, Cologne, texts Olafur
Eliasson, Maurice Merleau-Ponty, Andreas Spiegl,
Marianne Krogh Jensen, Rudolf Sagmeister

Artist's project, *The young land*,
Institute of Contemporary Art, Boston

Selected articles and interviews
2000–01

Jones, Kristin, 'Olafur Eliasson', *frieze*, London, May
Kunz, Sabine, 'Olafur Eliasson', *art Das kunstmagazine*,
Hamburg, March
Müller, Katrin Bettina, 'Gegen die Wand segeln', *die
Tageszeitung*, 26 September
Sandquist, Gertrud, 'Olafur Eliasson', *Afterall*, No. 2
Spiegl, Andreas, 'Olafur Eliasson, Non-Trueness as the
Nature of Theater', *Afterall*, No. 2
Wiensowski, Ingeborg, 'Olafur Eliasson', *Kultur Spiegel*,
April
'The iceman cometh', *i-D*, London, April

2001

Invitation card, 'The structural evolution project', Mala galerija, Ljubljana

Bers, Miriam, 'Berlin, from neo pop to crossculture',
Tema Celeste, Milan, January–February

Temin, Christine, 'Icelandic circles ring the ICA',
Boston Globe, 27 January
Silver, Joanne, 'Unnatural wonders', *Boston Herald*, 26
January
Sherman, Mary, 'Special effects: Olafur Eliasson brings
his versions of natural phenomena to the ICA', *Boston
Herald*, 6 February

Camhi, Leslie, 'And the Artist Recreated Nature (Or an
Illusion of It)', *New York Times*, 21 January
Richard, Frank, 'Olafur Eliasson', *Artforum*, New York,
January
Hurst, David, 'Olafur Eliasson', *Flash Art*, Milan,
January–February

Selected exhibitions and projects
2001–02

'Everything can be different',
organized by Independent Curators International,
New York (group)

'Aubette',
Museum Dhondt-Dhaenens, Deurle, Belgium (group)

'The Waste Land',
Atelier Augarten, Galerie Belvedere, Vienna, (group)

'Form follows fiction',
Castello di Rivoli, Turin (group)

'Confronting Nature',
Corcoran Gallery of Art, Washington, DC (group)

'En plein terre',
Museum für Gegenwartskunst, Basel (group)

'Palomino',
Galerie für zeitgenössische Kunst, Leipzig (group)

'Black Box',
Kunstmuseum, Bern (group)
Cat. *Black Box*, Kunstmuseum, Bern

'Vrai que Nature',
capc Musée d'art contemporain, Bordeaux (group)

'Freestyle: Werke aus der Sammlung Boros',
Museum Morsbroich, Leverkusen, Germany (group)
Cat. *Freestyle: Werke aus der Sammlung Boros*, Museum
Morsbroich, Leverkusen, Germany

'All-Terrain: An Exploration of Landscape and Place',
Contemporary Art Center of Virginia (group)

'New Work',
Tanya Bonakdar Gallery, New York (group)

2002
i8 gallery, Reykjavik (solo)

'Chaque matin je me sens différent, Chacque soir je me
sens le même',
Musée d'art moderne de la ville de Paris (solo)
Cat. *Chaque matin je me sens différent, Chacque soir je
me sens le même*, Musée d'art moderne de la ville de
Paris, texts Suzanne Pagé, d'Angeline Scherf, Yona
Friedman, Marianne Krogh Jensen, Sanford Kwinter,
Marco de Michelis, Hans Ulrich Obrist, Israël
Rosenfield, Luc Steels

Selected articles and interviews
2001–02

Chen, Aric, 'Spatial transcendence', *Dutch*,
March–April

2002

Selected exhibitions and projects
2001–02

Overgaden, Kulturministeriets Udstillingshus for
Nutidig Kunst, Copenhagen (solo)

'Claude Monet ... bis zum digitalen Impressionismus',
Fondation Beyeler, Basel (group)
Cat. *Claude Monet ... bis zum digitalen
Impressionismus*, Fondation Beyeler, Riehen, Basel,
texts Reinhold Hohl, Karin Sagner-Düchting, Hajo
Düchting, Philippe Büttner, Michael Leja, Michael
Lüthy, Markus Brüderlin, Verena Formanek.

'Thin Skin',
organized by Independent Curators International,
AXA Gallery, New York (group)

'From the Observatory',
Paula Cooper Gallery, New York (group)

'Next',
DO IT www.e-flux.com (group)

'New Work',
Tanya Bonakdar Gallery, New York (group)

2003
'Palacio Cristal',
Museo Reina Sofia, Madrid (solo)

Tate Modern, London (solo)

Kunstbau, Munich (solo)

Danish Pavilion,
50th Venice Biennale (group)

Selected articles and interviews
2001–02

Damianovic, Maia, 'Olafur Eliasson', *Tema Celeste*,
Milan, May–June
Troncy, Èric, 'Olafur Eliasson:Fait la pluie et le beau
temps', *Beaux Arts*, Paris, April
Sorbello, Marina, 'Olafur Eliasson', *Tema Celeste*, Milan,
January–February

Akimoto, Yuji, 'Making a Place', *Naoshima News'* Naoshima Contemporary Art Museum, No. 1, 2000

Arning, Bill, 'Camera Shy', *Time Out, New York*, 19–26 November, 1998

Artner, Alan, 'Playing with Perception', *Chicago Tribune*, 11 June, 2000

Berg, Ronald, 'Wer wird Millionär?', *Zitty*, No. 20, 2000

Berrebi, Sophie, 'Nuit Blanche, Musee d'art moderne de la ville de Paris', *frieze*, London, May, 1998

Bers, Miriam, 'Berlin, from neo pop to crossculture', *Tema Celeste*, Milan, January–February, 2001

Birnbaum, Daniel, 'Openings: Olafur Eliasson', *Artforum*, New York, April, 1998

Birnbaum, Daniel; Nilsson, Peter, *Like Virginity, Once Lost: Five Views on Nordic Art Now*, Propexus, Lund, 1999

Bonami, Francesco, 'Olafur Eliasson', *Flash Art*, Milan, May–June, 1996

Bonami, Francesco, 'Psychological atmospheres', *siksi* No. 3, Helsinki, Autumn, 1997

Bonami, Francesco, 'Olafur Eliasson', *Cream: Contemporary Art in Culture*, Phaidon Press, London, 1998

Brenson, Michael; Grynsztejn, Madeliene, 'Fact and Fiction', *Artforum*, New York, September, 1999

Brown, Katrina, *Your position surrounded and your surroundings positioned*, Dundee Contemporary Arts, 1999

Burkhard Riemschneider; Uta Grosenick, *Art at the Turn of the Millenium*, Taschen, 1999

Camhi, Leslie, 'And the Artist Recreated Nature (Or an Illusion of It)', *New York Times*, 21 January, 2001

Camper, Fred, ' Nature Containers', *Chicago Reader*, 4 August, 2000

Chen, Aric, 'Spatial transcendence', *Dutch*, March–April, 2001

Clancy, Luke, 'A room with a phew', *Evening Herald*, 17 January, 2000

Cotter, Holland, 'Update on Berlin Since the Wall', *New York Times*, 12 November, 1998

Damianovic, Maia, 'Olafur Eliasson', *Tema Celeste*, Milan, May–June, 2002

de Michelis, Marco, *Chaque matin je me sens différent, Chacque soir je me sens le même*, Musée d'art moderne de la ville de Paris, 2002

Eliasson, Olafur; Steiner, Barbara, 'Gegen die Zeit gehen', *Kunst Bulletin*, Kriens, January–February, 1998

Eliasson, Olafur, *Your position surrounded and your surroundings positioned*, Dundee Contemporary Arts, 1999

Eliasson, Olafur, *Your intuitive surroundings versus your surrounded intuition*, Art Institute of Chicago, 2000

Eliasson, Olafur, *Olafur Eliasson: Surroundings Surrounded, Essays on Space and Science*, MIT Press, Cambridge, Massachusetts, 2001

Eliasson, Olafur, *Olafur Eliasson: your only real thing is time*, Hatje Cantz Verlag, Ostfildern-Ruit; Institute of Contemporary Art, Boston, 2001

Eliasson, Olafur, *The mediated motion: Olafur Eliasson*, Verlag der Buchhandlung Walther König, Cologne, 2001

Eliasson, Olafur, *my now is your surroundings: Olafur Eliasson*, Verlag der Buchhandlung Walther König, Cologne, 2001

Eliasson, Olafur, *Chaque matin je me sens différent, Chacque soir je me sens le même*, Musée d'art moderne de la ville de Paris, 2002

Eller, Thomas E., 'Schön bunt hier', *Der Tagesspiegel*, Berlin, 15 December, 1999

Ferguson, Russell, *Your position surrounded and your surroundings positioned*, Dundee Contemporary Arts, 1999

Fortes, Márica, 'XXIV São Paul Biennal', *frieze*, London, January–February, 1999

Friedman, Yona, *Chaque matin je me sens différent, Chacque soir je me sens le même*, Musée d'art moderne de la ville de Paris, 2002

Grant, Simon, 'Olafur Eliasson: Poetry in Motion', *Tate: The Art Magazine*, No.19, London, Winter, 1998

Grasskamp, Walter, 'Kunst in der Stadt', *frame*, March–April, 2000

Groetz, Thomas, '100 000 Mark für junge Kunst', *art Das Kunstmagazin*, October, 2000

Hannula, Mika, 'Berliner Romanze', *Neue Bildende Kunst*, No. 7, Berlin, December, 1998

Hawkins, Margaret, 'Olafur Eliasson', *Chicago Sun-Tribune*, 10 June, 2000

Haye, Christian, 'The Iceman Cometh', *frieze*, London, May, 1998

Herbstreuth, Peter, 'Schauder des Glücks', *Der Tagesspiegel*, Berlin, 25 June, 1996

Hess, Barbara, 'Nase im Wind', *Texte zur Kunst*, September, 2000

Hurst, David, 'Olafur Eliasson', *Flash Art*, Milan, January–February, 2001

Jakobsen, Jakob, *Your position surrounded and your surroundings positioned*, Dundee Contemporary Arts, 1999

Jensen, Marianne Krogh, 'Biennial, Art Fair and Danish Initiatives in Berlin', *Newsletter from the Danish Contemporary Art Foundation*, No. 2, November, 1998

Jensen, Marianne Krogh, *Your position surrounded and your surroundings positioned*, Dundee Contemporary Arts, 1999

Jensen, Marianne Krogh, 'Landscape as an Unwinding Path', *Naoshima News*, Naoshima Contemporary Art Museum, July, 2000

Jensen, Marianne Krogh, *Chaque matin je me sens différent, Chacque soir je me sens le même*, Musée d'art moderne de la ville de Paris, 2002

Jensen, Marianne Krogh, *The mediated motion: Olafur Eliasson*, Verlag der Buchhandlung Walther König, Cologne, 2001

Jones, Kristin, 'Olafur Eliasson', *frieze*, London, May, 2000

Jowitt, Deborah, 'Merce's Major Events', *Village Voice*, 21 November, 2000

Juthady, Manisha, 'Olafur Eliasson, Neue Galerie Graz', *frame*, July–August, 2000

Kuhn, Nicola, 'Bin ich Jesus? Habe ich Latschen?', *Der Tagesspiegel*, 8 December, 2000

Kunz, Sabine, 'Olafur Eliasson', *art Das kunstmagazine*, Hamburg, March, 2000

Kwinter, Sanford, *Chaque matin je me sens différent, Chacque soir je me sens le même*, Musée d'art moderne de la ville de Paris, 2002

Leffingwell, Edward, 'Report From São Paulo: Cannibals All', *Art in America*, New York, May, 1999

Levin, Kim, 'Galleries', *Village Voice*, New York, May, 1996

Levin, Kim, 'Voice Choices: Short List', *Village Voice*, New York, 2 June, 1998

Levin, Kim, 'Turning the Gallery Inside Out: Natural Wonder', *Village Voice*, New York, 14 November, 2000

Lübbke, Maren, 'Olafur Eliasson: Surrounding Surrounded', *Camera Austria*, No. 71, 2000

Marcoci, Roxana; Murphy, Diana; Sinaiko, Eve (eds.) *New Art*, Harry N. Abrams, Inc., New York, 1997

Marcoci, Roxana, *Projects 73: Olafur Eliasson*, The Museum of Modern Art, New York, 2001

Meixner, Christiane, 'Kontemplative Baustelle', *Berliner Morgenpost*, 8 December, 2000

Metzel, Tabea, 'Olafur Eliasson', *zitty*, No. 25, Berlin, 1995

Mitchell, Charles Dee, 'Reports From Santa Fe: New Narratives', *Art in America*, New York, November, 1997

Morgan, Jessica, *Olafur Eliasson: your only real thing is time*, Hatje Cantz Verlag, Ostfildern-Ruit; Institute of Contemporary Art, Boston, 2001

Müller, Kai, 'Wir haben alles richtig gemacht' *Der Tagesspiegel*, 5 December, 2000

Müller, Katrin Bettina, 'Gegen die Wand segeln', *die Tageszeitung*, 26 September, 2000

Obrist, Hans Ulrich, *Chaque matin je me sens différent, Chacque soir je me sens le même*, Musée d'art moderne de la ville de Paris, 2002

Pagé, Suzanne, *Chaque matin je me sens différent, Chacque soir je me sens le même*, Musée d'art moderne de la ville de Paris, 2002

Potter, Chris, 'The Carnegie International explores boundaries in a complicated world', *Pittsburgh City Paper*, 3 November, 1999

Rapko, John, '"Glow" at New Langton Arts', *Artweek*, San Jose, July, 1996

Reust, Hans Rudolf, 'Reviews', *Artforum*, New York, Summer, 1997

Richard, Frank, 'Olafur Eliasson', *Artforum*, New York, January, 2001

Richter, Peter, 'Gewinnen ist auch eine Kunst', Süddeutsche Zeitung, 8 December, 2000

Rondeau, James, *Your intuitive surroundings versus your surrounded intuition*, Art Institute of Chicago, 2000

Rosenfield, Israël, *Chaque matin je me sens différent, Chacque soir je me sens le même*, Musée d'art moderne de la ville de Paris, 2002

Sagmeister, Rudolf, *The mediated motion: Olafur Eliasson*, Verlag der Buchhandlung Walther König, Cologne, 2001

Sander, Katja, *Your position surrounded and your surroundings positioned*, Dundee Contemporary Arts, 1999

Sandquist, Gertrud, 'Olafur Eliasson', *Afterall*, No. 2, 2000

Scherf, d'Angeline, *Chaque matin je me sens différent, Chacque soir je me sens le même*, Musée d'art moderne de la ville de Paris, 2002

Schmucki, Claudia, *Projects 73: Olafur Eliasson*, The Museum of Modern Art, New York, 2001

Schneider, Christiane, 'Olafur Eliasson', *frieze*, London, January–February, 1996

Shearing, Graham, 'Curator Reveals a Bold Theme', *Tribune Review*, 28 November, 1999

Sherman, Mary, 'Special effects: Olafur Eliasson brings his versions of natural phenomena to the ICA', *Boston Herald*, 6 February, 2001

Silver, Joanne, 'Unnatural wonders', *Boston Herald*, 26 January, 2001

Smith, P.C., 'Olafur Eliasson at Tanya Bonakdar', *Art in America*, New York, December, 1996

Smith, Roberta, 'Enter Youth, Quieter and Subtler', *New York Times*, 17 May, 1996

Smith, Roberta, 'Olafur Eliasson', *New York Times*, November, 2000

Sorbello, Marina, 'Olafur Eliasson', *Tema Celeste*, Milan, January–February, 2002

Spiegl, Andreas, 'Olafur Eliasson, Non-Trueness as the Nature of Theater', *Afterall*, No. 2, 2000

Spiegl, Andreas, *The mediated motion: Olafur Eliasson*, Verlag der Buchhandlung Walther König, Cologne, 2001

Steels, Luc, *Chaque matin je me sens différent, Chacque soir je me sens le même*, Musée d'art moderne de la ville de Paris, 2002

Temin, Christine, 'Icelandic circles ring the ICA', *Boston Globe*, 27 January, 2001

Troncy, Èric, 'Olafur Eliasson:Fait la pluie et le beau temps', *Beaux Arts*, Paris, April, 2002

Turner, Elisa, 'Photos Capture People Estranged from Their Surroundings', *Miami Herald*, 10 January, 1999

Verwoert, Jan, 'Berlin Biennale', *frieze*, London, January–February, 1999

Volk, Gregory, 'On the Edge; Olafur Eliasson: Fire and Iceland', *ARTnews*, New York, April, 1998

Wailand, Markus, 'Olafur Eliassom, Neue Galerie, Graz', *frieze*, London, 2000

Weibel, Peter (ed.), *Olafur Eliasson: Surroundings Surrounded, Essays on Space and Science*, MIT Press, Cambridge, Massachusetts, 2001

Wiensowski, Ingeborg, 'Olafur Eliasson', *Kultur Spiegel*, April, 2000

Winkelmann, Jan, 'Project: Olafur Eliasson', *Art + Text*, Sydney, February–April, 1998

Public collections

Albright-Knox Art Gallery,
Buffalo, New York
Middlebury College Museum of
Art, Middlebury, Vermont
Walker Art Center, Minneapolis
Art Institute of Chicago
Carnegie Museum of Art,
Pittsburgh, Pennsylvania
Deste Foundation, Athens
National Gallery of Iceland,
Reykjavik
Lannan Foundation, Santa Fe,
New Mexico
Museum of Contemporary Art, Los
Aangeles
Solomon R. Guggenheim Museum,
New York
Jumex Collection, Mexico City
Saint Louis Museum of Art
Centro Atlantico de Arte Moderno,
Las Palmas de Gran Canaria, Spain
San Francisco Museum of Modern
Art

Comparative images

page 86, **Albrecht Dürer**,
Draftsman Drawing a Reclining
Nude, c. 1527

page 49, **Andreas Gursky**, Niagara
Falls, 1989

page 60, **Bernd and Hilla Becher**,
Cooling Towers, 1970–1980

page 49, **Caspar David Friedrich**,
Monk by the Sea, 1809–10

page 89, **Caspar David Friedrich**,
View Through a Window, 1805-06

page 47, **Gordon Matta-Clark**,
Day's End, 1975

page 14, **Diana Thater**, Knots +
Surfaces, 2001

page 14, **James Turrell**, Lunette,
1974

page 47, **James Turrell**, Meeting,
1980–86

page 38, **Jannis Kounellis**,
Untitled, 1971

page 10, **Ludwig Mies van der
Rohe**, Farnsworth House,
1946–50

page 102, **Michelangelo
Antonioni**, Red Desert, 1964

page 11, **Peter Weir**, The Truman
Show, 1998

page 10, **Philip Johnson**, (with
John Burgee), Crystal Cathedral,
1979

page 38, **Pier Paolo Calzolari**,
Untitled (Malina), 1968–95

page 46, **Robert Irwin**, 1° 2° 3°
4°, 1992

page 14, **Robert Irwin**, Excursus:
Homage to the Square 3, 1998

page 45, **Robert Morris**, Steam,
1967/1974

page 82, **Robert Smithson**, A
Nonsite, Franklyn, New Jersey,
1968

page 84, **Robert Smithson**, Glue
Pour, 1969

page 27, **Victor Vasarely**, Eridan -
III, 1956

List of illustrated works

pages 62–63, **The aerial river
series**, 2000
page 22, **Beauty**, 1993
page 4, **Blitzableiter-
Induktionsspule** (Lightning
conductor induction coil), 2000
page 78, **By means of a sudden
intuitive realization, show me
your perception of presence**,
1996
page 36, **Camera obscura**, 1999
page 18, **Corner extension**, 2000
pages 70, 72, 93, **The curious
garden**, 1997
pages 76–77, **Der drehende Park**
(The turning park), 2000
page 119, **Die organische und
kristalline Beschreibung**, 1996
pages 50–51, **Double sunset**,
1999
pages 96–97, **Double window
projection**, 1999
pages 24–25, **Doughnut
projection**, 2000
pages 82, 83, **The drop factory**,
2000
page 26, **Earthwall**, 2000
page 79, **8900054**, 1998
pages 68–69, **Eine Beschreibung
einer Reflexion** (A description of
a reflection), 1995
page 84, **Erosion**, 1997
page 65, **The fault series**, 2001
page 89, **Fensterkaleidoskop**
(Window kaleidoscope), 1998
page 56, **Fivefold tunnel**, 1998
page 85, **Five orientation lights**,
1999
page 64, **The glacier series**, 1999
pages 100, 104, 107, 108, 111,
Green river, 1998–
pages 80–81, **Ice pavilion**, 1998
pages 120, 121, **The inventive
velocity**, 1998
page 46, **Konvex/Koncav**, 1995/
2000
page 61, **The lighthouse series**,
1999
pages 135, 136, 138, 139, 140,
The mediated motion, 2001
page 57, **Moss wall**, 1994
pages 85, 141, **The movement
meter tower for Lernaken**, 2000
page 35, **The movement meter
pavilion for Lernaken**, 2000
page 53, **No nights in summer,
no days in winter**, 1994
page 40, **1m³ light**, 1999
pages 98–99, **Proposal for a park**,
1997
pages 48, 49, **Reversed waterfall**,
1998
pages 130, 131, **Room for all
colours**, 1999
pages 58–59, **Room for one
colour**, 1998
page 19, **Seeing yourself seeing**,

2001
pages 125, 126, **Seeing yourself
sensing**, 2001
page 16, **Spiral pavilion**, 1999
pages 8, 9, **Succession**, 2000
page 45, **Suney**, 1995
page 39, **Sun window**, 1997
page 38, **Surroundings
surrounded**, 2001
pages 132–33, **Tell me about your
miraculous invention**, 1996
page 88, **Thoka**, 1995
page 94, **360° expectations**,
2001
page 55, **360° room for all
colours**, 2002
page 39, **Untitled**, 1991
page 30, **Ventilator**, 1998
page 87, **The very large ice floor**,
1998
page 15, **The very large icestep
experienced**, 1998
page 112, **Vortex for Lofoten**,
1999
page 37, **Waterfall**, 1998
pages 74, 75, **Well for Villa
Medici**, 1998
page 21, **Your blue afterimage
exposed**, 2000
page 33, **Your circumspection
disclosed**, 1999
pages 28, 29, **Your compound
view**, 1998
page 54, **Your intuitive
surroundings versus your
surrounded intuition**, 2000
pages 115, 116, **Your inverted
veto**, 1998
pages 11, 12–13, **Your natural
denudation inverted**, 1999
pages 90, 91, **Your now is my
surroundings**, 2000
page 44, **Your only real thing is
time**, 2001
page 20, **Your orange afterimage
exposed**, 2000
pages 140, 142–43, **Your position
surrounded and your
surroundings positioned**, 1999
pages 128–29, **Your spiral view**,
2002
pages 42–43, **Your strange
certainty still kept**, 1996
page 23, **Your sun machine**, 1997
page 52, **Your windless
arrangement**, 1997